Dedicated to

RICHARD F. BROWN

1916–1979

Founding Director

Kimbell Art Museum

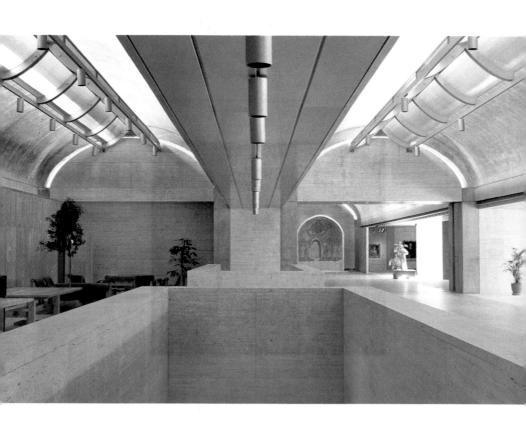

KIMBELL ART MUSEUM

Handbook
of the Collection

Kimbell Art Foundation
Fort Worth

Kimbell Art Museum Publication Four

Copyright © 1981 by Kimbell Art Foundation
All Rights Reserved
Copyright 1981 by *S.P.A.D.E.M.*, Paris/*V.A.G.A.*, New York, which asserts
copyright in works by the following artists: Degas, Maillol, Matisse, Monet, Picasso,
Redon, Rouault, Vuillard.

International Standard Book Number: 912804-04-1
Library of Congress Catalog Card Number: 80-82892

Designed by Bert Clarke
Printed by The Press of A. Colish, Mount Vernon, N.Y.
Maps designed by James A. Ledbetter
Photography by Robert Wharton except: cover, copyright 1976 by Yukio Futa-
gawa, Y. Futagawa and Associated Photographers; frontispiece, copyright 1972
by Marshall D. Meyers.

This project is supported by a grant from the National Endowment for the Arts
in Washington, D.C., and was also assisted by a grant from the Lorin Boswell
Foundation, Fort Worth.

Contents

Introduction

This *Handbook* is an introduction to the collections of the Kimbell Art Museum. Its purposes are twofold: to serve as a guide for museum visitors and to document the museum's holdings for interested readers. It provides an illustration, a brief interpretative text and historical data for nearly all the works of art in the Museum's collections. This information can aid in planning a visit to the Museum, enhance first-hand experiences of art while in the galleries and serve as an *aide memoire*. Many entries also cite more extensive discussions of individual works of art in periodicals and books and in the Kimbell Museum's *Catalogue of the Collection*, published when the museum opened in 1972. In addition, this *Handbook* documents the continuing growth of the collections; it includes the works of art acquired by purchase and gift since 1972 and shows the status of the collections as of June, 1980.

Explanatory Note

The sixteen historical sections of this *Handbook* are each arranged in approximate chronological sequence, except the geographically ordered African section. Works by the same artist are grouped together; occasional other chronological deviations achieve more gracious page combinations. Signed and/or dated works are explicitly identified in illustration captions. Dimensions are given in centimeters, followed by inches rounded up to the next higher eighth inch. Height precedes width (or diameter). For engravings and etchings dimensions are the plate size. In the Chinese section, transliterations are rendered in the recently established Pinyin form, followed by the traditional Wade-Giles form.

In the references, the term *Catalogue* refers to *Kimbell Art Museum: Catalogue of the Collection*; selected recent scholarly discussions of the work are then followed by cursory identification of previous collections. In the registration numbers, year of acquisition is indicated by the first two numerals; letter prefixes signify means of acquisition: ACF and ACK indicate works received through the Kimbell Bequest; AP identifies works purchased by the Kimbell Art Foundation; APX designates purchases funded by exchange of other works; AG identifies gifts.

Historical Note

The Kimbell Art Museum owes much to four people whose generosity and vision have established its character: Kay Kimbell, gifted financier and imaginative philanthropist; Velma Fuller Kimbell, generous benefactor and constantly supportive trustee; Richard F. Brown, passionate connoisseur and founding director of the Kimbell Art Museum; and Louis I. Kahn, the creative architect who designed our building. Their interests and efforts have been crucial in making the Kimbell Art Museum a marvelous place in which to appreciate the individual qualities of distinguished works of art.

Kay Kimbell, the founding benefactor of the Kimbell Art Museum, was a Fort Worth entrepreneur who built a substantial fortune through hard work, shrewd foresight and exceptional financial acumen. Born in 1886 in Oakwood, Texas, and schooled in Whitewright, he operated grain milling operations in North Texas for more than twenty years before moving to Fort Worth in 1924. Kimbell Milling Company flourished and his business activities broadened to include petroleum, insurance, and real estate investments. At the time of his death in 1964, he headed some 70 corporations, including the widely known Kimbell Foods, Inc., begun as a wholesale food operation in the 1940s, and the "Buddies" group of more than 225 retail stores, located in North Texas, Oklahoma and New Mexico. In his will Kay Kimbell bequeathed his entire interest in these companies to the Kimbell Art Foundation and charged its trustees "to encourage art in Fort Worth and Texas by providing paintings and other meritorious works of art for public display, study and observation in suitable surroundings."

Velma Fuller Kimbell, co-chairman of the Kimbell Art Foundation, has joined her husband's will by generously contributing her share of their community property to the Foundation, whose sole purpose is support of the Museum. Mr. and Mrs. Kimbell, who married on Christmas Eve, 1910, began collecting art in 1935 when Mrs. Kimbell persuaded her husband to acquire a British portrait from a loan exhibition of old master paintings at the Fort Worth Public Library. By 1964 their collection had grown to more than 200 paintings, all of which they gave to the Kimbell Art Foundation as the nucleus of the Kimbell Art Museum. The paintings given by Mr. and Mrs. Kimbell are identified by the phrase "Kimbell Bequest."

Louis I. Kahn of Philadelphia designed the Kimbell Art Museum between 1967 and 1972. One of the last buildings created by Kahn (who died in 1974), the Kimbell Museum is regarded as one of this renowned architect's most successful designs. In the museum's galleries Kahn's imaginative modulation of natural light and his sensitive articulation of space subtly enhance enjoyment of the works of art. Moreover, the building's gracious proportions, humane scale, careful detailing and innovative engineering make the museum a distinguished work of art in its own right.

Richard F. Brown guided the growth and development of the Kimbell Art Museum for nearly fifteen years until his death in November, 1979. As founding director of the Museum, Ric Brown established its distinctive character by leading the trustees of the Foundation in an uncompromising quest for excellence. He selected Louis I. Kahn as architect of the building and was a creative client who worked intimately with Kahn and contributed significantly to the building's functional success. He substantially enriched the museum's collections by vigorously pursuing a highly selective acquisition policy: to find and acquire masterworks of exceptional aesthetic quality and fulfilling visual appeal. His challenging ideals are well revealed in his own words, a private *apologia pro vita sua*, written in January, 1979:

> "We know better than to ask for immortality for ourselves. But we do fashion things with our utmost craft and devotion in an effort to say what we are in a way that will last. Some of these things we live by because we believe they mean just that. If you come to the museum and honestly search for that meaning you endow yourself, and me, with a measure of imperishable life."

Acknowledgments

Grants by the National Endowment for the Arts and the Lorin Boswell Foundation aided in the publication and distribution of this Handbook.

Numerous professional friends and associates have generously shared their insights. Special thanks are due to museum colleagues, Joseph Baillio, Elizabeth Benson, Rand Castile, Gillette Griffin, Henry Hopkins, William Jordan and John Lunsford. Also invaluable have

been the scholarly opinions of Fred Albertson, A. J. Ehlmann, Craig Felton, Julius Held, John Rewald, John Scott, Seymour Slive, Donald Stadtner and H. W. Van Os. The informed expertise of David Carritt, N. V. Hammer, Ben Heller, Alphonse Jax, Peter Marks, Clyde Newhouse, Michael Robbins, Margo Schab, Janos Scholz and E. V. Thaw is gratefully acknowledged.

Production of this *Handbook* has involved the concerted efforts of nearly all the museum staff. It was begun when founding director Ric Brown's enthusiasm encouraged me to begin planning a portable, relatively inexpensive publication about the museum's collections. Most of the entries were written by the museum's curators—Nicole Holland, Michael Mezzatesta, Ellen Oppenheim, Emily Sano and Ruth Sullivan—to whom grateful thanks are given. Entries were also contributed by Nell Johnson, Andrew Resnick, Frances Robb and myself. Research support was given by the late Ilse Rothrock and her capable library staff while technical data and measurements were verified by Foster Clayton, Perry Huston and Adrian Martinez. The efforts of photographers Bob Wharton and David Wharton are much appreciated as is the typing of Karen Rogerson and Helen Viola and the proofing of Ruth Ann Rugg. Special recognition is due to editor Shirley Spieckerman whose vigilant editorial precision has nurtured and guided this publication from its beginning. My deep thanks also to curatorial coordinator Nicole Holland who brought this publication to successful completion, to Andrew Resnick for his constant support and early administration of the project and to Frances Robb for curatorial advice and editorial assistance.

DAVID M. ROBB, JR.
Chief Curator

Handbook of the Collection

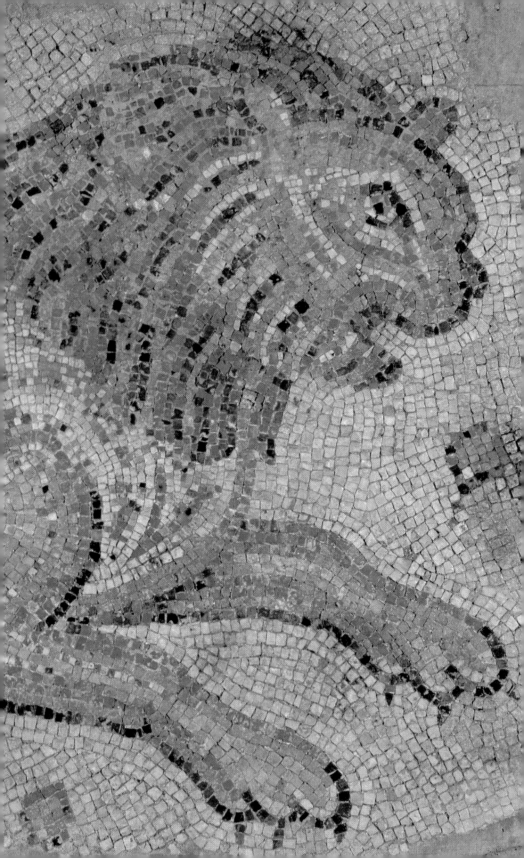

Ancient

Syrian, *Lion* (detail), page 16

Sumerian, Protoliterate Period

Head of a Ewe

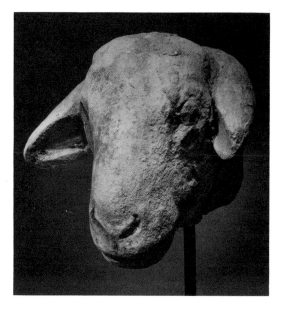

About 3200 B.C. From Uruk (?). Sandstone.
14.6 cm. high (5¾ in.)

This astonishingly realistic ewe's head, probably a fragment from a cult statue, reveals the artistic sophistication of an early chapter in man's civilization. The history of Mesopotamia, the land between the Tigris and Euphrates Rivers, truly begins in the Uruk era with the arrival of the Sumerians. Their development of city-states, use of cuneiform characters, and creation of temple towers known as ziggurats attest to a rich and complex culture. Although the head was probably intended for temple use, its precise ritualistic purpose is unknown. Sacred lambs are associated with the mother goddess, Ninhursag, and it has been suggested that the ewe symbolizes Duttur, the mother of Dumuzi, who was an important god of milk, sheepherding and the netherworld.

Collections: Borowski. AP 79.38

Cycladic, Prehistoric Period

Female Figure

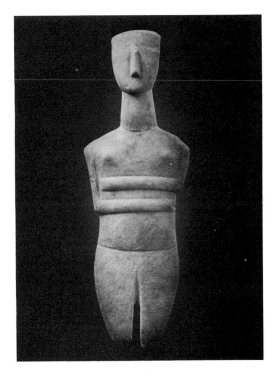

About 2500–2000 B.C. Marble.
41.2 cm. high (16¼ in.)

This slender, commanding marble sculpture from the Cyclades Islands in the Aegean Sea is thought to be the image of a deity. Though small, this figure represents the very beginning of the Western monumental tradition and embodies as well the form and feeling of much 20th-century art. Simple, rounded planes and lines evoke the female form, with a stylized abstraction readily appealing to the modern eye. The absence of the lower legs, as in so many Cycladic figurines, suggests that the object may have been deliberately broken in a funerary rite, for similar sculptures have often been excavated in burial sites.

Catalogue, p. 2. Collections: Heller. Gift of Ben Heller, AG 70.2

Cypriot, Archaic Period, 700–475 B.C.

Standing Female

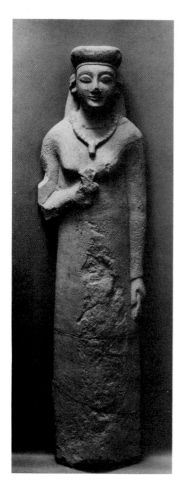

About 500–475 B.C. Sandy limestone.
47.4 cm. high (18¾ in.)

This serene, columnar statue may repre-
sent a goddess or votary. Frontally con-
ceived with a flat back, the slender figure
holds a flower in her right hand and
grasps another object at her side. The ele-
gant design of the headcloth and necklace
are of Near Eastern origin, but her sweet
expression and almond-shaped eyes de-
rive from Greek Archaic sculptural tradi-
tions. This mixture of styles, seen as well
in the *Wreathed Male Head,* evinces the
varied political and cultural allegiances of
the Mediterranean island during the
Archaic Period.

Collections: Borowski. Gift of Elie Borowski
in memory of Richard F. Brown, AG 80.2

Cypriot, Archaic Period, 700–475 B.C.

Wreathed Male Head

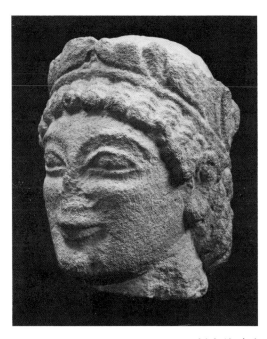

About 500–475 B.C. Sandstone. 16.0 cm. high (6¼ in.)

This rough-hewn sandstone sculpture depicts a vigorous and assertive young hero, his head crowned with a laurel wreath, symbolic of triumph. It was carved during the most creative period of Cypriot art. The idealized facial structure and enigmatic smile resemble Greek sculpture of about the same age, while the widely spread almond eyes and tightly knotted curls bespeak a Near Eastern influence. Such an artistic confluence reflects the international character of the island of Cyprus, then the mercantile crossroads between East and West.

Catalogue, p. 3. AP 72.5

Greek, Hellenistic Period, 323–31 B.C.

Head of a Child

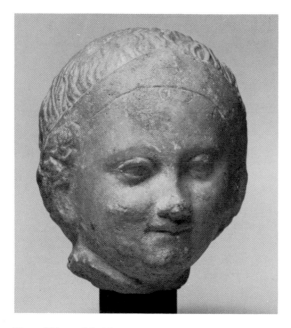

About 300 B.C. Marble.
15.9 cm. high (6¼ in.)

During the Hellenistic period the idealizing norm of classical figurative sculpture gave way to a fresh look at individual characteristics. The sweet, untroubled life of this round-faced young girl from Attica is evinced in her dreamy countenance, particularly in the shy smile and the enlivening tilt of her head. The diadem on the child's head (originally part of a full-length statue) suggests that she represented a child of the gods or one dedicated to a particular god.

Catalogue, p. 7. AP 72.4

Greek, Late Classical Period, 400–323 B.C.

Young Female Attendant

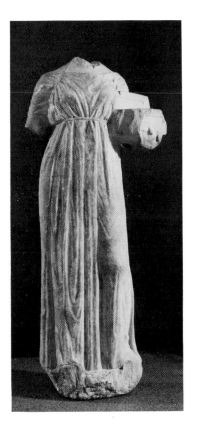

About 340–330 B.C. Marble.
116.9 cm. high (46 in.)

A young girl, as dignified in bearing as
the Panathenaic maidens on the Parthe-
non frieze, stands with stately grace, her
weight balanced on the right leg. Her
simple gown, caught up beneath her
bosom, falls in natural folds, emphasizing
her youthfully slim, long-legged appear-
ance. Figures like this of the mid-4th
century exemplify classical ideals of se-
renity, harmony and balance as conveyed
through the female form. Throughout
the history of Classical Greek art, there is
a continuous development in the relation-
ship of the figure with its surrounding
space. This young maiden is sculpted in
the round, her left knee and arm extend-
ing into the viewer's space. She offers a
jewelry box in her left hand. Such figures
are commonly found in funerary reliefs
where the offering is made to a lady of
high standing or a priestess, and they are
also widely found as votary statues in
temple precincts.

Catalogue, p. 5. AP 72.3

Roman, Late Republican-Early Imperial Period
After Greek 3rd century B.C. prototype

Crouching Aphrodite

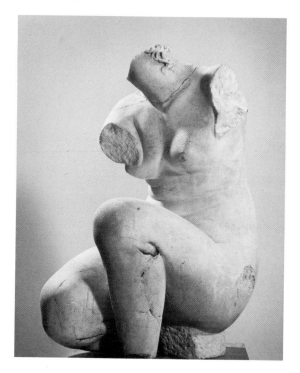

About 50 B.C. to A.D. 140. Marble. 63.5 cm. high (25 in.)

This shimmering marble statue captures the full sensuality of female beauty embodied in Aphrodite, goddess of beauty and love. The crouching figure was based on a prototype from the 3rd century B.C., formerly identified as by a Greek sculptor named Doidalsas. She is shown in the intimacy of her bath, and the missing right arm was probably intended to shield her nudity. Possibly designed for the decoration of a Roman garden or bath, the lifelike figure is fully Hellenistic in the soft, tangible folds of flesh, delicately modeled contours and firm anatomical structure.

Catalogue, p. 8

AP 67.9

Roman, Late Republican-Early Imperial Period
After Skopas (Greek), about 370–330 B.C.

Head of Meleager

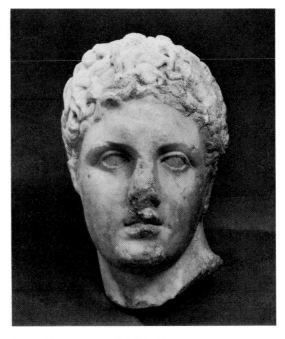

About 50 B.C. to A.D. 100. Marble.
29.8 cm. high (11¾ in.)

This head is a Græco-Roman copy from a full-length statue by the
famed Greek sculptor Skopas of the 4th century B.C. Its depiction of a
mythological hero victimized by fate reveals the predilection of that
artist for themes of human suffering which invited a trenchant, emo-
tional realism of style. Meleager, the intrepid slayer of the Calydonian
boar, was doomed to death by the Fates soon after his birth, a dire
prophecy carried out by his mother Althæa after he took the lives of
her brothers in a quarrel. The artist has suggested the suppressed
anxiety of the noble youth in the parted lips, deeply sunken eyes and
raised brow.

Catalogue, p. 10. AP 67.10

Roman, Imperial Period

Portrait Head of Marcus Aurelius

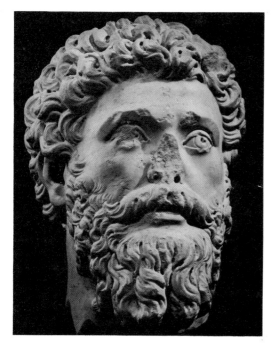

About A.D. 170–225. Marble. 36.5 cm. high (14⅜ in.)

Imperial Roman portraits such as this one were used to glorify the emperor, who stood as the symbol of Rome's power and majesty. Marcus Aurelius, emperor from A.D. 160 to 180 and best known as author of the "Meditations," was both soldier and Stoic philosopher. This powerful head, with its broad features and massively carved hair and beard, evokes great physical strength. The smoothly polished surface of forehead and cheeks contrasts with the rough-textured hair, which is further defined by deeply drilled shadows. Possibly produced in Asia Minor during the Severan Period, this image has the upward gaze which signifies the divine nature of the emperor.

Catalogue, p. 12. AP 67.11

Roman, Imperial Period

Portrait Head of Faustina the Younger

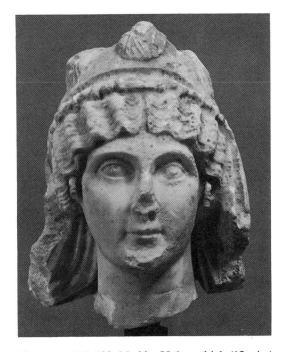

About A.D. 175–180. Marble. 33.6 cm. high (13¼ in.)

This idealized portrait exalts Faustina, wife of Marcus Aurelius, by presenting her as a priestess of the imperial cult. This type of head-dress is associated with Asia Minor, where the emperor and his wife were worshipped as part of the state religion. Faustina's face is youthful, her features carved with sensitivity and refinement, and the wavy hairstyle is one of her most characteristic features. The sand-colored incrustations on the white marble result from burial.

Catalogue, p. 14. AP 69.18

Egyptian, Late Period, 1085–332 B.C.

Ibis

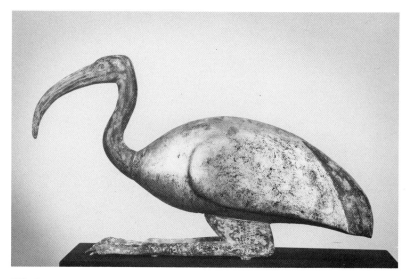

XXVI–XXX Dynasty, 664–343 B.C. Gilded wood and bronze. 22.1 cm. high (8¾ in.)

Most small sculptures of sacred animals like this ibis were produced in the Late Period of Egypt when the cult of animal worship became part of official religion. A wading bird, the ibis is dedicated to Thoth, scribe to the gods and the god of wisdom, learning and magic who invented numbers and letters. Although naturalistic features are indicated, the gilded body and stiff form of the bird indicate its sacred status. The large size of this ibis suggests it was a temple gift.

Collections: Matossian; Johnson. Gift of Ruth Carter Johnson, AG 75.1

Egyptian, Roman Period, 30 B.C. to A.D. 395

Mummy Mask

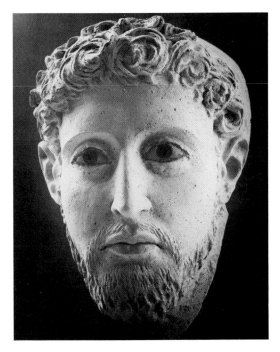

About A.D. 160. Probably from Middle Egypt.
Stucco. 29.4 cm. high (11⅝ in.)

Roman imperial sculpture influenced ancient burial customs in Egypt, where this head is thought to have been made, shortly before these venerable traditions were abandoned forever. The facial proportions and modeling derive from the Roman tradition of realistic portraiture, rather than Egyptian antecedents. Made to cover the skull of a mummy, the portrait head is hollow inside. The face was pressed from a mold, with hair and ears and striking inlaid eyes added to increase its individuality and expressive quality. Painted flesh and gilded hair once lent the mask funereal pomp.

Catalogue, p. 16; see also: Grimm, *Die Römischen Mumienmasken aus Äegypten*, 1974, p. 82. AP 70.5

Syrian, 5th Century

Early Christian Mosaics

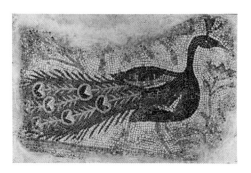

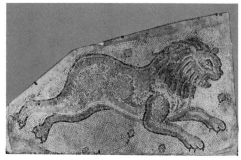

Peacock
About A.D. 400. One of seven
mosaics, ranging in size from about
35.5 × 50.8 cm. (14 × 20 in.) to
63.5 × 99.0 cm. (25 × 39 in.)

Lion
About A.D. 450–462. From Emesa
(Homs, Syria). Mosaic.
108.0 × 195.5 cm. (42½ × 77 in.)
Also illustrated p. 2.

Mosaics with bird and animal motifs set in geometric borders were
commonly used as pavement decoration in early Christian churches.
Sacred personages and biblical narratives, on the other hand, usually
appeared on walls and ceilings. With the advent of Islam, these struc-
tures were either destroyed as abominations or fell into disuse, and
their mosaics are preserved today mostly as fragments. The bird, ani-
mal, and vine motifs derived from Near Eastern and Græco-Roman
prototypes. These pagan images carried over into Early Christian art,
expressing new spiritual concepts.

AP 72.17–24

Persian, Sasanian Dynasty, A.D. 224–651

Plate with King Peroz Hunting Boars

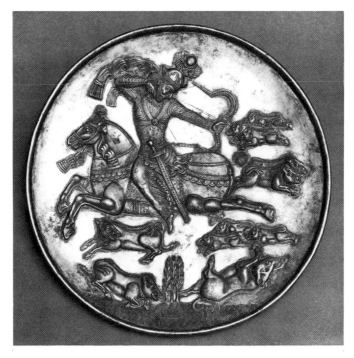

About 6th-7th century. Silver, partially gilt. 22.6 cm. diam (8⅞ in.)

This richly embellished plate reflects the wealth and sumptuous living of the Sasanian court, which ruled the last great Persian empire before the Moslem conquest. Here we see the reigning monarch astride his horse charging through a pack of wild boars. His wide-open eye and dilated nostril reflect tense excitement, while his scarf flutters in the wind. This scene of the royal hunt glorifies the king by dramatizing his strength as a hunter. Because of his distinctive crenellated crown, adorned with globe, crescent, and eagle sky wings, the king has been identified as Peroz, who reigned A.D. 457/9–484.

Catalogue, p. 224.

AP 67.3

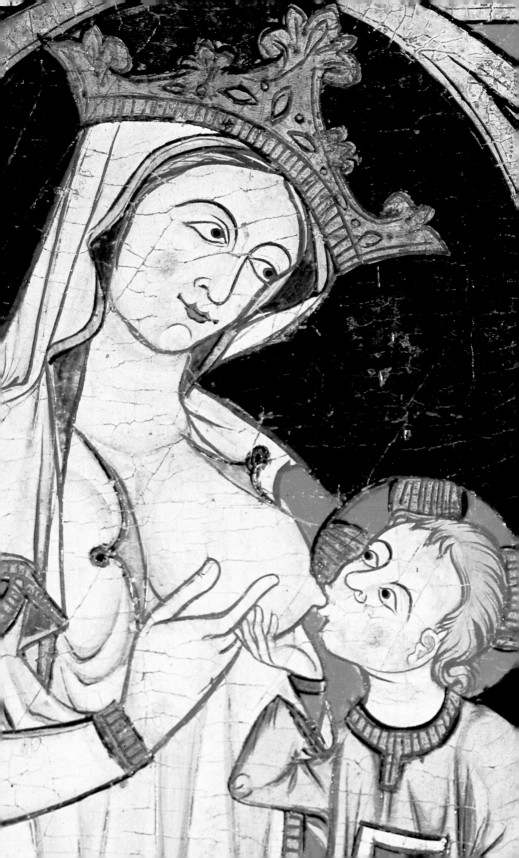

Medieval

English, *Barnabas Altarpiece* (detail), page 23

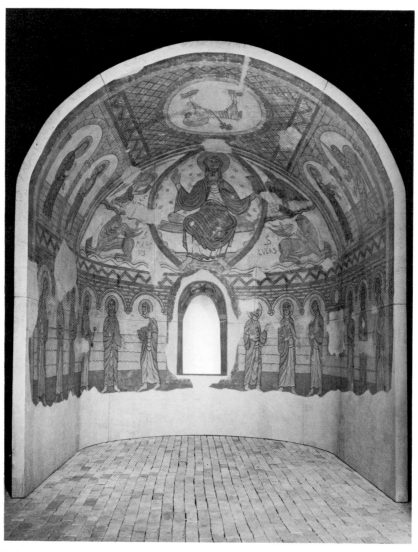

Painted about 1150. From the Chapel of St. André de Bagalance, near Avignon.
Dry fresco on plaster (transferred to canvas and mounted on wood).
376.2 × 310.2 × 343.2 cm. (12 ft. 4¾ in. × 10 ft. 1 in. × 11 ft. 3 in.)

French, 12th Century

Romanesque Wall Paintings

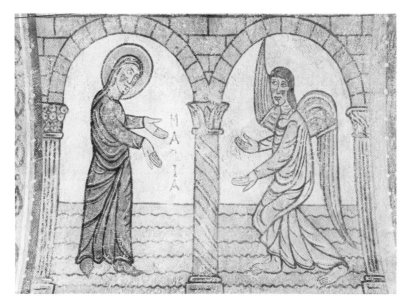

The Annunciation (detail)
From the Chapel of St. André de Bagalance, near Avignon.

For centuries after the birth of Christianity, Western Europe was wracked by great political and social turmoil, but by the late 10th and 11th centuries a period of sustained stability began when the first cohesive European culture since Roman times emerged. This new epoch nurtured the Romanesque style in art, which revived classical forms in sturdy, arched churches whose walls were covered with common emblems of the faith. These frescoes of Christ and his Apostles from the apse of a small chapel in southern France display a remarkable canonical consistency to others found throughout the Continent. Figures and space, depicted in muted earth tones, were abstracted to conform to the plane of the wall. The restrained design was intended to produce a solemn environment conducive to spiritual contemplation.

Catalogue, p. 18. AP 71.1

French, 12th Century

Reliquary Arm

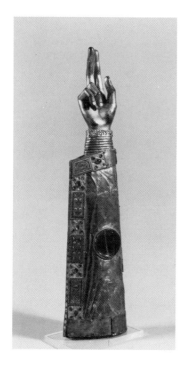

Made about 1150–1200, crystal possibly
added in 15th century. From Liège.
Silver, champlevé enamel on copper
over wood, gilt bronze.
62.1 × 15.3 cm. (24½ × 6⅛ in.)

During the Middle Ages a major focus of Christian worship centered
on the cult of sacred relics. Containers were created to enshrine the
holy objects for preservation and display and, through their own
beauty and form, to enhance the relics' spiritual significance. This
reliquary arm, its hand raised in a gesture of benediction, once con-
tained a bone fragment from an unidentified saint. The sleeve border
is embellished with a fine series of colorful champlevé enamel
plaques, delicately patterned with stylized floral and heart motifs.
Such superb enamel work is characteristic of Mosan art, which flour-
ished during the 12th and 13th centuries in Liège (now in Belgium).

See: Braun, *Die Reliquiare des christlichen Kultes und ihres Entwicklung*, 1940,
pp. 338–390; *The Ernest Brummer Collection*, vol. 1, Galerie Koller, 1979,
cat. no. 225. Collections: Brummer. AP 79.25

English, 13th Century

The Barnabas Altarpiece

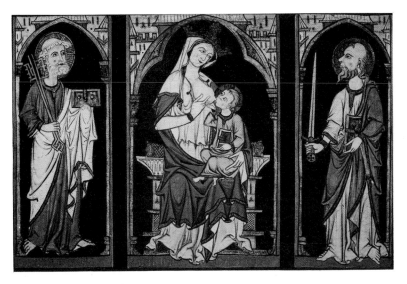

Painted about 1250–60. Tempera and oil on panel. Central panel, 91.0 × 57.5 cm.
(35¾ × 22⅝ in.); side panels 91.0 × about 37.3 cm. (35¾ × 14⅝ in.).
Also illustrated p. 18

The earliest surviving English painting on wood panel, this magnificent altarpiece truly defines medieval Anglo-French art, a cosmopolitan style standing between the symbolic abstraction of Romanesque art and the naturalism of the mature Gothic. Rich in meaning, the work shows the Queen of Heaven nursing her child, an unusual subject for this early date, reflecting the newly emerging tenderness and humanity of Roman Catholicism. Sts. Peter and Paul stand in attendance and buildings crowd up behind the framing arches, suggesting the union of the mundane world with the divine. The lively facial expressions and gestures are expressed in energetic drawing and bold color. Originally this altarpiece had additional panels above and below whose design can be imagined from comparison to contemporary manuscripts. Below the center panel was probably the kneeling figure of the donor, Bishop Barnabas. Now only the tip of his finger can be seen, just below the first letter of his name.

Catalogue, p. 20. Collections: Hochon; Gangnat; de Coppet. AP 69.6

French, 13th Century

Reliquary Casket

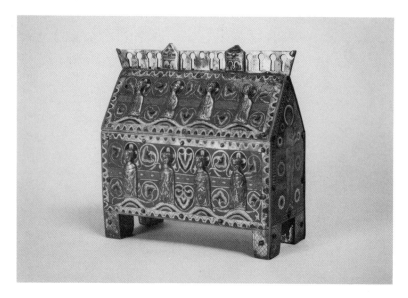

Made about 1200–1220. From Limoges. Champlevé enamel on copper over wood. Dimensions: 22.6 × 24.2 cm. (9 × 9⅝ in.)

A second great center of medieval enamel work was Limoges in southwest France. This casket, which may have contained the relics of several saints, is remarkable for its richness and brilliance. Emerging from undulating bands of clouds are two rows of four half-length saints, similar to those in the frescoes of the Kimbell's Romanesque apse. These gilt figures stand out strongly against the background of blue enamel strips yet, by their haloes, are carefully integrated into the overall decorative pattern defined by the clouds, graceful foliated scrolls, and colorful fleurons. The saints are subtly differentiated through gesture and, with the standing figures on the gabled end panels, present a heavenly convocation which conveys the mystical symbolism of the container and its contents.

See: Gómez-Moreno, *Medieval Art from Private Collections*, 1968, no. 157; *The Ernest Brummer Collection*, vol. 1, Galerie Koller, 1979, cat. no. 225. Collections: Bourgeois; Daguerre; Kahn; Brummer. AP 79.26

French, 13th Century

Miniature Casket

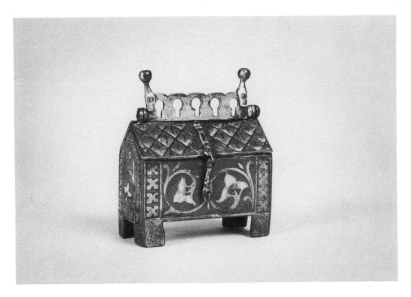

Made about 1250–1300. From Limoges. Champlevé enamel on copper over wood.
9 × 7.7 cm. (3⅝ × 3⅛ in.)

This miniature casket, produced in the Limoges region during the
second half of the 13th century, has the same basic form as the reli-
quary casket, but its compact size and ornamental decoration suggest
that it may have been intended for domestic use. The fleurons display
masterful craftsmanship, especially in the subtle color transitions
from the gilt stems to the red, blue and white of the blossoms. The
graceful curves of the flowers are in striking contrast to the varied
geometric designs of the casket's framework. These motifs, similar to
those on the earlier casket, may have been derived from pattern books
handed down from generation to generation.

See: Gómez-Moreno, *Medieval Art from Private Collections*, 1968, no. 163;
The Ernest Brummer Collection, vol. 1, Galerie Koller, 1979, cat. no. 237.
Collections: Brummer. AP 79.27

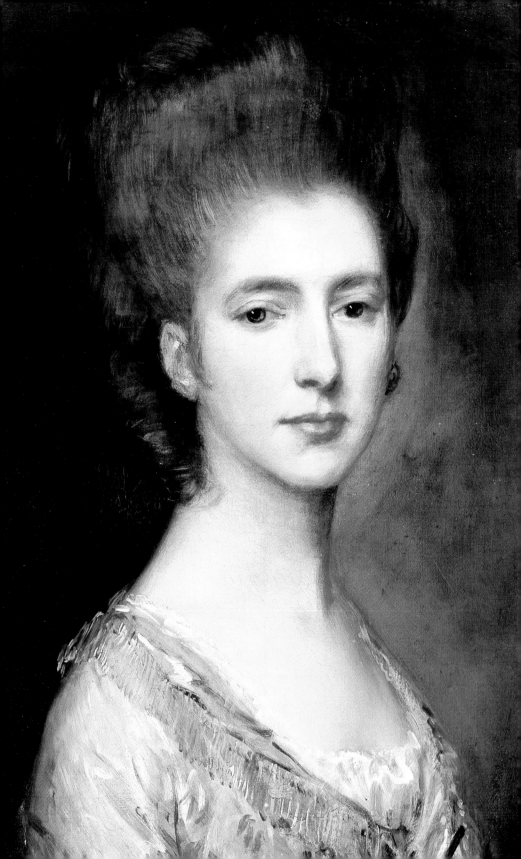

British

Gainsborough, *Mrs. Champion* (detail), page 39

PETER LELY, English, 1618–1680, and assistants

Richard and Anne Gibson

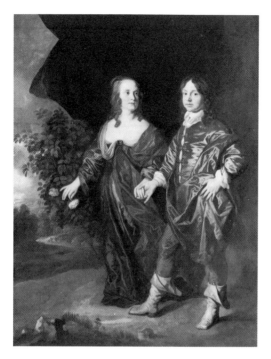

Painted after 1640, probably about 1650–60. Oil on
canvas. 165.2 × 122.1 cm. (65⅛ × 48⅛ in.)

A portrait painter with an extensive practice, Lely commanded a
large studio and was Principal Court Painter to Charles II. This double
portrait depicts Richard Gibson, an accomplished painter of minia-
tures, and his wife Anne, both of whom were dwarfs (about 3 feet,
10 inches in height) and served the English court. They had nine
children, all of normal size, including several who became artists like
their father. In this portrait, Van Dyck's influence is clearly evident
in the rich, warm reds and browns as well as in the landscape setting,
which became the conventional background for 18th-century por-
traiture.

Catalogue p. 117; see also: Millar, *Sir Peter Lely*, 1978, cat. no. 18.
Collections: Earl of Pembroke; First Earl Poulett; Sheffield; Kimbell Bequest.

ACF 44.1

WILLIAM HOGARTH, English, 1697–1764

A Rake's Progress

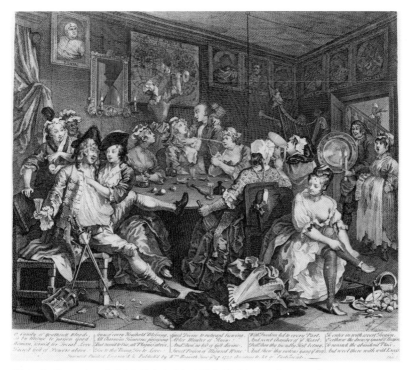

Plate 3 of a series of eight. Printed in 1735. Etching and engraving on paper, third of three states. 35.7 × 40.8 cm. (14⅛ × 16⅛ in.)

This tavern scene chronicles a gin-soaked moment in the downward "progress" of a dissolute young rakehell who conspicuously lacks the virtues of moderation, self-control and common sense prized by 18th-century society. In later images of this eight-part series, the rake comes to a bad end. Hogarth's protagonists are invariably vain, affected, ridiculous—and irresistibly interesting. The artist was uniquely gifted at visual narrative, and the fine-line clarity of his engraving technique makes every detail and incident revealing. Hogarth's wide-ranging imagination is exemplified in this print and 99 others which have been given to the museum.

Collections: Hudson. Gifts of Mr. and Mrs. Edward R. Hudson, Jr.,
 in memory of Edward R. Hudson, AG 77.2, 78.1, 78.4

Attributed to GEORGE
BEARE, active 1744–1749

Attributed to TILLY
KETTLE, 1735–1786

Mrs. Ann Burney (?)

Mrs. Baldwin (?)

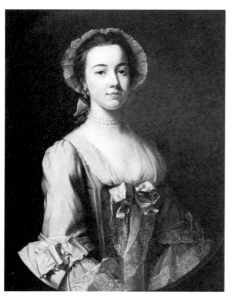

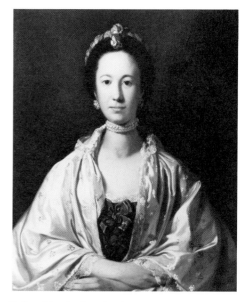

Painted about 1740–50.
Oil on canvas. 76.2 × 63.5 cm.
(30 × 25 in.)

Painted in the late 1760s.
Oil on canvas. 76.8 × 64.1 cm.
(30¼ × 25¼ in.)

Increased patronage in the mid-18th century brought forth an abun-
dance of practicing portrait painters, including Beare and Kettle
about whom relatively little is known. This pleasant, unpretentious
portrait is attributed to Beare because the erect pose and facial features
are similar to those in his few signed and dated works. The oval-
shaped head of Mrs. Baldwin is a distinguishing characteristic of
Kettle's style. He is known to have gained considerable recognition
for portraits done in India, 1769–1775.

Beare—*Catalogue*, p. 119. Collections: Burney family (?), Mountbatten (?);
Kimbell Bequest. ACK 48.1
Kettle—*Catalogue*, p. 123. Collections: Baldwin; Kenyon-Slaney;
Kimbell Bequest. ACF 60.7

ARTHUR DEVIS, English, 1711–1787

Mrs. Edward Travers *Mr. Edward Travers*

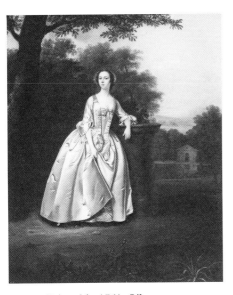 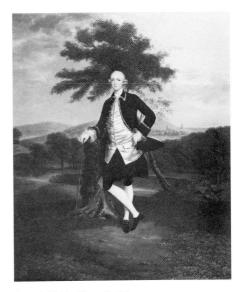

Painted in 1751. Oil on canvas. Dated 1751. Signed. Oil on canvas.
75.8 × 63.2 cm. (29⅞ × 24⅞ in.) 75.8 × 63.2 cm. (29⅞ × 24⅞ in.)

A refreshing naïveté characterizes these portraits, whose modest size
was appropriate for a country squire's drawing room. Mr. and Mrs.
Travers are posed in the carefully tended, peaceful parklands of their
country home. The artist's meticulous draftsmanship is seen in the
precisely rendered details of the couple's fashionable dress, especially
in the pristine folds of Mrs. Travers' gown. The bright, often silvery
highlights of their clothing set the figures off from the atmospheric
background. Devis never worked in London. Rural patrons commis-
sioned most of his small-scale, full-length portraits, whose restrained
style reflects the influence of Dutch artists like Ter Borch.

Catalogue, p. 121. Collections: Davis; Kimbell Bequest. ACF 64.5, 64.4

JOSHUA REYNOLDS, English, 1723–1792

Miss Warren (?)

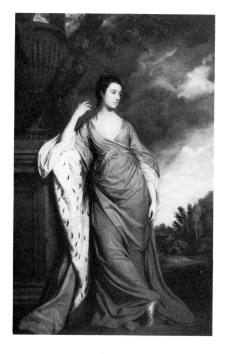

Dated 1759. Signed. Oil on canvas.
238.1 × 147.8 cm. (93¾ × 58¼ in.)

Reynolds, the preeminent English painter of his day, was elected first president of the Royal Academy in 1768. With his large-scale works of eloquent idealism, he set out to raise the status of the British artist from that of a mere "face painter" to a man of learning. This painting is one of the earliest examples of his mature and innovative style of large portraits with allusions to classical poses, dress and themes. A reserved lady wears a blue dress inspired by classical drapery and stands against an antique pedestal, her elbow resting on an ermine cape with rose-colored lining. Known as the "grand manner," this style was prompted by the artist's journeys to Italy to study ancient art and the work of Bolognese, Venetian and Roman Renaissance masters.

Catalogue, p. 124. Collections: Warren; Bulkeley family; Hearst;
Kimbell Bequest. ACF 61.2

JOSHUA REYNOLDS, English, 1723–1792

Miss Anna Ward with her Dog *Miss Charlotte Fish*

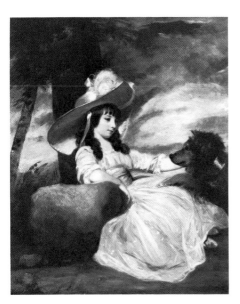 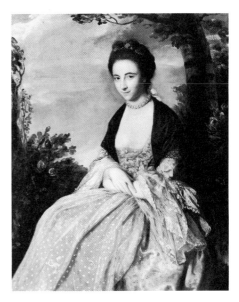

Painted in 1787. Oil on canvas.
141.6 × 113.7 cm. (55¾ × 44¾ in.)

Painted in 1761. Oil on canvas.
127.0 × 101.0 cm. (50 × 39¾ in.)

Unlike his heroic, large-scale works, Reynolds' domestic portraits are
of modest size, informally posed and present distinct characterizations
of the sitters. The portrait of Miss Fish, a well-known and very fine
example, evokes the friendly personality of the sitter in her relaxed
pose and look of amused inquiry. The intimate setting is enhanced
through the rich colors of her strawberry pink gown and the warm
greens and browns of the background against a blue sky. The portrait
of Anna Ward, then about eight years of age, reflects the increased in-
terest in portraits of children during the 18th century. Reynolds fre-
quently pictured them, as here, in a pensive and restrained mood.
This was one of thirteen Reynolds paintings (six of children) in-
cluded in the annual Royal Academy exhibition of 1787.

Ward—*Catalogue*, p. 127. Collections: Dudley and Ward; St. Paul family;
Woods; Wertheimer; N. de Rothschild; Kimbell Bequest. ACF 48.3
Fish—*Catalogue*, p. 126. Collections: Addington; Bischoffsheim; Fitzgerald
family; Kimbell Bequest. ACF 50.5

THOMAS GAINSBOROUGH, English, 1727–1788

Miss Lloyd (?)

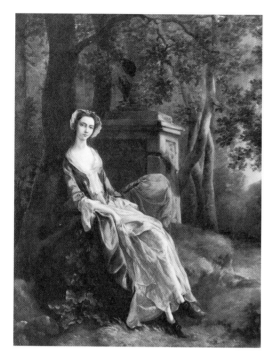

Painted about 1750. Oil on canvas.
69.6 × 53.0 cm. (27⅜ × 20⅞ in.)

The informally posed figure and soft colors combine to give a fresh charm to this small canvas, in contrast to the painter's more elegant later portraits. The marble pedestal and urn behind the sitter reflect the growing interest in classical ideas. The dominant notes of the painting are distinctive to Gainsborough's early work: the clarity of hues on the highlighted figure, her slender elongation, and the rippling angularity of the curves and flounces of the dress. Landscape background was a major concern of Gainsborough during his Suffolk years. Three surviving pencil sketches for this portrait indicate the various compositions he considered.

Catalogue, p. 129. Collections: Knighton; de Zoate; Kimbell Bequest. ACF 46.4

THOMAS GAINSBOROUGH, English, 1727–1788

Suffolk Landscape

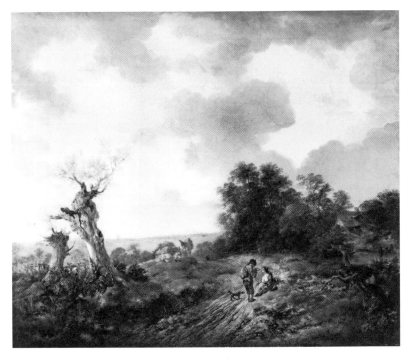

Painted in the mid-1750s. Initialed. Oil on canvas. 63.8 × 76.9 cm. (25⅛ × 30¼ in.)

In his early landscapes, Gainsborough often combined the wooded, rolling hills of Suffolk with anecdotal motifs, producing paintings which frequently served as chimneypiece decorations in country houses. Here, two travelers, a man smoking a pipe and a woman nursing her child, pause along a winding country road. The resting figures and a small dog are placed in the midst of a dark earth-toned landscape, while above the low horizon clouds scud dramatically across the sky. The composition is deliberately balanced by two gnarled trees on the left and a cottage in a leafy grove on the right. The subdued colors and warm lighting are characteristic of Gainsborough's landscapes of the mid 1750s.

Catalogue, p. 131. Collections: Hills; Kimbell Bequest. ACF 42.2

THOMAS GAINSBOROUGH, English, 1727–1788

Harriet, Viscountess Tracy

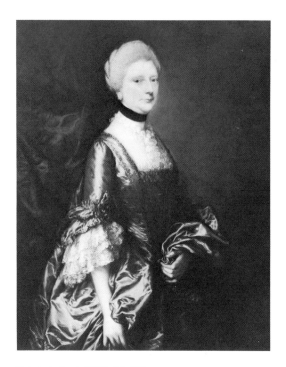

Painted about 1760–65. Oil on canvas.
126.3 × 101.3 cm. (49¾ × 39⅞ in.)

This formal portrait, produced during the years Gainsborough lived
in Bath, illustrates the painter's concern for rich fabrics, strong regal
posing and deeply toned colors, a combination appealing to his aris-
tocratic clientele. Unlike many of his contemporaries, Gainsborough
enjoyed painting the costumes himself, here producing an exciting
pattern of lights and shadows in the blue folds of the dress. Cleaning
of the work removed overpainting by a later artist which had amended
the sitter's features to produce a more youthful portrait.

Catalogue, p. 132. Collections: Tracy family; Sudeley family; Denny;
Wythes; Kimbell Bequest. ACF 49.2

THOMAS GAINSBOROUGH, English, 1727–1788

Miss Sarah Buxton

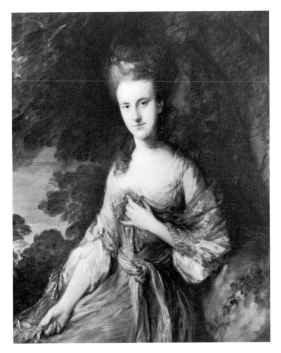

Painted about 1776–77. Oil on canvas.
109.7 × 86.7 cm. (43¼ × 34⅛ in.)

This elegant portrait shows the sitter at about twenty years of age, just before her marriage in 1777. Here Gainsborough's broad, loose brushwork harmoniously relates figure and outdoor setting. The highlighting, particularly on the gold-fringed shawl, creates a flickering brilliance against the softer background tones. The painting was originally a full-length composition with a greyhound resting at the sitter's feet.

Catalogue, p. 135. Collections: Dumbleton family; Gary; Jonas; Bush; Kimbell Bequest. ACF 50.1

Thomas Gainsborough, English, 1727–1788

Wooded Landscape with a Cottage and Cattle

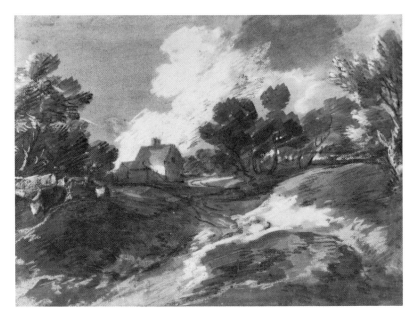

Drawn in the 1770s. Black chalk, watercolor and oil on paper.
21.5 × 29.4 cm. (8½ × 11⅝ in.)

Gainsborough's landscape drawings record some of his most personal
and spontaneous artistic investigations. This sketch was made in the
1770s when the artist began adding oil varnishes to his watercolors,
in an effort to make the drawings more monumental. The composi-
tion is harmoniously balanced by the groves of trees to left and right,
with a stream in the middle winding diagonally into the distance.
Gainsborough conveyed the vigor and strength of a country scene
through rapidly executed strokes of chalk and pigment which struc-
ture the view, mark the sunlight and denote the forms.

AP 79.28

THOMAS GAINSBOROUGH, English, 1727–1788

Mrs. Alexander Champion

Louis-Edmond Quantin, Chevalier de Champcenetz (?)

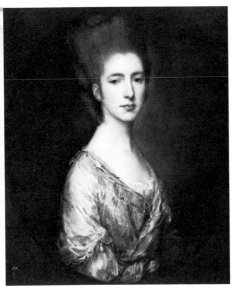

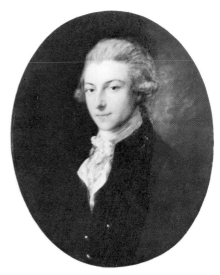

Painted in the mid-1770s.
Oil on canvas.
75.0 × 62.9 cm. (29½ × 24¾ in.)
Also illustrated p. 26.

Painted in the mid-1780s.
Oil on canvas.
68.3 × 55.2 cm. (26⅞ × 21¾ in.)

These works exemplify two aspects of portraiture in Gainsborough's late career. The regal, decorous pose of Mrs. Champion almost dominates the naturalism of her likeness. Her reserved formality is tempered, however, by Gainsborough's swift, illusionistic brushwork and the strong contrasts of alabaster-smooth flesh tones, powdered coiffure and gold-fringed bodice. The more restrained male portrait is an incisive, strongly focused likeness of a confident young Frenchman, a political writer whose beliefs caused his beheading during the French Revolution.

Champion—*Catalogue*, p. 134. Collections: Cobbe family; Jackling; de Coppet; Kimbell Bequest. ACF 54.7

Champcenetz—*Catalogue*, p. 137. Collections: Sackville family; de Coppet; Kimbell Bequest. ACF 54.8

JOHANN ZOFFANY, English, 1734/35–1810

The Sayer Family

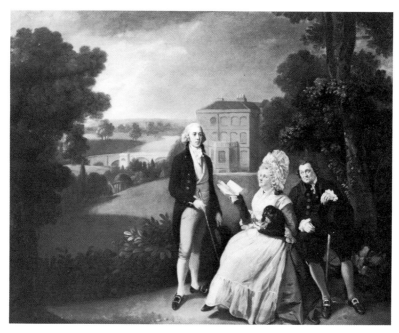

Painted about 1760–70. Oil on canvas. 101.7 × 127.4 cm. (40⅛ × 50¼ in.)

This portrait of an English family belongs to that class of painting called "conversation pieces," which mirror the life of the times, particularly that of the upper class and nobility. Zoffany was a master of group portraits including theatrical subjects. Here in fact, the backdrop effect of the house and distant landscape resembles a stage setting, and the figures are posed in a vivid domestic tableau. Zoffany is said to have been a friend of the Sayer family, noted London publishers, and this portrait reveals his facility for penetrating characterization. The father's expression—red-faced with eyebrows raised and lips pursed—is a trenchant study in displeasure.

Catalogue, p. 138. Collections: Sayer family. AP 69.21

RICHARD WILSON, English, 1713–1782

Tivoli: The Temple of the Sibyl and the Campagna

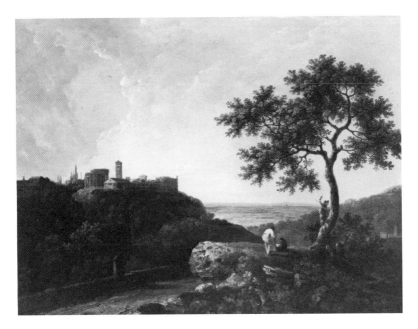

Painted about 1765. Oil on canvas. 72.6 × 97.8 cm. (29 × 38½ in.)

This luminous view of the Italian countryside was painted in London during the 1760s by Richard Wilson, one of England's most distinguished 18th-century landscape painters. Inspired by the work of Claude Lorrain and Gaspard Dughet, he developed a landscape style which conveyed the ideal beauty and meditative calm of nature as well as a nostalgic sentiment for the past. In the 1750s when he lived in Rome, Wilson made sketches in the surrounding countryside which he later used as the basis for oil paintings in London, where this work was done. Here an artist is shown sketching a view of Tivoli, a picturesque town 20 miles east of Rome, as a peasant leans over to observe. Wilson's sensitive handling of light and atmospheric space distinguishes his work from his contemporaries and endeared him to later English artists.

See: W. G. Constable, *Richard Wilson*, Cambridge, Mass., 1953, cat. no. 116b–1. Collections: Hinkel. APX 79.29

George Romney, English, 1734–1802

George and Katherine Cornewall

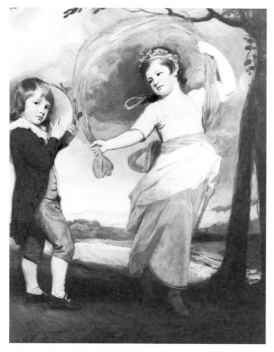

Painted in 1778. Oil on canvas.
152.5 × 123.2 cm. (60⅛ × 48½ in.)

After several years in Italy, Romney settled in London in 1775 where
he became one of the most prolific and fashionable portraitists. His
paintings of children such as this double portrait are among his most
notable achievements. The brother and sister, ages four and five, are
posed before a richly painted but simply depicted landscape. They en-
gage the viewer's attention by diverse means, the boy by his appeal-
ing, direct gaze, and the girl by her lilting posture and the rhythmic
sweep of her outflung sash.

Collections: Cornewall family; Kimbell Bequest. ACF 49.3

GEORGE ROMNEY, English, 1734–1802

Lady Mary Sullivan George B. Greaves

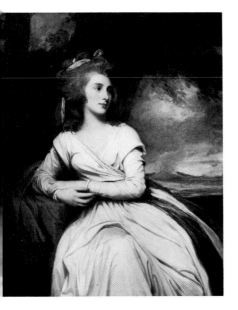

Painted in 1779 and 1784.
Oil on canvas.
127.7 × 102.6 cm. (50¼ × 40⅜ in.)

Painted in 1786. Oil on canvas.
127.7 × 101.6 cm. (50¼ × 40 in.)

Rich, loosely brushed landscape backgrounds complement the strongly modeled figures in these handsome commissioned portraits. That of Lady Sullivan, which required an unusual sixteen sittings, is one of Romney's better works. It is especially notable for its composition: the broad curves formed by the crossed arms, the lapped bodice and blue sash create a complex but cohesive mass. The simpler design of the portrait of Greaves—a seated three-quarter figure illuminated strongly from the side—was a favorite of the artist.

Sullivan—*Catalogue*, p. 146. Collections: Sullivan family; Ross; Chapin; Hutton; Kimbell Bequest. ACF 58.5
Greaves—*Catalogue*, p. 143. Collections: Greaves family; Harris; Kimbell Bequest. ACF 59.9

GEORGE ROMNEY, English, 1734–1802

Miss Jemima Yorke *A Lady Reading*

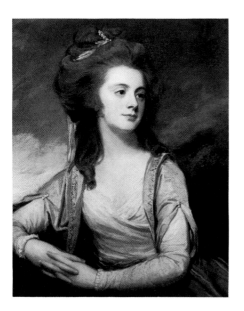 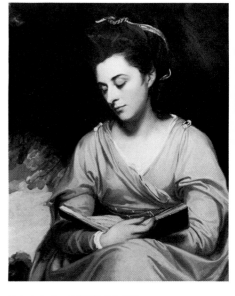

Painted in 1783–84. Oil on canvas. Painted about 1777–80. Oil on canvas.
76.2 × 63.5 cm. (30 × 25 in.) 75.8 × 63.8 cm. (29⅞ × 25⅛ in.)

These polite and tranquil images typify Romney's talent as a painter of flattering portraits. Miss Yorke, a member of a noble family, was painted in ten sittings in 1783–84, just before her marriage at the age of twenty-one. The sitter for the other portrait, in an unusual pose looking away from the viewer, is unknown. In each painting, emphasis rests on the strongly modeled face, set off against the fresh, clear colors of the costume and the loosely brushed and extremely varied tonalities of the background. The sweeping ovals formed by body, arms and costume formally complement the detached serenity of the faces in both portraits.

Yorke—*Catalogue*, p. 147. Collections: Yorke; Carew; Topping; Kimbell Bequest.
ACF 63.3

Lady—*Catalogue*, p. 144. Collections: Bentley; Ruston; Kimbell Bequest.
ACF 59.3

GEORGE ROMNEY, English, 1734–1802

Edward and Randle Bootle

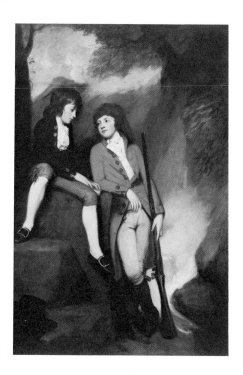

Painted in 1786. Oil on canvas.
220.7 × 152.7 cm. (86⅞ × 60⅛ in.)

This double portrait of the Bootle brothers, about fifteen and thirteen
years of age, is one of several Romney executed for this aristocratic
Lancashire family. The elder son Edward, dressed in the red-coated
uniform of Eton College, dominates the center of the canvas in a re-
laxed, self-assured pose. Randle appears more casual and introspec-
tive, yet both possess the dignity and elegance associated with their
privileged class. As an attractive foil for his sitters, Romney infused
the setting with a romantic, loosely painted and possibly unfinished
scenery of mountains, foliage and waterfall.

Catalogue, p. 149. Collections: Bootle family; Earl of Latham; Leigh;
Kimbell Bequest. ACF 61.1

HENRY RAEBURN, Scottish, 1756–1823

Mrs. John Parish *Mrs. John Anderson of Inchyra*

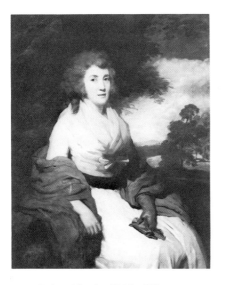
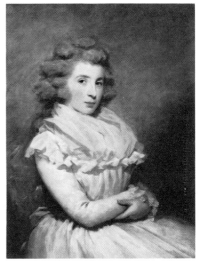

Painted in the 1780s. Oil on canvas. Painted in the late 1780s. Oil on canvas.
127.3 × 101.9 cm. (50⅛ × 40⅛ in.) 90.2 × 69.8 cm. (35½ × 27¾ in.)

Documentary likenesses and extremely restrained palettes dominate both these paintings by Raeburn, the first major Scottish portraitist. The artist's directness is visible in the unaffected pose and candid gaze of Mrs. Parish and in the strong self-possession and individualized features of Mrs. Anderson. The artistic means are equally direct: broad areas of light and shadow mark the portrait of Mrs. Parish, and blunt strokes of paint, produced by a square-tipped brush, lend emphasis to the portrayal of Mrs. Anderson. Little is known about Mrs. Anderson, but Mrs. Parish and her husband, both from illustrious Scottish families, lived in Hamburg, Germany, where he was a powerful banker.

Mrs. Parish—*Catalogue*, p. 151. Collections: Parish family; Kimbell Bequest.

ACK 51.2

Mrs. Anderson—*Catalogue*, p. 150. Collections: Wood; Wilson-Wood; Donaldson; Kimbell Bequest.

ACF 54.6

English, 18th Century

Miss Susanna Randolph

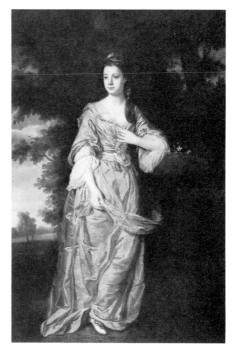

Painted about 1771–79. Oil on canvas.
198.2 × 134.0 (78 × 52¾ in.)

Susanna Randolph, though born in Virginia, lived most of her life in England. This portrait shows her as a young woman before her marriage in 1783 to Charles Douglas. Painted by an unidentified artist, it is an unpretentious adaptation of the "grand manner" style, evident here in the classical pose based on an antique statue. The dark-toned background, her demure expression, and the straightforward detailing of her blue silk dress and filmy, white scarf evoke a tranquil mood, less grand than the worldly air of more imposing portraits.

Catalogue, p. 141. Collections: Randolph family; Wigsell; Sprague; Brandagee; Kimbell Bequest. ACF 48.1

THOMAS ROWLANDSON, English, 1756–1827

George III and Queen Charlotte Driving through Deptford

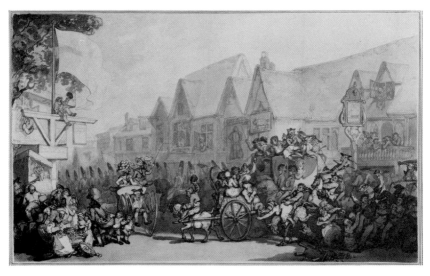

Drawn about 1785. Watercolor and ink on paper.
42.4 × 70.2 cm. (16⅝ × 27⅝ in.)

Rowlandson raised caricature to a fine art in his breezy, spirited drawings, which reveal an unerring eye for comic incident. Here in one of his largest works, he grandly mocks the pretenses of English society, high and low. At the extreme right, the royal coach enters the teeming Broadway—complete with theatrical advertisements—of London's river port, Deptford. Standing below it is the famed boxer John Jackson, and at the rear of the stagecoach is James Hanway, who introduced the umbrella into England. The open carriage at left holds two well-known Mayfair beauties, the Watson sisters. Rowlandson integrated these vignettes into a lively composition, through animated line, atmospheric space and deft passages of translucent color.

See: Hayes, *Rowlandson Watercolors and Drawings*, 1972, p. 88.
Collections: Wilson; Blake-Tyler. AP 79.12

JAMES WARD, English, 1769–1859

Disobedience in Danger *Disobedience Detected*

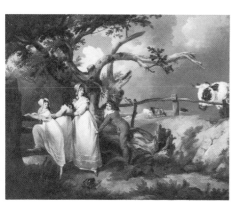
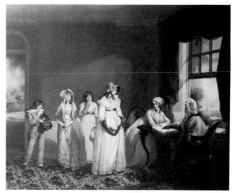

Dated 1797. Signed. Oil on canvas. Painted in 1797. Oil on canvas.
71.8 × 91.7 cm. (28¼ × 36⅛ in.) 71.8 × 91.7 cm. (28¼ × 36⅛ in.)

These colorful, anecdotal scenes were done early in Ward's career and
are probably based on an unidentified literary source. The children's
feelings of fright and, later, remorse are displayed by their studied
attitudes and gestures. Combined with the artist's use of light and
shadow, bright colors and atmospheric details, the domestic narrative
is heightened almost to melodrama. Ward was recognized as an out-
standing mezzotint engraver before he turned to painting in the early
1790s, and he achieved success at the turn of the century as a painter
of prized livestock.

Catalogue, p. 156. Collections: Kimbell Bequest. ACF 62.1, 62.2

JOHN HOPPNER, English, 1758–1810

Romantic Landscape *Mrs. Sophia Fielding*

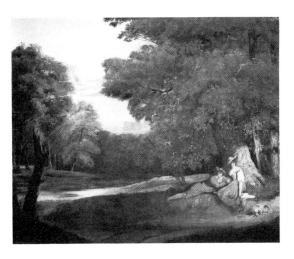
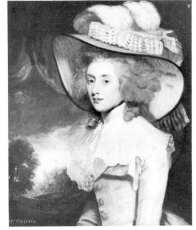

Painted about 1787. Oil on canvas. Painted in 1787. Oil on canvas.
103.2 × 127.0 cm. (40⅝ × 50 in.) 80.0 × 64.8 cm. (31½ × 25½ in.)

Hoppner was principally a portraitist, but his talent for landscape is revealed in the distant parkland behind Mrs. Fielding and in the woodland scene painted about the same time. The landscape, one of no more than seven the artist produced, is rendered in the deep red and gold shades of autumn. It is enlivened by a man stretched on the grass and a seated woman with a dog at her feet. Mrs. Fielding was a widow in her mid-thirties when Hoppner recorded her slender prettiness, fashionable costume and extravagant hat. She was governess to the children of King George III and woman of the bedchamber to his consort, Queen Charlotte. Hoppner moved in the same lofty circles, becoming portrait painter to the Prince of Wales in 1793.

Landscape—*Catalogue*, p. 154. Collections: Kimbell Bequest. ACK 40.1
Mrs. Fielding—*Catalogue*, p. 153. Collections: Fielding; Pegge;
Kimbell Bequest. ACF 52.1

MARTIN ARCHER SHEE,
Irish, 1769–1850

THOMAS LAWRENCE,
English, 1769–1830

A Standing Lady

Lady Maria Oglander

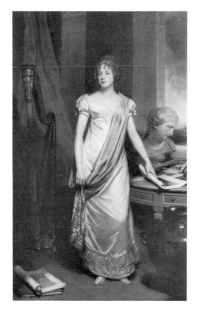

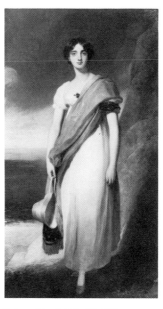

Painted about 1815. Oil on canvas.
237.5 × 146.1 cm. (93½ × 57½ in.)

Painted in 1816–17. Oil on canvas.
208.6 × 116.8 cm. (82⅛ × 46 in.)

Lawrence followed in the tradition of the great school of British portraiture as developed by Reynolds and Gainsborough. He succeeded Reynolds as portrait painter to the king in 1792 and later became president of the Royal Academy where this portrait of Lady Oglander was exhibited in 1817. The work is characterized by delicate modeling, golden lights and rich, harmonious colors. In the portrait by Shee, who succeeded Lawrence as Royal Academy president, the aristocratic lady is unidentified. The prevailing interest in classical culture is revealed not only in the sitter's hairstyle and dress but by the objects about her—a Greek vase, harp and marble bust.

Shee—Collections: Blakeslee; Bacon; Jacobs; Kimbell Bequest. ACF 41.1
Lawrence—Collections: Fitzroy; Hude; Yerkes; Mulliken;
Kimbell Bequest. ACK 35.6

THOMAS LAWRENCE, English, 1769–1830

Frederick H. Hemming *Mrs. Frederick Hemming*

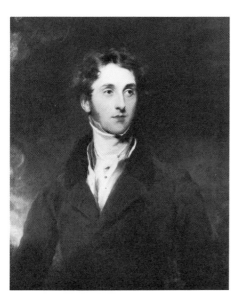 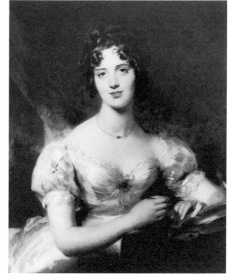

Painted about 1824–25. Oil on canvas. Painted about 1824–25. Oil on panel.
76.2 × 64.5 cm. (30 × 25⅜ in.) 76.2 × 62.2 cm. (30 × 24½ in.)

These attractive companion portraits date from late in Lawrence's career when he was regarded as the outstanding portraitist of his day. The high-keyed animation of the paintings is appropriate to the Romantic era in which they were done. The portrait of Mr. Hemming is an arresting image of a confident, well-appointed gentleman, and that of his wife emphasizes her feminine curves and innocent, dreamy countenance. She delicately holds a brush, a reference to her abilities as a porcelain painter. Lawrence painted both portraits in exchange for old master drawings owned in the Hemming family.

Catalogue, p. 165. Collections: Hemming; Hirsch; Gould; Manville; Dresselhuys; Kimbell Bequest. ACF 63.1, 63.2

THOMAS CRESWICK, English, 1811–1869

Luggellaw, County Wicklow

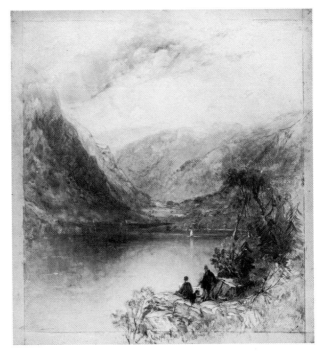

Painted by 1837. Oil on panel. 18.7 × 17.9 cm. (7⅜ × 7⅛ in.)

This idyllic view of the landscape surrounding the quiet waters of an Irish lake epitomizes the response to nature of the Romantic era. This tiny oil painting has the spontaneity and translucency of watercolor, with thin glazes subtly evoking the delicate greys and warmer yellows of the atmosphere. The small figures in the rocky foreground provide scale for the monumental mountains around them. Like many early 19th-century English artists who traveled abroad, Creswick made sketches like this which are notable for their intimate charm and freshness.

Catalogue, p. 177 (as by R. P. Bonington); see also: Ritchie, *Ireland, Picturesque and Romantic*, London, 1837, vol. I, p. 60. Collections: Neilson; Evans. AP 70.20

JOSEPH MALLORD WILLIAM TURNER, English, 1775–1851

Glaucus and Scylla

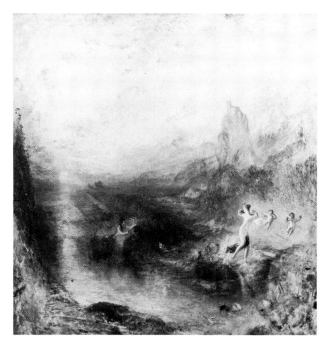

Painted in 1841. Oil on panel. 78.3 × 77.5 cm. (30⅞ × 30½ in.)

Dissolving forms in light and color, Turner astonished his contemporaries with works of art far ahead of their time. In his hands, landscape painting gained new abstraction and expressive power, visible here in the sun's dazzling radiance which charges the hazy circle of mountains and sea with mythic distance. Bathed in its golden atmosphere, the nymph Scylla rejects forever the sea god's plea for love, a subject taken from Ovid's *Metamorphoses*. The molten forms are sustained in a harmony of warm hues and interlocking circular planes. This landscape was one of six paintings Turner exhibited at the Royal Academy in 1841.

Catalogue, p. 168; see also: Butlin and Joll, *Turner*, vol. 2, 1977, cat. no. 395.
Collections: Windus; Huth; de Murietta; Davies; Jaffe; Leitz;
Chamberlain. AP 66.11

FREDERIC LEIGHTON, English, 1830–1896

Miss May Sartoris

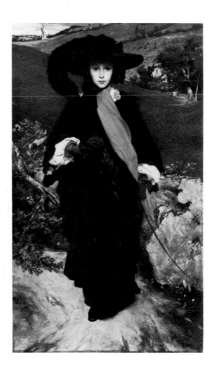

Painted about 1860. Oil on canvas.
152.1 × 90.2 cm. (59⅞ × 35½ in.)

This magnificent portrait depicts a sober-faced girl of about fifteen
dressed in riding habit and holding a crop, in the setting of her rural
home in Hampshire, England. Bold details, such as the brilliant red
scarf and elaborate plumed hat, focus attention on her lovely face.
Leighton was an intimate friend of Edward and Adelaide Sartoris,
who were noted for their literary and theatrical interests, and painted
several portraits of their daughter. This painting is an early work by
Leighton whose superb draftsmanship and carefully calculated de-
signs brought enormous success. He was elected president of the
Royal Academy in 1878 and elevated to the peerage in 1896.

Catalogue, p. 188; see also: Ormond, *Leighton*, 1975, cat. no. 62.
Collections: Sartoris family; Turner; Kimbell Bequest. ACF 64.3

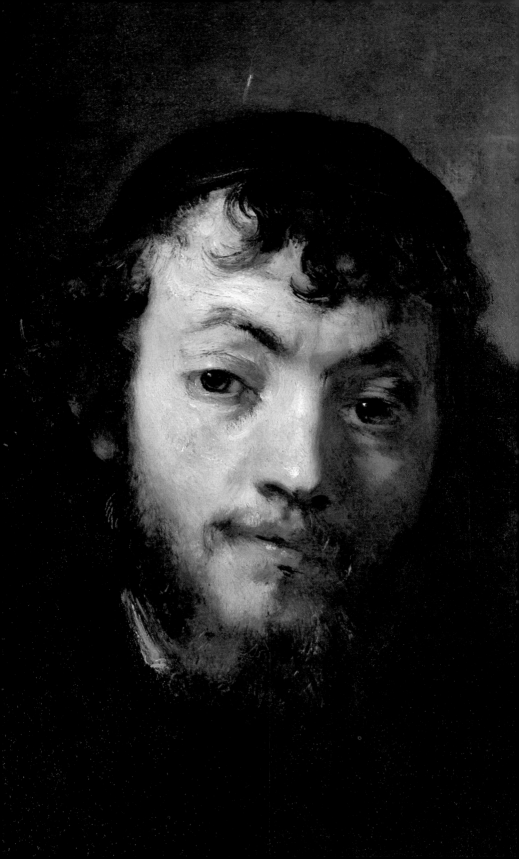

Dutch

Rembrandt, *Portrait of a Young Jew* (detail), page 67

FRANS HALS, 1581/85–1666

Portrait of a Man

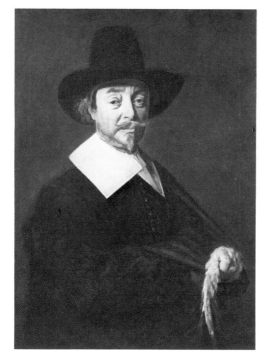

Painted about 1643–45. Oil on canvas.
87.9 × 65.1 cm. (34⅝ × 25⅝ in.)

This dignified portrait of a mature Dutch burgher is powerfully ren-
dered through a careful orchestration of rich tones, deft highlights
and forceful brushwork. A leading master of the 17th century, Hals
was famed for his portraits which combined a directness of style with
penetrating characterization. The spontaneous vitality of his brush-
work, especially evident in the face and collar of this portrait, was to
have profound influence on 19th-century artists, including Courbet
and the Impressionists.

Catalogue, p. 55; see also: Slive, *Frans Hals*, 1974, cat. no. 158.
Collections: Hofman; van Mourik; van Beukering; Hotinov; Kemperdick.

<div align="right">AP 65.2</div>

After FRANS HALS, 1581/85–1666

The Rommel Pot Player

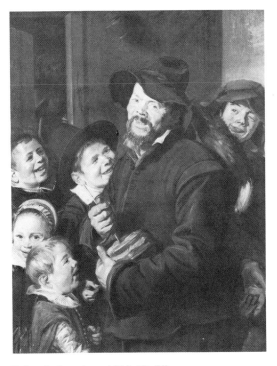

Painted after about 1615–18. Oil on canvas.
106.0 × 80.3 cm. (41¾ × 31⅝ in.)

In this spirited painting, a smiling beggar captivates his young audience with a rommel pot, a vibrating instrument, partially filled with water, which produces a resonant, gurgling whine. The best and largest of several surviving copies of a lost work by Hals, the picture engages the viewer's interest through devices typical of that artist: bold brushwork, large-scale figures and dense composition, within which the children tease the main figure. The joy of the five laughing children and the unrestrained carnival mood may reflect the pre-Lenten celebration of Shrovetide.

Catalogue, p. 52; see also: Slive, *Frans Hals*, 1974, cat. no. L3-1.
Collections: Cook family; Kimbell Bequest. ACF 51.1

Jan van Goyen, 1596–1656

View of Arnhem

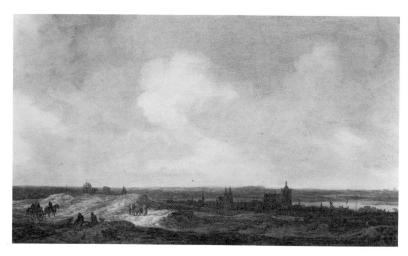

Painted about 1645–48. Oil on panel. 35.9 × 61.9 cm. (14⅛ × 24⅜ in.)

The rise of realism in 17th-century Dutch landscape painting was fueled by views like this which became quite popular with bourgeois patrons. Looking toward the Rhine River, this distant view of Arnhem shows its large churches, Groote Kerk and the twin-towered St. Walbergkerk. Under a majestic sweep of luminous sky, the low horizon is also punctuated by small towns and picturesque figures that establish scale. The spare composition, fluid brushwork, subdued tonality and suggestion of atmosphere are hallmarks of Van Goyen's innovative and influential style.

Catalogue, p. 62; see also: Beck, *Jan van Goyen*, vol. II, 1972, cat. no. 276.
Collections: Gluck; Lowenstein; Gratama. AP 66.4

JAN VAN GOYEN,
1596–1656

Attributed to AELBERT CUYP,
1620–1691

*Buildings on the Bank
of a Canal*

Landscape with Windmill

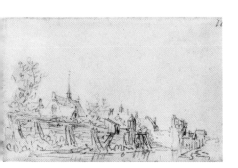

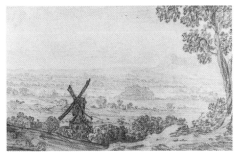

Drawn about 1650–51. Chalk and
wash on paper. 9.6 × 15.9 cm.
(3¾ × 6¼ in.)

Drawn about 1650–60. Red
chalk on paper. 18.0 × 29.1 cm.
(7⅛ × 11½ in.)

The development of landscape drawings, a distinctive Dutch genre, is well illustrated by these works. *Buildings on the Bank of a Canal* is one of four Kimbell drawings from a Van Goyen sketchbook. With the greatest economy, architectural details are rendered in chalk as spontaneous yet precise notations. The red chalk (sanguine) drawing is not firmly attributed, although it is an excellent example of this Dutch specialty. From the heavily outlined tree and windmill in the foreground, space appears to recede in this serene, panoramic view as the tones become progressively lighter in the background.

Van Goyen—See: Beck, *Jan van Goyen*, vol. 1, 1972, cat. no. 847/5, 11, 57, 84.
Collections: Neale; Hovell; Suhr; Granville.
Gifts of Miss Henriette Granville, AG 72.2, 72.3, 72.4
Gift of Mr. and Mrs. William Suhr in memory of Richard F. Brown, AG 80.7
Cuyp—*Catalogue*, p. 86. AP 70.16

Salomon van Ruysdael, 1600/02–1670

Landscape with Ruins of Egmond Abbey

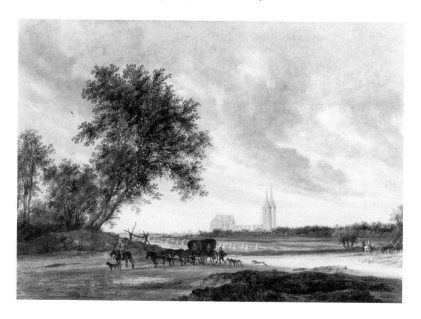

Painted in 1644. Oil on panel. 68.0 × 98.2 cm. (26¾ × 38⅝ in.)

Like his contemporaries, the Haarlem painter Salomon van Ruysdael used a low horizon to emphasize the sky, but he also introduced the "heroic tree motif" seen here. The great trees silhouetted against the sky create an even stronger sense of space and direct the eye toward the 12th-century church, Egmond Abbey. The people, animals and horsedrawn wagon, recurrent motifs in Ruysdael's work, add color and scale. Although, like Van Goyen, he used subdued tonalities, Ruysdael added brighter color accents and painted more precisely defined forms.

Catalogue, p. 68. Collections: Flersheim; Kreuger. AP 66.5

REMBRANDT VAN RIJN, 1606–1669

Landscape with Cottage and Haybarn

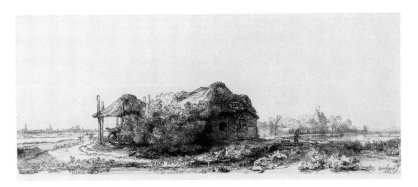

Dated 1641. Signed. Etching and drypoint on paper, only state,
12.7 × 32.1 cm. (5 × 12⅝ in.)

This atmospheric view of a tranquil, untroubled country scene on the
River Amstel outside Amsterdam marks a private moment in Rem-
brandt's creative life. In contrast to the drama of many of his land-
scape paintings, in this etching the artist sensitively observes unpre-
tentious aspects of nature. The pervasive horizontals of the lowlands
are emphasized in this view of an overgrown cottage with several
peasants busy at their simple tasks. Beyond the river to the right is a
castle, probably Kostverloren, which was painted by many Dutch
landscapists. One of a group of poetic landscapes etched in the 1640s
and 1650s, this fine print, with its velvety foreground, softer distant
views and vast, uninked sky, affirms Rembrandt's superb mastery of
this intaglio medium.

Collections: Oval collector's mark: SB (unidentified). AP 76.4

REMBRANDT VAN RIJN, Dutch, 1606–1669

Faust in His Study, Watching a Magic Disc

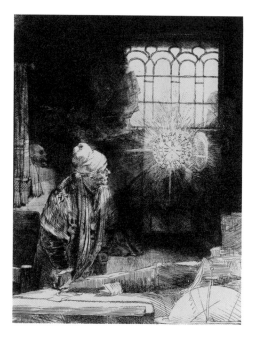

Printed about 1652. Etching, drypoint and
engraving on paper; first of three states.
20.9 × 15.9 cm. (8¼ × 6¼ in.)

This enigmatic print depicts a scholar who has risen at the astonishing
sight of a supernatural vision appearing at the leaded window. The
radiant disc is held in mid-air by ghostly hands, one pointing to an
attached mirror. Arcane inscriptions surround the monogram of
Christ, INRI, at the center. The subject of the work, described in a
17th-century inventory as a "practicing alchemist," acquired the
identification of Dr. Faust in the 18th century and was popularized as
such in a freely copied illustration to the first edition of Goethe's *Faust*,
published in 1790. Rembrandt's mastery of line and tone in the cre-
ation of brilliant lights and somber shadows is clearly evident in this
dramatic visualization of a strange spiritual event.

Collections: Karshan. AP 79.33

REMBRANDT VAN RIJN, 1606–1669

St. Jerome Reading in an Italian Landscape

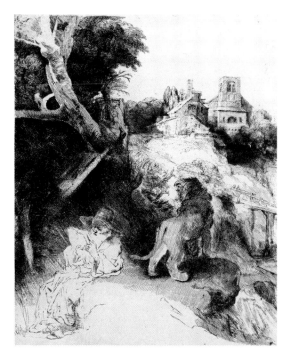

Printed about 1653–54. Etching and drypoint on paper;
second of two states. 26.6 × 21.2 cm. (10½ × 8¾ in.)

Rembrandt enriched the world with his highly personal and insightful interpretations of religious themes. The subject of St. Jerome he treated no less than seven times but nowhere with such compassion as in this etching, done in his later years. Strengthened by drypoint, it is a masterpiece of graphic technique. Its composition is a poetic fugue of lights and darks, with play and counterplay of solidity and dissolution, tangled wildness and tranquil civilization. St. Jerome is attended by the lion whose foot he had healed, in a rural landscape with farm buildings in the distance. The architecture may have been directly inspired by Rembrandt's reworking of a drawing by the 16th-century Venetian artist, Domenico Campagnola.

Catalogue, p. 72. Collections: Goldsmid; Peoli. AP 70.17

REMBRANDT VAN RIJN, Dutch, 1606–1669

The Three Crosses

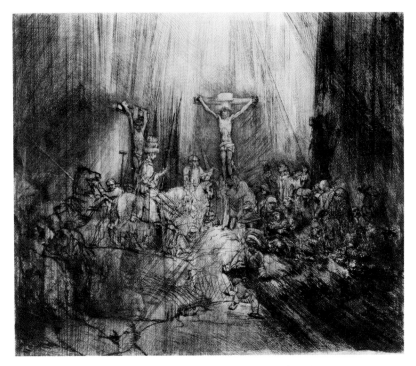

Printed about 1660. Drypoint and engraving on paper; fifth of five states.
38.5 × 45.4 cm. (15¼ × 17⅞ in.)

This print is considered one of the crowning achievements of Rembrandt's graphic work, for it attains an unprecedented monumentality of subject matter and human emotion through his use of the drypoint technique. A supernatural light illuminates the suffering Christ and central grouping, as John raises his arms in despair behind the sorrowing Mary. The powerful contrasts of light against curtains of darkness heighten the profound sense of pathos and agony. Begun in the early 1650s, the plate for this work was signed in the third state by Rembrandt in 1653. Returning to it a few years later, he radically transformed his original conception. The most important change was made in the figure of Christ, now shown suffering on the cross, rather than at the moment of death.

Collections: Maitland. AP 79.33

REMBRANDT VAN RIJN, 1606–1669

Portrait of a Young Jew

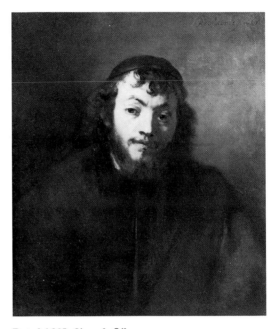

Dated 1663. Signed. Oil on canvas.
65.8 × 57.5 cm. (25⅞ × 22⅝ in.). *Also illustrated p. 56.*

This painting is an exceptionally sympathetic portrait from Rembrandt's mature years. Painted when the artist was 57 years old and at the very height of his creative powers, it clearly shows Rembrandt's compassionate sensitivity to human individuality. The exquisitely subtle modulations of subdued coloring, masterful modeling and selective detailing are characteristic of his paintings of the 1660s and are readily perceived here because of the painting's near-pristine condition. Combined with the dramatic lighting and intimate view, they form an arresting image of understated simplicity but great monumentality. The unidentified sitter is assumed to be Jewish because of his black skullcap, the yarmulke worn by orthodox Jewish men.

See: Bredius, *Rembrandt*, 1969, no. 300; Robb, "Rembrandt's *Portrait of a Young Jew*," vol. CVII, January, 1978. Collections: Despuig (?); Cotoner; R. Kann; Van Horne. AP 77.4

GÉRARD TER BORCH, 1617–1681

Portrait of a Gentleman *Portrait of a Lady*

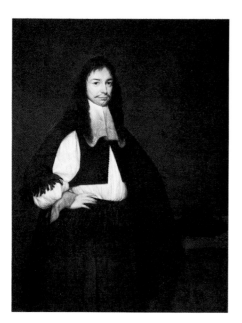
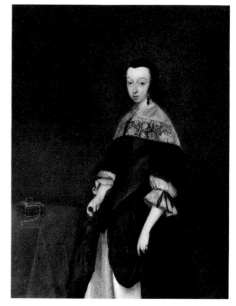

Painted about 1667–68.
Monogrammed. Oil on canvas.
47.0 × 36.8 cm. (18½ × 14½ in.)

Painted about 1667–68.
Monogrammed. Oil on canvas.
47.3 × 36.9 cm. (18⅝ × 14½ in.)

A distinguished painter of domestic life, Ter Borch specialized in small portraits which were quite popular in 17th-century Holland. Meticulous craftsmanship and a delicate psychological sensitivity characterize these likenesses of a comfortable, assured gentleman and his decorous wife. Both portraits are done in subdued tones of grey, black and violet, contrasting with areas of crisp white. Ter Borch observed details with a precision and economy recalling the lucid realism of 15th-century Flemish painting. A jewel box with a glistening string of pearls commands the monochromatic background of the lady's portrait. In both, the artist's superb rendering of textures is noteworthy, especially in his treatment of the ornamental fabrics.

Catalogue, p. 80. Collections: M. Kann; d'Erlanger; Pöhlmann. AP 70.24, 70.25

JAN VAN HUYSUM, 1682–1749

Flower Still Life

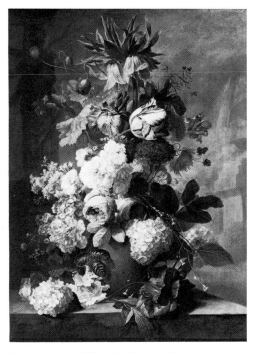

Painted about 1720–40. Signed. Oil on canvas.
74.7 × 54.6 cm. (29⅜ × 21½ in.)

This exquisitely colored, elegantly arranged still life is a superb example of Van Huysum's paintings of flowers which gained him an international reputation. The Dutch specialist had numerous close followers and inspired generations of decorators of porcelain and crockery. He created his enamel-smooth still lifes by combining sketches he had made of actual flowers which bloom in different seasons. The light background, overall light tonality and use of cool, clear colors—Van Huysum's unique contributions to this well-established genre—conform to 18th-century rococo taste.

Catalogue, p. 88. Collections: Count Von Shoenborn; Haro. AP 70.21

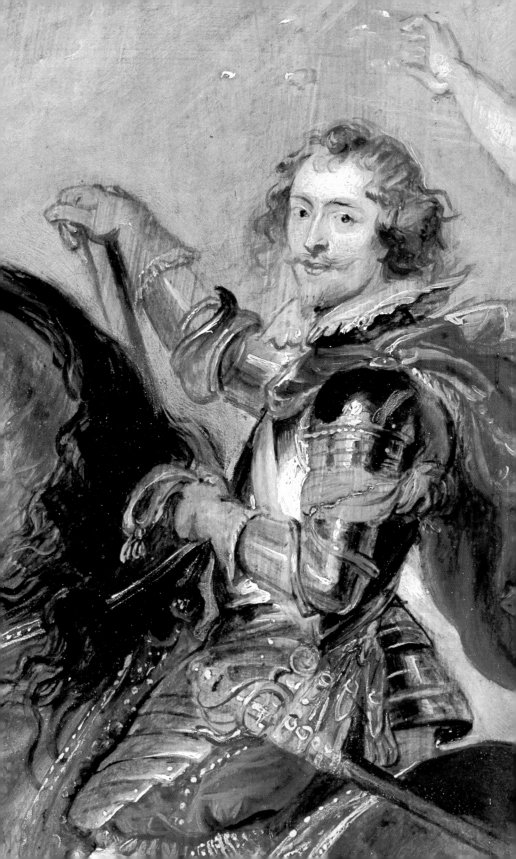

Flemish

Rubens, *The Duke of Buckingham* (detail), page 76

JAN GOSSAERT, called MABUSE, about 1478–1532

Henry III, Count of Nassau-Breda

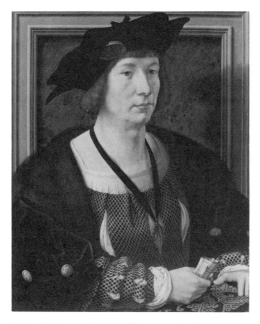

Painted about 1516–17. Oil on panel. 57.2 × 45.8 cm. (22⅝ × 18 in.)

This portrait by the prominent Netherlandish painter Mabuse fully conveys the character of an esteemed dignitary in Burgundian and Hapsburg court circles. Dressed in rich raiments, the count is seated at a carpeted table and posed against a luxuriant marble backplate. He wears the Order of the Golden Fleece, a lay confraternity dedicated to the defense of the Church and the upholding of chivalry, into which he was inducted in 1505. The count was a great military and political power in Northern Europe and a close friend and advisor to emperors Maximilian I and Charles V. During the Renaissance, portraits like this were ideal expressions of the humanist focus on man and his achievements. In this portrait Mabuse used vibrant color and awesome technical mastery to create one of his finest paintings.

See: Friedländer, *Early Netherlandish Painting*, vol. VIII, 1972, cat. no. 52.
Collections: A. de Rothschild; Carnarvon; Rosenfeld; Hickox. AP 79.30

After HANS MEMLING, about 1434–1494

St. John the Baptist; St. John the Evangelist

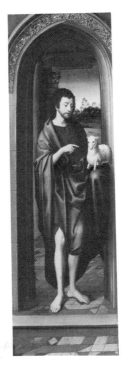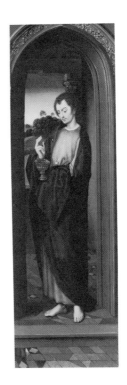

Painted about 1490–1530.
Oil on panel.
Each 63.0 × 20.0 cm.
(24¾ × 7⅞ in.)

Hans Memling of Bruges was regarded as one of the most accomplished Flemish artists of his generation; his paintings became widely admired models throughout northern Europe. These two panels are early copies of the inner wings of Memling's *Madonna Enthroned* altarpiece (Gemäldegalerie, Vienna), painted about 1485. Their Flemish copyist, adhering closely to the original paintings, sought to capture the serene religious vision which made Memling's works popular. The two saints John, shown here contemplating their symbolic attributes, the lamb and the chalice, are commonly associated in Christian iconography of this period.

Catalogue, p. 34. Collections: Emperor Charles V (?); King Louis Philippe; Kimbell Bequest. ACF 65.1, 65.2

JOOS DE MOMPER, 1564–1635

Travelers in a Mountainous Landscape

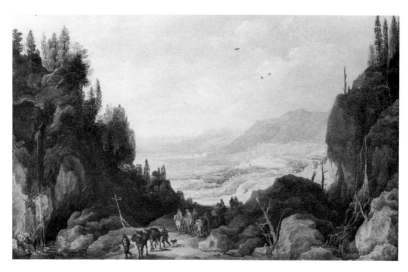

Painted about 1590–1620. Oil on panel. 45.7 × 74.9 cm. (18 × 29½ in.)

Landscape painting was a new category of subject matter in the late 16th-century, and de Momper achieved fame in this speciality in the commercially burgeoning city of Antwerp. Zones of brown, green and blue organize the foreground, middle and distant spaces of the landscape, which was probably inspired by the artist's recollection of Alpine scenery in Italy. The view is enlivened by veils of cascading water, soaring birds, the humble travelers and their animals. The figures may have been painted by Jan Brueghel I or another artist close to de Momper, for this was a common practice.

Catalogue, p. 46. Collections: Count de Limbourg-Stirum. AP 70.23

Flemish School, 17th Century

Saint Andrew

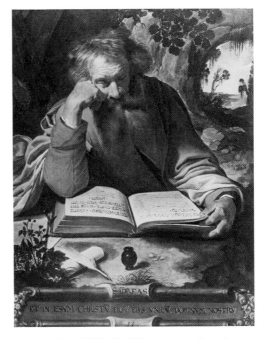

Painted about 1620–35. Oil on canvas. Inscribed.
116.2 × 91.4 cm. (45¾ × 36 in.)

Saint Andrew, a massive, weatherbeaten old man, reads an ancient
text in a rocky landscape. Partly visible at the upper left are transverse
timbers which 17th-century viewers would have recognized as the
X-shaped cross upon which he was crucified in A.D. 70. The crossed
quill and parchment roll in the foreground are also allusions to his
death. This painting was probably one of a series of works depicting
the twelve apostles, a popular theme of Flemish and Spanish baroque
artists. Many of its characteristics suggest that the unknown artist
was trained in Flanders and may have based the work on engravings
by the Dutch artist Hendrik Goltzius. These include the golden light
and rich colors, the meticulous detail of natural and symbolic ele-
ments, and the forceful characterization of the saint.

Catalogue, p. 48 (as by F. de Herrera). Collections: Kimbell Bequest. ACF 58.2

PETER PAUL RUBENS, 1577–1640

The Duke of Buckingham

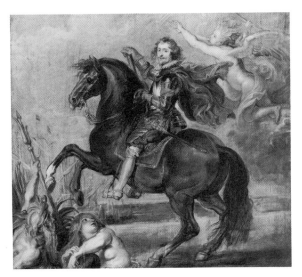

Painted in 1625. Oil on panel. 46.6 × 51.7 cm.
(18⅜ × 20⅜ in.). *Also illustrated p. 70.*

Handsome, charming and reckless, George Villiers, first Duke of Buckingham, was the ultimate 17th-century cavalier. His presumed romance with the queen of France, Anne of Austria, is immortalized in *The Three Musketeers* by Alexandre Dumas. The favorite of King Charles I, he traveled to Paris in 1625 for that ruler's proxy marriage to the sister of the French king. There he met Rubens, an enormously successful artist and diplomat, and commissioned several large paintings. Rubens painted the duke at the height of his career, as commander of all English army and navy forces. This lively oil sketch was the model for a life-size equestrian portrait which was destroyed by fire in 1949. The work is in unusually good condition, and its rich colors and delicate detail fully demonstrate Rubens' exceptional ability as a draftsman.

See: Held, "Rubens' Sketch of Buckingham Rediscovered,"
Burlington Magazine, vol. CXVIII, August, 1976. Collections: de la Salle; Stern; Langlade. AP 76.8

Attributed to PETER PAUL RUBENS, 1577–1640

The Triumph of David

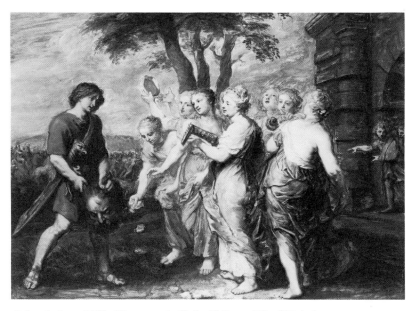

Painted about 1638. Oil on panel. 58.5 × 80.0 cm. (23 × 31½ in.)

In this hero's reception, the young David grasps Goliath's head with muscular arms. The welcoming music of the women is echoed in the harmony of the massed forms and the subtle colors of their drapery. The deliverance of the Chosen People is also the theme of a companion sketch, *Moses Rejoicing After the Crossing of the Red Sea* (Staatliche Kunsthalle, Karlsruhe). Rubens celebrates significant events and persons in many of his finest works; however, the unusual linkage of subjects here may specifically reflect the optimism of the Counter-Reformation. Such quick, expressive sketches were models for large compositions executed with the aid of assistants. While on a visit to London, Rubens made an ink drawing of the central figures of Orazio Gentileschi's painting of Apollo and the Muses; this was adapted for the Old Testament musicians of the David sketch.

Catalogue. p. 49. Collections: Coulouma. AP 66.3

ANTHONY VAN DYCK, 1599–1641

Self-Portrait, about age 15

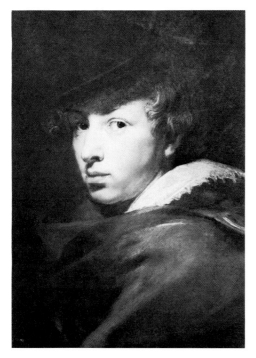

Painted about 1614. Oil on panel.
36.5 × 25.8 cm. (14¾ × 10⅛ in.)

This self-portrait, a rare, direct image of adolescence, attests to Van
Dyck's precocious artistic maturity. It was painted, like a slightly
earlier self-portrait now in Vienna, while Van Dyck was fostering his
prodigious talent in Rubens' studio, and predates his admission as
master to the painters' guild of Antwerp at eighteen years of age.
Watchful, aware but guarded, the facial expression in this second
self-portrait shows a greater complexity of emotion than the gay inno-
cence of his first. Remarkable assurance is evident in the smooth mod-
eling and delicate glazes of the face, contrasted with bolder brushwork
and sweeping lines of cloak and collar. The hat is restored.

Catalogue, p. 64. Collections: Mont; Kimbell Bequest. ACF 55.1

Anthony van Dyck, 1599–1641

Portrait of a Cavalier, age 57

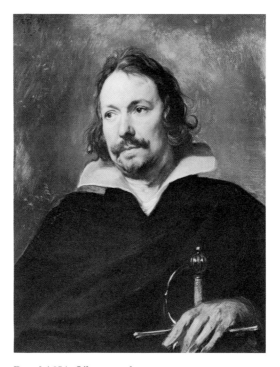

Dated 1634. Oil on panel.
73.1 × 55.6 cm. (28¾ × 21⅞ in.)

Van Dyck's ability to understand the character of his aristocratic patrons and endow them with noble poise was significant in his enormous success as a portrait painter. In this work, the typical elegance of the artist's style is subdued within a simple format which focuses attention on the fluently painted face and hand. The cavalier's averted gaze, sensitive expression and relaxed pose, with his hand casually placed across the gleaming hilt of his sword, create an impression of worldly ease. The inscription, upper left, provides the age of the unidentified sitter.

Catalogue, p. 66. Collections: de Rothschild family; Kimbell Bequest. ACF 59.6

French

Boucher, *Boreas Abducting Oreithyia* (detail), page 95

CORNEILLE DE LYON, about 1510–1574/75

James V of Scotland

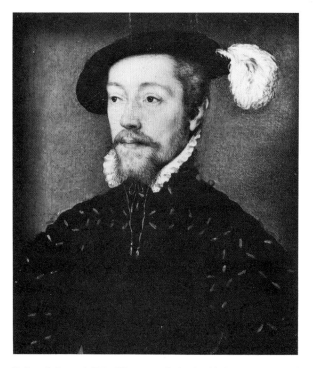

Painted about 1537. Oil on panel. 17.1 × 14.6 cm. (6¾ × 5¾ in.)

This exquisite gemlike portrait was probably painted at the time of King James' marriage to his first wife Madeleine, daughter of King Francis I of France. The intimacy and individuality of this image, doubtless painted from life, are in keeping with the fresh, humanistic spirit of the Renaissance. Its bright colors and intricate detailing continue the conventions of two small-scale traditions—illuminated manuscripts and antique portrait cameos and medals. Corneille, a successful artist of Dutch birth, was official painter to the Dauphin (later King Henry II) and counted many members of the French court among his sitters.

Catalogue, p. 39. AP 66.1

CLAUDE LORRAIN, 1600–1682

A River Landscape

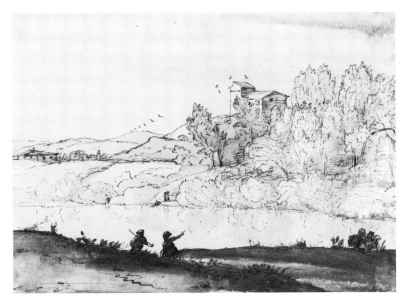

Drawn about 1635–40. Pen and brown ink, brown wash, on paper.
21.0 × 30.2 cm. (8¼ × 11⅞ in.)

This luminous pen and wash drawing comes from the finest collection
of Claude Lorrain drawings ever formed, that of Prince Livio Odes-
calchi who was a distinguished art collector in Rome. Claude is famed
as a landscape artist, and his gifts are fully revealed in this wondrous
view of the Italian countryside. The warm sunlight and deep shadows
of a summer afternoon are captured through the subtle tones of brown
ink and wash and the skillful use of the untouched white paper to
create areas of intense light. The illusion of infinite space is heightened
by the flight of birds above the rolling hills.

Collections: Queen Christina of Sweden(?); Azzolini(?); Odescalchi family.

AP 78.2

CLAUDE LORRAIN, 1600–1682

A Pastoral Landscape

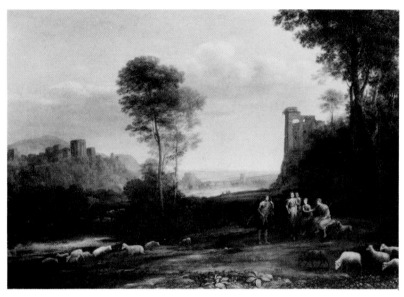

Dated 1677. Signed. Oil on canvas. 57.2 × 82.2 cm. (22½ × 32⅜ in.)

A serene and timeless mood pervades this pastoral scene of shepherds in a poetic landscape suffused with light. Repeating colors and carefully balanced diagonals, in the weaving paths of river, mountains and sheep, form patterns which recede infinitely into the background. Claude, a Frenchman deeply influenced by the Italian countryside, became a master of idyllic landscape in which antique ruins, mythological themes, and natural forms evoke memories of a golden age.

Catalogue, p. 70. Collections: Colonna family; Corbet family. APX 67.4

PHILIPPE MERCIER, 1689–1760

The Concert

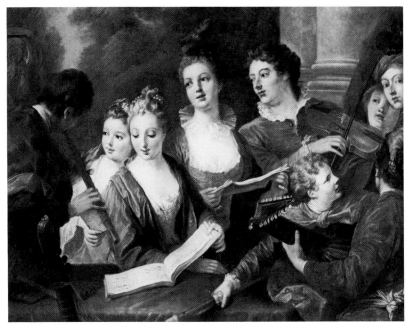

Painted about 1740. Oil on canvas. 123.2 × 153.3 cm. (48½ × 60⅜ in.)

Harmony of color, composition and mood prevails in this charming depiction of attractive youths enjoying a musical diversion. The musical theme suggests that it was created as part of a set of paintings, each symbolizing one of the five senses. Such series were common in the early 18th century, and at least one by Mercier survives intact. A French Huguenot born in Berlin, the artist emigrated in 1725 to England where he gained a prestigious appointment as Principal Painter to Frederick, the Duke of Wales.

Catalogue, p. 91. Collections: Hodgkins; Kimbell Bequest. ACF 41.6

HUBERT ROBERT, 1733–1808

The Fountain

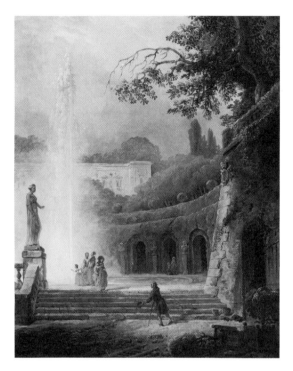

Painted about 1760–65. Oil on canvas. 113.0 × 90.2 cm.
(44½ × 35½ in.)

In the 18th century, artists flocked to Rome to study art, Robert
among them. Influenced by Panini and Piranesi, he was attracted to
the pleasurable melancholy and drama of picturesque ruins, which
he painted the rest of his life. In this view of an overgrown grotto and
garden, moldering neglect is transformed into charm and enlivened
by a towering jet of water. Composed like a theatrical backdrop, the
garden provides a setting for the display, not of grand passion, but of
fine sensibility and sentimental gesture.

Catalogue, p. 111. Collections: Duchess of Marlborough; Spencer-Churchill
family. AP 70.15

HUBERT ROBERT, 1733–1808

Figures at a Pool near Antique Ruins

Painted about 1776–80. Signed.
Oil on canvas.
162.5 × 98.1 cm. (64 × 38⅝ in.)

To have one's salon painted by Robert was considered very fashionable indeed by Parisian society of the late 18th century. In 1776 Madame Rouillé de L'Etang commissioned Robert to decorate her illustrious salon on Place Louis XV (now Place de la Concorde) with thirteen scenes of aqueducts, bridges, grottoes and fountains, among them this painting. It was probably hung rather high, where its broad expanses, thin brushwork and small figures suited its purpose as part of a background ensemble. In the painting, the robust washerwomen and playful dog form a pleasing foil to the magnificent setting of parasol pines and ancient ruins.

Collections: de L'Etang; Piscatory; Marquise de Pastoret; Marquise du Plessis-Bellière; Harrison; McBride; Humphrys; Battson.

Gift of Mr. and Mrs. Leigh M. Battson, AG 75.2

JEAN-HONORÉ FRAGONARD, 1732–1806

The Pond

Painted about 1761–65. Oil on canvas. 65.2 × 73.1 cm. (25¾ × 28¾ in.)

A sparkle in the foliage, a gay fluidity in the brushwork of a branch, a brilliance in the blue of the sky—all reveal Fragonard's roots in the French Rococo. This wit and charm, which pervade his famous rose-laden scenes of lovers, here enrich a landscape done in the spirit of Jacob van Ruysdael, following a current vogue for intimate views of Dutch landscape. Fragonard's abilities as a pure landscape painter were long overlooked, but in his lyrical appreciation of nature he is now considered an important precursor of Corot and the Barbizon painters.

Catalogue, p. 109. Collections: de Senneville; Quenet; Walferdin; Febvre; Courtin. AP 68.3

JEAN-HONORÉ FRAGONARD, 1732–1806

Danaë Visited by Jupiter

Drawn about 1770. Pencil or black chalk and brown washes on paper.
33.5 × 45.4 cm. (13¼ × 17⅞ in.)

Light is the dramatic vehicle for the illustration of one of Jupiter's renowned scenes of passion in this intriguing wash drawing. The mythological beauty Danaë is ravished by Jupiter who appears in the guise of a fallen shower of gold coins and an enthralling cloud, surmounted by his symbolic eagle. A group of beauteous maids, modeled in varying brown washes, surrounds the central event where the rapturous scene is brilliantly suggested in the highest value of the untouched paper. This unusual technique imparts a delicate reticence to the sensuous subject.

See: Ananoff, *L'Oeuvre Dessiné de Jean-Honoré Fragonard*, 1961, vol. 1, no. 396.
Collections: Renaud(?); Lafontaine(?); Foulon de Vaux; Meyer; Seligman.

AP 79.5

FRANÇOIS BOUCHER, French, 1703–1770

Young Girl Reclining

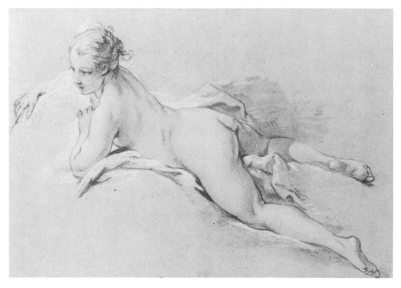

Drawn about 1751. Red, black and white chalks on paper.
31.6 × 46.2 cm. (12½ × 18¼ in.)

Boucher delighted in rendering the sensuous, ripe beauty of the fe-
male nude, in large painted allegories and in such intimate studies as
Young Girl Reclining. This drawing, done in the celebrated three-
chalks technique, richly conveys the shimmering effects of light on
eloquent contours and lovely, palpable flesh. It may be a study of
Mlle. Louise O'Murphy, an Irish belle at the court of Louis XV and
a favorite model of the artist. In pose, the work is closely related to
several paintings, drawings and engravings made by Boucher in the
1740s and 50s.

See: Ananoff, *L'Oeuvre Dessiné de François Boucher*, vol. 1, 1966, no. 502.
Ananoff, *François Boucher*, vol. 1, 1976, cat. no. 264/2. Collections: Greville;
Earl of Warwick; Michel-Lévy; Mayer. AP 78.4

FRANÇOIS BOUCHER, 1703–1770

Bacchanale before a Statue of Pan

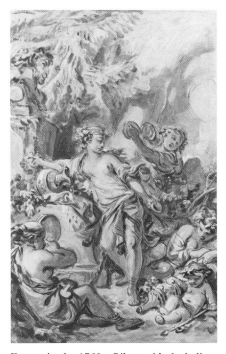

Drawn in the 1760s. Oil over black chalk,
on paper. 30.1 × 19.2 cm. (11⅞ × 7⅝ in.)

This drawing, rendered in rich tones of translucent oil glazes, epito-
mizes the robust, elegant style of Boucher. A group of beauteous
nymphs, their voluptuous forms partially draped, enjoys the music
of tambourine and cymbals before an antique bust of Pan near fallen
wine vessels and a sleeping cherub. Fluent, swirling curves high-
lighted with dapples of white create a rich, dense fabric of shapes and
light. The swift execution of this complex drawing suggests that it
may be a study for a larger composition.

See: Slatkin, *François Boucher in North American Collections: 100 Drawings,*
1974, cat. no. 52. Collections: Harrison. AP 76.7

FRANÇOIS BOUCHER, 1703–1770

Juno Inducing Aeolus to Loose the Storm on Aeneas

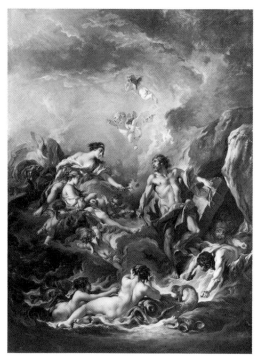

Dated 1769. Signed. Oil on canvas.
278.2 × 203.2 cm. (109½ × 80 in.)

The culminating masterworks of Boucher's illustrious career are the
four large paintings shown above and on the following pages. The
favored painter of Louis XV and Madame de Pompadour, Boucher
completed this opulent suite of paintings shortly before his death.
Their themes, centered on the power of love, are drawn from vari-
ous mythological sources; two scenes are from Virgil's *Aeneid*. In the
first, Juno, goddess of the domestic hearth, tempts the muscular wind
god Aeolus with an offering of her most beautiful attendant, the
golden-haired Deiopea. Juno wants Aeolus to release a storm to wreck
the ships (at left) belonging to Aeneas, son of her arch-rival, Venus.

Juno—*Catalogue*, p. 101; see also: Ananoff, *Boucher*, 1976, no. 674. AP 72.8

FRANÇOIS BOUCHER, 1703–1770

Venus Securing Arms from Vulcan for Aeneas

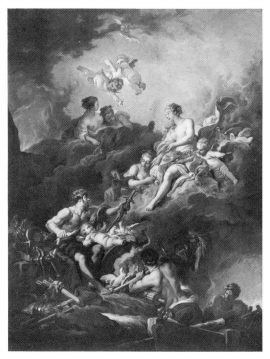

Dated 1769. Signed. Oil on canvas.
273.5 × 204.7 cm. (107¾ × 80⅝ in.)

Boucher's virtuoso orchestration of dazzling color, curving line and swirling brushwork pervades these four scenes of godly passions. In the second *Aeneid* scene Venus, goddess of carnal love, descends from heaven to receive the weapons she had entreated her husband Vulcan to craft for Aeneas. At first reluctant, Vulcan had eventually succumbed to Venus' amorous blandishments and now, seized by passion, offers her the arms forged in his fiery furnace below.

Venus—*Catalogue*, p. 104; see also: Ananoff, *Boucher*, 1976, no. 675. AP 72.9

FRANÇOIS BOUCHER, 1703–1770

The Birth of Bacchus

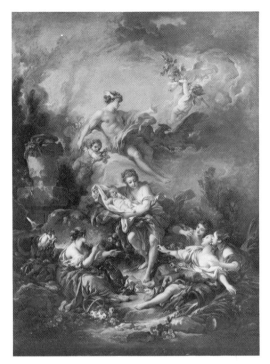

Dated 1769. Signed. Oil on canvas.
272.5 × 201.6 cm. (107¼ × 79⅜ in.)

The third narrative of Boucher's grand suite draws on a classical myth
on godly love from Ovid's *Metamorphoses*. Here is shown the new-
born Bacchus being delivered from Mercury into the outstretched
arms of his aunt Ino. Bacchus was conceived when Jupiter seduced
Ino's sister Semele. But the mortal nymph was later tricked by
Jupiter's jealous wife, Juno, into being divinely consumed by Jupi-
ter's fiery love, suggested here by the glowing thunderbolt grasped
by the eagle personifying Jupiter. Bacchus, rescued from Semele's
ashes and nurtured in Jupiter's thigh until birth, later became the
god of wine, symbolized here by the grapes borne by the flying cherub.

Bacchus—*Catalogue*, p. 105; see also: Ananoff, *Boucher*, 1976, no. 676. AP 72.7

FRANÇOIS BOUCHER, 1703–1770

Boreas Abducting Oreithyia

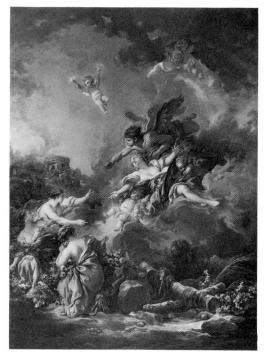

Dated 1769. Signed. Oil on canvas. 273.5 × 205.0 cm.
(107⅝ × 80⅝ in.). *Also illustrated p. 80.*

Here Boucher depicts a passage from the *Metamorphoses* in which
the angry wind god Boreas, rejected in his courtship of the lovely
Oreithyia, swoops down and rudely carries away the Athenian prin-
cess to his northern realm. Here again the theme is love, in this case
the violent passion of Boreas for Oreithyia. Love dominates the god
and animates his behavior, for he is swept away by the passionate
desires of his heart. These four paintings, perhaps conceived as tap-
estry designs but never woven, were subsequently installed in the
Hôtel de Marcilly in the Marais district of Paris.

Zephyrus—*Catalogue*, p. 106; see also: Ananoff, *Boucher*, 1976, no. 677. AP 72.10
Collections (all four paintings): Countess de Marcilly; Johnson; Rothschild family.

Marie Louise Elizabeth Vigée-Lebrun, 1755–1842

Self-Portrait

Painted about 1781. Signed. Oil on canvas.
64.8 × 54.0 cm. (25½ × 21¼ in.)

When Madame Vigée-Lebrun painted this beguiling self-portrait in her twenties, she was already celebrated for her sparkling likenesses of members of the French aristocracy. Of many surviving self-portraits done by the artist, this is surely one of the finest. No other presents the same freshness in the lovely, intelligent face or is painted with such an assured yet spontaneous touch. Light focuses on the artist's pearly complexion and elegant costume, set against a muted background. The complex intermingling of innocence and sophistication here revealed helps to explain the artist's astonishing early success. She went on to become the official portraitist to Queen Marie Antoinette and later enjoyed great success painting highborn figures in the major cities of Italy, Austria, Germany and Russia.

Catalogue, p. 112. Collections: Muhlbacher; Springer-Rothschild; Kunst-historisches Museum, Vienna; Springer-Rothschild; Kimbell Bequest. ACK 49.2

MARIE LOUISE ELIZABETH VIGÉE-LEBRUN, 1755–1842

Louise of Savoy,
Comtesse de Provence

Comtesse Potocka

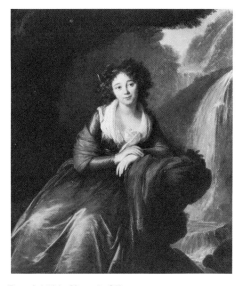

Painted about 1778–83. Oil on canvas.
73.0 × 60.0 cm. (28¾ × 23⅝ in.)

Dated 1791. Signed. Oil on canvas.
142.2 × 126.4 cm. (56 × 49¾ in.)

These two dissimilar paintings attest to Vigée-Lebrun's mastery of flattering aristocratic portraiture. The oval, half-length study, a type the artist developed while working in the French court, was done in Paris just before the French Revolution. The sitter was the daughter of the King of Sardinia and wife of the Comte de Provence, who became King Louis XVII in 1815, five years after her death. The full-length painting of a Polish beauty was done in Rome soon after the artist began a self-exile during the Revolution. The Comtesse, then a newlywed, is shown seated in a lush outdoor setting reminiscent of Tivoli near Rome. In both paintings, the artist's superb technical competence is revealed by the fluent harmonies of color and rhythm.

Louise of Savoy—Collections: Foinard; Kimbell Bequest. ACF 45.1
Potocka—*Catalogue,* p. 114. Collections: Count Lanckoronski; Kimbell Bequest.
 ACK 52.1

Marie Louise Elizabeth Vigée-Lebrun, 1755–1842

Angelica Catalani

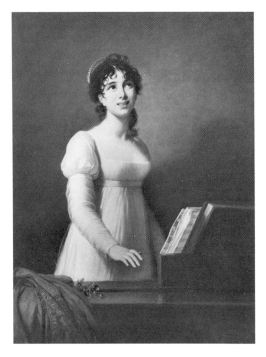

Dated 1806. Signed. Oil on canvas.
122.0 × 91.4 cm. (48 × 36 in.)

Upon returning to Paris after years of self-exile, Vigée-Lebrun met the vivacious prima donna Angelica Catalani who became the principal singer at the artist's evening soirées. The soprano, famed for her magnificent voice and dramatic presence, is shown performing a selection from the opera *Semiramis*. She was then at the height of her career and newly married to a captain named Valabreque. The artist, a great music-lover, considered this painting one of her finest efforts and kept it hanging in her home until her death.

Catalogue, p. 115. Collections: Vigée-Lebrun; Prince de Talleyrand; Muhlbacher; Comte de Normand; Kimbell Bequest. ACF 56.2

FRANCOIS-HENRI MULARD, 1769–1850

Portrait of a Lady

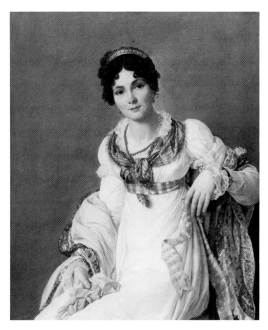

Painted about 1810. Signed. Oil on canvas.
99.0 × 80.7 cm. (39 × 31¾ in.)

Mulard was a student of David, leader of the French neoclassical movement, and followed his style primarily as a history painter. He gained recognition for examples which were exhibited in the Paris Salons of 1808–17. This engaging painting of an unidentified young lady is one of only two portraits known to have been done by the artist. Without any specific classical allusions, the painting reflects Mulard's neoclassical tastes in its strong colors, precise draftsmanship and attention to detail and pattern. The 1810 date is suggested by the sitter's fashionable high-waisted dress and its multicolored accessories —a striped sash, plaid scarf and floral-patterned shawl.

Catalogue, p. 164; see also: *French Painting 1774–1830. . .*, Detroit Institute of Arts and Metropolitan Museum of Art, 1975, cat. no. 136.
Collections: Normand family; Kimbell Bequest. ACF 58.6

THÉODORE GÉRICAULT, 1791–1824

Portrait Study of a Youth

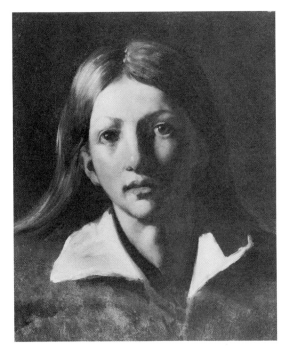

Painted about 1818–20. Oil on canvas.
47.0 × 38.1 cm. (18½ × 15 in.)

This small oil sketch shows Géricault's ability to probe his sitter's mood of youthful optimism. The deftly modeled planes of the face, assured brushstrokes of the collar and dramatic highlights communicate the intensity of the artist's rapid exploration of mood and feeling. Once Géricault had achieved his desired effect, he felt no need to continue, here leaving the shadowed side of the face partially unfinished. Géricault painted this unidentified young man soon after completing his most famous work, *The Raft of the Medusa*, which greatly influenced the burgeoning Romantic movement.

Catalogue, p. 171; see also: Clark, *The Romantic Rebellion: Romantic versus Classic Art*, London, 1973, p. 182. Collections: Leclerc; Dubaut. AP 69.7

Théodore Rousseau, 1812–1867

Landscape in Normandy

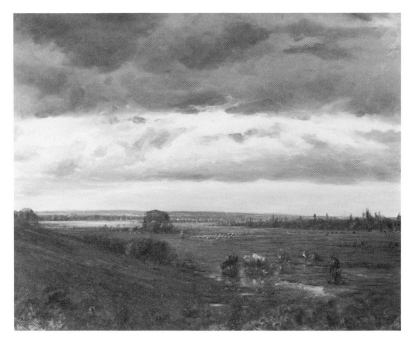

Painted in 1832–33. Signed. Oil on canvas. 72.7 × 92.3 cm. (28⅝ × 36⅜ in.)

Rousseau's fresh vision made him the guiding spirit of a group of French artists known as the Barbizon School, a name derived from a village at the edge of Fontainebleau Forest. Influenced by Dutch and British landscape painters and embracing a romantic back-to-nature attitude, they painted and sketched outdoors to produce their natural views of the French countryside. These pictures became a major stimulus to later Realist and Impressionist painters. In this early work, Rousseau captured the moody atmosphere and dramatic lights of Normandy's marshy plains, observed on a stormy day.

Catalogue, p. 179 AP 69.2

GUSTAVE COURBET, 1819–1877

Study for Man with a Pipe, Self-Portrait

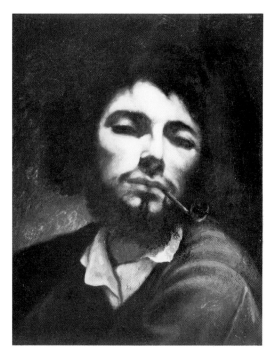

Painted in 1845. Initialed. Oil on canvas.
46.0 × 35.0 cm. (18¼ × 13¾ in.)

This painting is a preliminary study for one of Courbet's best-known
self-portraits. The artist considered the finished work a watershed in
his career because its successful combination of proletarian subject
matter and sensuous physicality was a crucial step in his solution to
the problems of Realism. Courbet presented himself with unblinking
honesty as the young bohemian artist, nonchalant and languorous.
The close-up, strongly lighted view has a powerful and immediate
dramatic appeal.

Catalogue, p. 183; see also: *French Nineteenth Century Oil Sketches*. . ., Ackland
Art Center, 1978, cat. no. 12. Collections: J. Courbet; Blondon; Léger;
Degoumois family. AP 68.5

GUSTAVE COURBET, 1819–1877

Roedeer at a Stream

Dated 1868. Signed. Oil on canvas. 97.5 × 129.8 cm. (38⅜ × 51⅛ in.)

Painted at the height of Courbet's career, this landscape and others like it were immediately successful. The artist's objective rendering of such prosaic subject matter, in both landscapes and figures, had originally provoked controversy. Later, however, this style which became known as Realism was highly influential. By the late 1860s Courbet's deer paintings were in great demand. A great hunter all his life, Courbet painted the landscapes outdoors and added the deer in his studio from sketches and his own keen memory. In this scene, done near his family home in Ornans, rich, dark tones are subtly juxtaposed with luminous colors. The dense solidity of the rocky bluff was sculpted with a palette knife and the soft fur of the deer painted with feathery brushstrokes.

Catalogue, p. 185. Collections: de Curel; Duensing; von Guggenberger. AP 68.2

JEAN-AUGUSTE-DOMINIQUE INGRES, 1780–1867

Alphonse-Pierre Hennet

Dated 1846. Signed.
Pencil on paper.
32.0 × 24.2 cm.
(12⅝ × 9½ in.)

In his mature years, Ingres became the leader of the neoclassical art movement in France. Throughout his career he knew official recognition, winning the Prix de Rome in 1801 and later the Cross of the Legion of Honor and a senatorial appointment. This exquisite portrait of a friend and student clearly reveals Ingres' enormous gift for penetrating observation and his superb mastery of pure line. Varying the pencil strokes, he flawlessly delineated the gentle and dignified character of the sitter. Though Ingres placed higher importance on history paintings, his portraits, both in oil and pencil, are now considered among his most extraordinary accomplishments.

See: Naef, *Die Bildniszeichnungen von J.-A.-D. Ingres*, vol. II, 1978, cat. no. 405.
Collections: Hennet de Goutel; Hennet; de la Panissais; Lesseigneur;
Shoenberg. AP 77.2

EUGÈNE BOUDIN, 1824–1898

View of Penmarch, Brittany

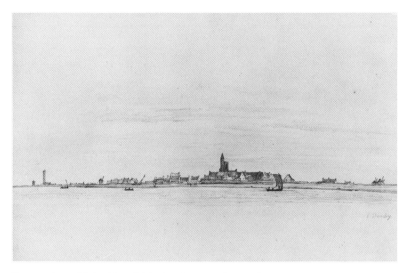

Drawn about 1857–58. Initialed and stamped. Pencil on paper.
25.6 × 41.5 cm. (10⅛ × 16⅜ in.)

Boudin's conviction that works drawn or painted from nature have a
power not found in those done in the studio is revealed in this charm-
ing pencil sketch from a notebook he used on one of his first trips to
Brittany. It is typical of his early drawings in its meticulous obser-
vation and rather tight draftsmanship. The panoramic view is domi-
nated by an expansive, luminous sky, the low horizon punctuated by a
lighthouse, church tower and three windmills. Boudin's work provides
an important transitional link between Realism and Impressionism;
in fact, he influenced the young Monet to become a landscape painter.

Collections: Boudin family. APX 72.11

JEAN BAPTISTE CAMILLE COROT, 1796–1875

View of the Ville-d' Avray

Painted about 1857–70. Signed. Oil on canvas. 59.7 × 99.2 cm. (23½ × 39⅛ in.)

By the 1860s, Corot was at mid-career with his reputation established as one of the foremost landscape painters of his time. His precisely topographical early style had changed in the late 1850s to a more lyrical one, well exemplified by this tranquil scene with its cool color harmonies, silvery light and feathery brushstrokes. This painting depicts one of the artist's favorite scenes, the family property on the outskirts of Paris. The serenity of the nostalgic view is enlivened by small figures.

Catalogue, p. 173. Collections: Edwards; Hecht; Kimbell Bequest. ACK 56.2

Jean Baptiste Camille Corot, 1796–1875

Orpheus Singing His Lament for Eurydice

Painted about 1865–70. Signed. Oil on canvas. 41.9 × 61 cm. (16½ × 24 in.)

Late in his life, Corot painted a series of lyrical landscapes coupling mythological themes with "souvenirs"—motifs based on his idealized memories of sites visited in France and Italy. This painting of a secluded grotto was inspired by Gluck's opera, *Orpheus and Eurydice*. Standing beside three seated companions, Orpheus plays a lyre and laments the death of his beautiful bride Eurydice, who had been poisoned by a serpent's bite. The idyllic setting, with its placid lake, classic buildings and heroic trees, recalls the work of Claude Lorrain and typifies the atmospheric views of Corot's latest style.

Catalogue, p. 174. Collections: Sensier; Vanderbilt family; Kimbell Bequest.

ACF 61.3

CLAUDE MONET, 1840–1926

Pointe de la Hève, at Low Tide

Dated 1865. Signed. Oil on canvas. 90.2 × 150.5 cm. (35½ × 59¼ in.)

This early masterpiece is one of two Monet seascapes accepted for exhibition in the Paris Salon of 1865, which brought the young, then-unknown artist his first critical acclaim. Remarkable for its confident, expressive brushwork, this seascape also reveals a mastery of firmly organized composition. It is an exceptional pre-Impressionist painting, manifesting Monet's early interest in pattern and texture and in the atmospheric conditions observed at his father's summer home in St. Adresse, near Le Havre. Before its acquisition, this painting had not been exhibited publicly since the 1865 Salon.

Catalogue, p. 200; see also: Wildenstein, *Monet*, 1974, cat. no. 52.
Collections: Leon Monet; de Saint-Albin; Remond; Bernheim. AP 68.7

CLAUDE MONET, 1840–1926

Still Life with a Spanish Melon

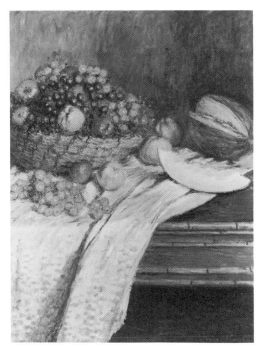

Painted in 1880. Signed. Oil on canvas.
90.2 × 68.6 cm. (35½ × 27 in.)

During his long career Monet painted relatively few still lifes, most
of them during the bleak years of 1878–81 while he was living in
Vetheuil, a Seine River village west of Paris. There he painted some
thirty still lifes of fruits and flowers to investigate and confirm his
maturing Impressionist ideas. In this painting these concerns are
seen in the varying surface textures of the fruits, the asymmetrical
composition and the unusual color harmonies.

Catalogue, p. 203; see also: Wildenstein, *Monet*, 1974, cat. no. 544;
Issacson, *The Crisis in Impressionism*, 1980, cat. no. 29.
Collections: Theulier; Marsault; Phillips. AP 67.5

PAUL CAMILLE GUIGOU, 1834–1871

Scene on the Durance River

Dated 1866. Signed. Oil on canvas. 66.0 × 117.8 cm. (26 × 46⅜ in.)

Straightforward objectivity and ordered grandeur characterize the rural landscapes of this little-known master. During his regrettably brief career, Guigou worked in southern France away from the artistic mainstream in Paris. In his work, he successfully fused the literal representation of the Realists with Impressionist concerns for deliberate patterning and experimentation with the effects of light and color. This taut, emphatically horizontal composition is made more dramatic by the intense, pervasive light and the crisp clarity of forms.

Catalogue, p. 194; see also: Pillement, *les Pre-Impressionists*, 1974, p. 220; *Bazille and Early Impressionism*, Art Institute of Chicago, 1978, cat. no. 66.

AP 69.4

CHARLES-FRANÇOIS DAUBIGNY, 1817–1878

French River Scene

Dated 1871. Signed. Oil on panel. 38.1 × 68.0 cm. (15 × 26¾ in.)

Daubigny was one of the ablest and most influential of the Barbizon painters, a group of French artists who turned to nature for their inspiration and painted outdoors. He painted this poetic landscape in the summer of 1871 when he returned to France following his self-exile in England during the Franco-Prussian war. The painting was probably done from the artist's remarkable studio-boat and shows a view of the Oise River valley where Daubigny did some ten landscapes that summer near his home in Auvers. Its simplification of detail, carefully juxtaposed strokes of unblended color, and flickering reflections of light on the water reveal the artist's interest in capturing atmospheric effects. These qualities also place Daubigny as a link between the Barbizon tradition and that of the Impressionists, whose work he encouraged in the 1870s.

Catalogue, p. 181; see also: Hellebranth, *Daubigny*, 1976, cat. no. 804. Collections: Wetmore family. AP 69.20

CAMILLE PISSARRO, 1830–1903

Near Sydenham Hill

Dated 1871. Signed. Oil on canvas. 43.5 × 53.5 cm. (17 × 21 in.)

Pissarro painted this atmospheric landscape in England during his
self-exile from the Franco-Prussian War. A major founder of Impres-
sionism, he worked directly on the spot, objectively recording the
landscape about him in fresh colors. In this work, he captured the
diffused light and silvery mist of the scene, applying broad strokes
and patches of cool greens, blues and ruddy browns. The tree trunks
in the foreground provide a structural framework within which the
branches form intricate, linear patterns. A puff of steam rises from a
passing train in the right center of the painting, with the West
Norwood cemetery in the distance.

Catalogue, p. 190; see also: Roberts, *The Impressionists and Post-Impressionists*,
1975, plate 30; Reid, "Camille Pissarro: Three Paintings of London of 1871. . .,"
Burlington Magazine, vol. CXIX, April, 1977. Collections: Seligman;
de Koenigsberg; Pearlman. AP 71.21

CAMILLE PISSARRO, 1830–1903

View Through the Trees: The Hermitage, Pontoise

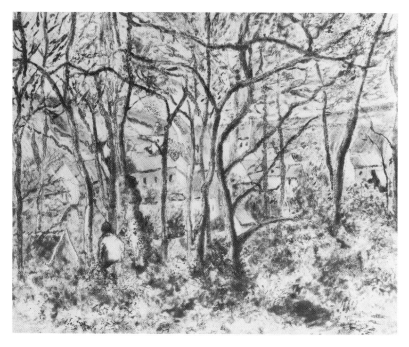

Printed in 1879. Signed. Etching and aquatint on paper; sixth of six states.
22.0 × 26.8 cm. (8⅝ × 10½ in.)

One of Pissarro's finest graphic works, this print shows an exceptional
mastery of subtle technical processes to achieve aesthetic goals. The
concerns of Impressionist painting for color and light are here trans-
formed into monochromatic patterns of etched lines, softened by
aquatint wash to produce the fine, granular texture and to modulate
the contrasts of light and dark. Depicting the rural town of Pontoise,
near Paris, where Pissarro lived for many years, the work is typically
Impressionist in its direct response to nature. An ardent advocate for
investigating the unique expressive qualities of graphic media, Pis-
sarro created this print as his contribution to *Le Jour et La Nuit*, the
short-lived Impressionist publication that sought recognition of prints
as independent works of art.

Catalogue, p. 193. AP 70.18

ALFRED SISLEY, 1839–1899

Fishermen Drying Their Nets

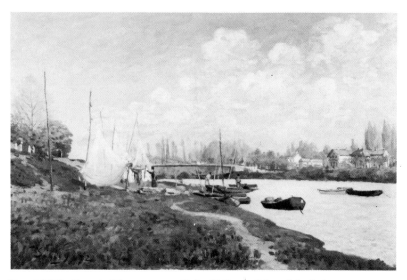

Dated 1872. Signed. Oil on canvas. 42.0 × 65.0 cm. (16½ × 25⅝ in.)

In 1872, a landmark year in his early career, Sisley painted some forty landscapes and emerged as an important artistic personality. He also met the Paris art dealer Durand-Ruel who not only bought some of his paintings but included Sisley's works in two exhibitions that same year. The dealer is historically important for having fostered the work of the Impressionist painters. This poetic river scene, with its glowing, fresh coloration demonstrates Sisley's exceptional ability to transmute an everyday scene into an image of surpassing lyricism. The subtly balanced composition of even-valued colors, the assured brushwork and splendid sense of atmosphere all attest to Sisley's consummate talent.

See: Daulte, *Alfred Sisley*, 1959, cat. no. 27. Collections: Mallet; Cassel; Ryan.

APX 77.1

WILLIAM ADOLPHE BOUGUEREAU, 1825–1905

Motherhood

Dated 1878. Signed. Oil on canvas.
135.9 × 100.3 cm. (53½ × 39½ in.)

This sweetly sentimental depiction of motherhood was painted by
Bouguereau at the height of his considerable fame. His confident
draftsmanship and brushwork create an archetypal image which
idealizes both the smiling figures and the fecund landscape about
them. Bouguereau has established the tender relationship of mother
and child through glance and touch, and the wheel-like composition
brings the eye repeatedly to their clasped hands at the spotlighted
center of the painting.

Collections: Kimbell Bequest. ACF 42.4

EDGAR DEGAS, 1834–1917

Self-Portrait

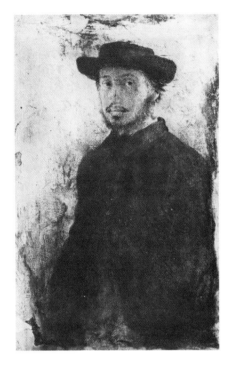

Printed about 1857. Signed.
Etching on paper, third of five
states. 22.9 × 14.4 cm. (9 × 5⅝ in.)

This early self-portrait was done when Degas was only 23, soon after he had learned the technique of etching. Cogently portraying his serious and self-confident character, the artist heightened the formal mood of this work by silhouetting his figure against a blank background, a device used by Rembrandt in his portrait etchings. In this fine impression, Degas' proficiency in the medium is revealed by the quality of line and varied crosshatching, as well as the rich contrasts between delicately light and velvety dark tones. The qualities of this particular impression must have been valued by Degas, for he inscribed it to his close friend, the sculptor Paul Bartholomé.

Catalogue, p. 196. Collections: Bartholomé; de Hauke; Leylan. AP 69.5

EDGAR DEGAS, 1834–1917

Dancer with Upraised Arms

Drawn about 1887–90. Stamped.
Pastel on grey paper. 46.7 × 29.7 cm.
(18⅜ × 11¾ in.)

Scenes of the ballet are among Degas' best known and most popular works, although in his time the subject was considered unorthodox and unacademic. This drawing is a study for a figure in the painting, *Dancers in the Rehearsal Room, with a Double Bass* (Metropolitan Museum of Art, New York). It exemplifies the artist's concentration on complex, animated movement and expressive gesture. In his later years, Degas experimented with pastels, often laying in the forms in brown and building them up with varied hues, which allowed him to suggest movement through repeated, somewhat overlapping outlines. This appealing pastel is a realistic and sympathetic portrayal of an anonymous young ballerina, caught in an unguarded moment. Its beauty derives from the subtle combinations of iridescent color and spontaneous but precise draftsmanship.

Catalogue, p. 198. Collections: R. de Gas; N. de Gas; Wallis; Rockefeller.

AP 68.4

French – 19th Century | 117

PAUL CÉZANNE, 1839–1906

Peasant in a Blue Smock

Painted about 1896–97. Oil on canvas.
79.7 × 63.5 cm. (31⅜ × 25 in.)

In this superb portrait, distinguished by consummate resolution of color, form and subject, Cézanne has captured the natural dignity of his sitter, perhaps a workman on his farm in southern France. The serious, sun-bronzed face is the focus of the thoughtfully structured composition. The face is solidly modeled in dense planes of warm colors which resonate with the cool hues of the sturdy torso and the luminous setting. The diffuse background, showing foliage, a lady with a parasol and the arm of a hidden companion, is a partial abstraction of a scene from Cézanne's earliest-known painting, a six-fold screen. Between Cézanne's characterization of the sitter and his painting style there is an impressive unifying accord; both are monumental, deliberate and profoundly humane. This moving image dates from Cézanne's late period, whose works form an influential bridge between the art of the 19th and 20th centuries. In it, the great European portrait tradition is sustained and enriched.

See: Reff, "Painting and Theory in the Final Decade," *Cézanne, The Late Years,* 1977; Grand Palais, Paris, *Cézanne, les dernières années,* 1978, cat. no. 5; Christie's, New York, *Ten Important Paintings,* May 13, 1980, cat. no. 3. Collections: Reber; Goodyear; Kenefick; H. Ford.

Acquired in memory of Richard F. Brown, Founding Director, by the Trustees of the Kimbell Art Foundation, assisted by the gifts of many friends. APg 80.3

German

MARTIN SCHONGAUER, about 1450–1491

Madonna and Child with an *Christ Before Annas*
Apple

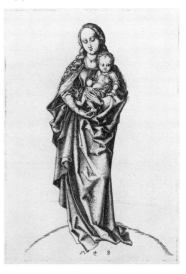
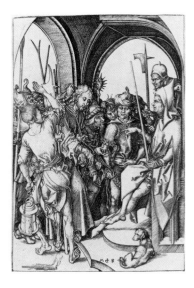

Printed in the 1470s. Monogrammed. Printed about 1480. Monogrammed.
Engraving on paper. Only state. Engraving on paper. Only state.
17.8 × 12.7 cm. (7 × 5 in.) 16.2 × 11.4 cm. (6¾ × 4½ in.)

Schongauer raised engraving in northern Europe from a minor craft
to an important medium of artistic expression. In this tender por-
trayal of Mother and Child, Christ holds an apple, signifying the new
Adam. The calm dignity of this devotional image is enhanced by the
polished contours and crisp draperies, characteristics adapted by
Schongauer from late Gothic and Flemish art. By contrast, the horror
and pathos of the Passion are conveyed in the powerfully expressive
language of German realism. Christ stands before Annas, father-in-
law of the high priest Caiaphas, amid a throng of ugly, grotesque sol-
diers and officials. In both works, Schongauer's innovative technique
of refined crosshatching produces firm modeling as well as rich shad-
ows and pure lights.

Madonna and Child—Collections: Ackermann; Johnson.
 Gift of Ruth Carter Johnson, AG 78.4
Christ Before Annas AP 79.32

The Beast with Two Horns Like a Lamb

Madonna and Child on the Crescent Moon

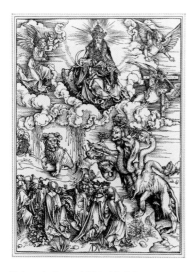

Printed about 1496–98. Mono-
grammed. Woodcut on paper.
38.9 × 28.1 cm. (15⅜ × 11⅛ in.)

Printed about 1510–11. Woodcut on
paper. 29.2 × 21.9 cm.
(11½ × 8⅝ in.)

Albrecht Dürer, the greatest artist of the German Renaissance, raised the graphic arts to unprecedented technical, expressive and artistic heights. In 1498 Dürer published *The Apocalypse*, a folio book consisting of the Biblical text of Revelation and fifteen large woodcuts. This proof impression of *The Beast with Two Horns Like a Lamb* presents two prophecies—the appearance of false prophets and the vision of Armageddon—in a design in which they appear natural and convincing. *Madonna and Child on the Crescent Moon* is a proof impression for the frontispiece of Dürer's 1511 book, *The Life of the Virgin*. Combining two popular themes, the Madonna of Humility and the Apocalyptic Woman, Dürer created an image at once intimate and visionary.

The Beast—Collections: Bull. AP 76.6
Madonna and Child—Collections: Hausmann; Johnson.
 Gift of Ruth Carter Johnson in memory of Richard F. Brown, AG 79.3

ALBRECHT DÜRER, 1471–1528

Knight, Death and the Devil *Melencolia I*

Dated 1513. Monogrammed.
Engraving on paper. Only state.
24.7 × 18.9 cm. (9¾ × 7½ in.)
Also illustrated p. 120.

Dated 1514. Monogrammed.
Engraving on paper. Only state.
24.1 × 18.9 cm. (9½ × 7½ in.)

Between 1513 and 1514 Dürer produced these three works, since called his "Master Engravings." Although he did not plan them as a unified series, the prints share an elevated moral and intellectual tenor and an extraordinary technical and artistic mastery.

Knight, Death and the Devil was the first print executed. Dürer, combining the themes of the pilgrim and soldier, presents an image of the stalwart Christian who rides through the wilderness, unafraid of the specter of Death or the horrible grasping claw of the Devil because of the strength of his own faith.

The brooding, winged figure of Melancholy, surrounded by symbols of geometry (polyhedron, sphere, tools) and of the melancholic humor (dog, bat), represents what has been called Dürer's spiritual self-

St. Jerome in his Study

Dated 1514. Monogrammed.
Engraving on paper. Only state.
24.7 × 19.0 cm. (9¾ × 7½ in.)

portrait. One interpretation suggests that the artist, who may possess great practical skill and theoretical knowledge, is nevertheless paralyzed by an awareness of the finite capabilities of the human mind in comparison to the perfection of the universe.

St. Jerome in his Study, perhaps the finest technical achievement of the three, may be seen as a spiritual pendant to Melencolia I, if not a formal one. In contrast to the inertia and disorder of the latter, here a harmonious, productive order prevails. The scholarly saint is shown at work, snug in his study, at peace with himself, and filled with the security which comes from divine wisdom.

Knight—Collections: Block; R.H.S.; Leendertz. APX 76.10
Melencolia—Collections: Beham; Robert-Dumesnil; Schlotz;
Gerstenberg; Leendertz. APX 76.12
St. Jerome—Collections: Mariette; Gordon; Leendertz. APX 76.11

The Sudermann Altarpiece: Donor Panels

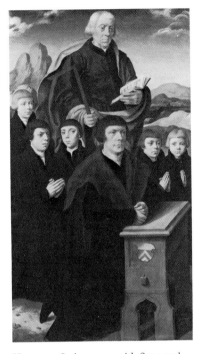
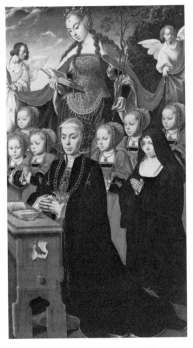

Hermann Sudermann with Sons and *Elizabeth Hupp Sudermann with*
St. Thomas *Daughters and St. Ursula*

Painted in 1525–30. Oil on two panels. 63.5 × 35.6 cm. (25 × 14 in.) each.

Bruyn founded an influential school of portraiture in Cologne, well favored by its bourgeois patrons. He painted them sympathetically but without idealization, while emphasizing their individuality and pious dignity and ensuring recognition of their social status by exact detailing of their dress. Sudermann, Burgomaster of Cologne ten times from 1541 to 1568, and his wife were members of prominent Cologne families, identifiable by the escutcheons on their prayer benches. Initially these two paintings were the inner wings of a three-part altarpiece whose central panel is now lost.

Catalogue, p. 36. Collections: Chrysler; Kimbell Bequest. ACF 65.3, 65.4

BARTHEL BRUYN, THE ELDER, 1493–1555

The Sudermann Altarpiece: Annunciation Panels

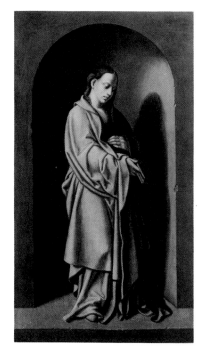 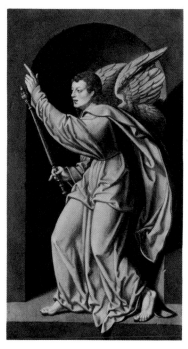

The Virgin The Angel

Painted in 1525–30. Oil on two panels. 63.5 × 35.6 cm. (25 × 14 in.) each.

These two paintings originally formed the reverse side of the Suder-
mann donor panels. In March, when the feast of the Annunciation is
celebrated, these exterior panels would have been closed over the
brightly colored inner images, their muted, nearly monochromatic
coloring appropriate for the Lenten season. The unidealized render-
ing of the holy figures, also evident in the saints of the donor scenes,
is typical of Bruyn's straightforward, yet appealing realism. The two
pairs of paintings, split and separated during a restoration treatment,
are now once again reunited through the generosity of the most recent
owner of the Annunciation panels.

Collections: Chrysler (?); Suhr. Gift of William Suhr, AG 73.4, 73.5

Italian

Duccio, *The Raising of Lazarus* (detail), page 130

DUCCIO DI BUONINSEGNA, Sienese, active 1278–1319

The Raising of Lazarus

Predella panel from the *Maestà* Altarpiece of Siena
Cathedral. Painted in 1308–11. Tempera on panel.
43.5 × 46.4 cm. (17⅛ × 18¼ in.). *Also illustrated p. 128.*

On June 9, 1311, the city of Siena joyously celebrated the unveiling
of the new cathedral altarpiece, the *Maestà* ("Majesty"), one of the
great monuments of Western art. This small panel was originally a
part of that work, which is considered the supreme summation of
Duccio's creative imagination and technical genius. The very large,
double-sided altarpiece depicted the enthroned Madonna and Child
and more than fifty narrative scenes from the lives of Christ and
Mary, as well as images of the saints and angels. In it, Duccio synthe-
sized the deeply spiritual, iconic qualities of the prevailing Byzantine
style of art with his own highly innovative conception of emotion and
drama. By portraying the touching responses of the crowd, Duccio
created a profoundly human interpretation of the Lazarus miracle
which symbolically prefigured the Resurrection.

See: Deuchler, "Duccio Doctus: New Readings for the *Maestà*," *The Art
Bulletin*, vol. LXI, December, 1979; White, *Duccio: Tuscan Art and the Medieval
Workshop*, 1979, p. 122. Collections: Siena Cathedral; Dini (?); Murray (?);
Benson; Rockefeller family. APX 75.1

GIOVANNI DI PAOLO, Sienese, about 1400/3–1483

Triptych of the Madonna and Child with Saints

Painted about 1445–60.
Tempera on panel. Central
panel: 50.8 × 25.0 cm.
(20 × 9⅞ in.); wings, each
50.8 × 12.5 cm. (20 × 4⅞ in.)

This finely wrought devotional altarpiece is richly imbued with the otherworldly spirit pervading Sienese art of the Early Renaissance, especially the works of Giovanni di Paolo. In this triptych, the artist reveals a mastery of precise detail, elegant line and graceful gesture. The gold background establishes a supernatural space for the courtly figures. Standing beside the enthroned Madonna and Child are St. Catherine of Alexandria and St. Margaret, surmounting her conquered dragon. All are blessed by God the Father above. The wings show Saints Jerome and Bartholomew on the left, opposite Saints Lawrence and Ansanus, one of the four patron saints of Siena. This heavenly assemblage results from a rare museum feat, the reunification of separated and presumably lost parts of a work of art. The central panel, acquired alone in 1967, was reunited with the missing side panels after their discovery in 1974 and, finally, with its central pinnacle image of God the Father in 1978.

Central panel—*Catalogue*, p. 25; see also: Van Os, "Reassembling a Giovanni di Paolo Triptych," *Burlington Magazine*, vol. cxix, March, 1977. Collections: Convent of San Girolamo, Siena; Chigi-Saracini; Somzée; Platt. AP 66.7
Side panels and central pinnacle—Collections: Ramboux; Taveirne.
 AP 74.1 a, b; AP 78.3

Italian, 15th Century

Maiolica Ware

Apothecary Jar with Oak Leaf
and Lily Motifs
From the vicinity of Florence.
About 1425–50. Tin-glazed
earthenware. 22.8 cm. high (9 in.)

Apothecary Jar with Oak Leaf
Motif and Fish
From Florence. About 1425–50.
Tin-glazed earthenware.
19.7 cm. high (7¾ in.)

These apothecary jars are superb examples of early Florentine Severe style *maiolica*. This type of earthenware has a tin-glazed, opaque white surface which provides an excellent ground for pictorial decoration. Although this ceramic type came to Sicily directly from the Near East, fine Spanish examples reached Italy via Majorca, the island which gave the earthenware its name. By the mid-15th century, Florence was producing its own distinctive *maiolica*, painted in a thickly applied cobalt pigment. These distinguished examples have bold, stylized oak leaf motifs in blue and purple which complement the jars' shapes. On the jar with the fish motif, the sunburst below the handle identifies it as a product of Giunta di Tugio's workshop.

AP 79.7, AP 79.6

Italian, 15th Century

Maiolica Ware

*Apothecary Jar with
Gothic Leaf Motif*
From Faenza. About
1450–75. Tin-glazed
earthenware. 20.6 cm.
high (8⅛ in.)

*Albarello with
Gothic Leaf Motif*
From Faenza. About
1450–1500. Tin-glazed
earthenware. 32.0 cm.
high (12⅝ in.)

*Albarello with
Pine Cone Motif*
From Tuscany. About
1500. Tin-glazed
earthenware. 31.1 cm.
high (12¼ in.)

By the late 15th century, polychrome wares like these replaced Severe style *maiolica* with its limited palette. To the basic blues, purples and browns were added new shades of gold and green. Plant forms predominated in the designs, especially an elegantly scrolled "Gothic-floral" leaf. This motif is often combined with a wavy ray pattern associated with San Bernardino of Siena, as seen on the two Faenza examples. The Tuscan jar, perhaps from Cafaggiolo, has a staggered design of pine cones derived from Persian palmettes. Like the taller Faenza example, it is an *albarello*, a cylindrical vessel of Near Eastern form with a distinctive incurved profile and flanged opening over which a parchment cover can be tied. *Albarelli* were widely used in pharmacies to store herbs, honey and ointments.

AP 79.8, AP 79.10, AP 79.9

GIOVANNI BELLINI, Venetian, about 1430–1516

Madonna and Child

Painted about 1470–75.
Tempera and oil on panel.
82.5 × 58.4 cm. (32½ × 23 in.)

This painting by Bellini, Venice's unrivaled Early Renaissance artist, illustrates his unique mastery of rich color and light. His debt to his brother-in-law Mantegna is revealed in the linear modeling of shallow volumes and planes, as well as the broad surface lights, which became subtler and more searching in the later *Christ Blessing*. Pictures of the Madonna and Child were extremely popular in Venice for use as private devotional panels. In this image, the Byzantine flavor—the dominant frontal figure against a dazzling gold leaf background—reflects the cosmopolitan character of the city, the mercantile crossroads of East and West.

Catalogue, p. 27. Collections: Mündler; Prince Napoleon. AP 71.6

GIOVANNI BELLINI, Venetian, about 1430–1516

Christ Blessing

Painted about 1500.
Tempera and oil on
panel. 59.0 × 47.0 cm.
(23¼ × 18½ in.)

When this panel was painted, Bellini had long been regarded as the preeminent artist of Venice, commanding a large workshop and creating a coloristic style of painting that gave birth to a flourishing "school" in the 16th century. This truly glorious image fuses the worldly with the divine in a magnificent orchestration of rich colors and glowing lights. The risen Christ is silhouetted against an atmospheric landscape softly lighted by the sun. The theme of the Resurrection is poetically enhanced by symbolic figures: the three women who found Christ's tomb empty; two rabbits, symbols of love; and the bird perched on a withered tree, symbolizing life everlasting. This impressive painting, replete with all the artist's skill and understanding, was Bellini's gift to his parish church of Santo Stefano.

Catalogue, p. 30; see also: Pignatti, *The Golden Century of Venetian Painting*, 1979, cat. no. 3. Collections: Church of Santo Stefano; Cunningham; Fisher; Dasser. AP 67.7

ANDREA MANTEGNA, North Italian, 1431–1506

The Risen Christ between St. Andrew and St. Longinus

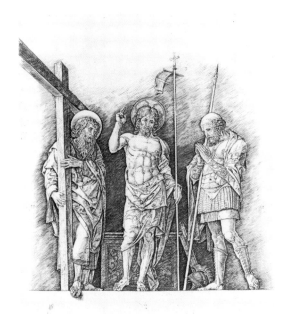

Printed about 1472. Engraving on paper.
37.5 × 33.3 cm. (14¾ × 13⅛ in.)

In the history of prints Mantegna is a pioneer, and this particular engraving is a landmark. For the first time, the illusion of three-dimensionality was convincingly achieved in an engraving, through carefully modeled figures, shaded background, and especially the projecting foot of Saint Andrew. The print shows Mantegna's profound understanding of antique art, seen in the classical dress, friezelike composition of figures, and the noble pathos of their emotion. The artist probably created this work in conjunction with Leon Battista Alberti's new basilica of Sant' Andrea in Mantua, for Andrew is depicted to the left holding his cross. To the right stands Longinus, patron saint of Mantua, the Roman soldier who is traditionally thought to have brought the relic of the Blood of Christ to Mantua, where it is still enshrined in the basilica.

Catalogue, p. 32. Collections: Cumberland; Royal Academy of Arts. AP 71.8

Jacopo Tintoretto, Venetian, 1518–1594

The Raising of Lazarus

Painted in 1573. Oil on canvas. 69.2 × 79.0 cm. (27¼ × 31⅛ in.)

Tintoretto's rich colors and free handling of paint enormously influenced the development of Venetian painting. This depiction of the most startling of Christ's public miracles is one of numerous paintings of religious subjects Tintoretto painted throughout his long career. It is one of five works commissioned in 1573 by Antonio da Mula for the library of his Venetian palazzo. The event is dramatically rendered in a dense, swirling composition dominated by foreshortened figures in dynamic poses. The strong colors, though somewhat darkened through time, and the contrasting extremes of lighting heighten the expressive intensity of the scene.

Catalogue, p. 40. Collections: da Mula; Holford; Rothermere; Hasson. AP 66.2

JACOPO PALMA, Il Giovane, Venetian, 1544–1628

Studies for an Annunciation

Drawn about 1580–90. Pen and
brown ink on paper.
38.0 × 25.6 cm. (15 × 10⅛ in.)

The leading painter in Venice after Tintoretto's death in 1594, Palma
Giovane was also a prodigious draftsman who produced more than a
thousand drawings. On the front of this sheet, which is not related
to any known painting, Palma explored the expressive potency of the
Annunciation in two variations. Here, as in the male figure study on
the reverse side, figural contours are defined by flowing, restless lines
and modeled in areas of hatching and crosshatching. In his work,
Palma combined the lyrical qualities of his Venetian artistic heritage
with the monumental dignity of Roman High Renaissance masters,
especially Michelangelo.

Collections: Sagredo (?); Borghese (?).

Funded by gift of Ruth Carter Johnson, APg 79.21

ANNIBALE CARRACCI, Bolognese, 1560–1609

Madonna and Child with St. John

Drawn about 1597–1600. Black chalk, pen and brown ink on paper.
11.6 × 16.4 cm. (4⅝ × 6½ in.)

This exquisite sheet of studies evinces the consummate skill of the
famed Bolognese classicist Carracci. The drawing is a preparatory
study for the oil painting, *Il Silenzio*, in the Royal Collection at Hamp-
ton Court. The Virgin raises her right hand in a cautionary gesture of
silence to young John, who approaches with his arm raised to touch
the sleeping Child. The tender intimacy of the Holy Family is con-
veyed through simple yet monumental strokes of chalk and ink. The
artist's profile studies in the upper right are not related to the central
composition.

See: Posner, *Annibale Carracci*, vol. 2, 1971, cat. no. 122.
Collections: Duke of Alva; Lawrence; Woodburn; Earl of Ellesmere;
Duke of Sutherland. APX 76.15

IL GUERCINO (Francesco Barbieri), Bolognese, 1591–1666

Judith with the Head of Holofernes

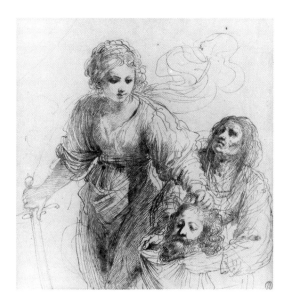

Drawn about 1640–60. Pen and brown ink on paper.
23.0 × 19.7 cm. (9⅛ × 7¾ in.)

Guercino was the leading master in Bologna, an important 17th-century artistic center. His position as one of the earliest Baroque artists is revealed by the vibrant composition and emotional intensity found in this fluent drawing. Here Judith is shown after severing the head of Holofernes, general of the Assyrian army, as her aged attendant watches. Guercino's swirling lines, hatched strokes and tiny stipples convey her beauty and determination. The book of Judith in the Apocrypha was a popular source of inspiration in Counter-Reformation art, along with biblical heroes who served as edifying spiritual examples.

Collections: Greville; Earl of Warwick. APX 75.5

MASSIMO STANZIONE, Neapolitan, about 1585–1656

Madonna and Child

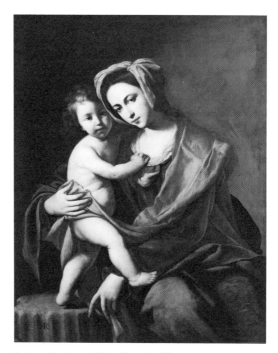

Painted in the 1630s. Signed. Oil on canvas.
127.4 × 96.8 cm. (50⅛ × 38⅛ in.)

Stanzione followed the Baroque tradition of presenting the Madonna
and Child with warmth and immediacy by choosing a close viewpoint
and directing their mild, accepting gazes to the beholder. The emo-
tional unity of the figures is emphasized by their interwoven gestures
and common glance. Complexities of curving, intersecting lines are
balanced by the simple pyramidal composition and the straightfor-
ward manner in which light and shade stress form and structure.
Working in Naples, Stanzione was influenced both by the naturalism
of Caravaggio and the Bolognese classicism of the Carracci family,
contrasting tendencies here brought to harmonious resolution.

Catalogue, p. 57. Collections: Princes of Liechtenstein; Kimbell Bequest.

ACF 56.1

Italian – 17th Century | 141

SALVATOR ROSA, Neapolitan, 1615–1673

Pythagoras Emerging from the Underworld

Painted in 1662. Signed. Oil on canvas. 132.2 × 189.0 cm. (51⅝ × 74⅜ in.)

Rosa's fame rests on his dramatic landscapes, but he himself preferred
subjects of an esoteric, moralizing nature. According to legend, Pytha-
goras descended to Hades where he saw the souls of poets tormented
for betraying secrets of the gods. In a charged and ominous atmos-
phere, Rosa shows Pythagoras rushing back, horrified, to join his
waiting disciples. The friezelike composition of large figures, looking
toward the isolated Pythagoras at the lower right, reflects the classi-
cizing influence of Poussin on Rosa's late style. Upon finishing this
painting, Rosa wrote a friend on July 26, 1662, that he was well
pleased with it and its companion, *Pythagoras and the Fishermen*
(Dahlem Museum, Berlin). He promptly put them on exhibit and
sold both to the renowned collector, Antonio Ruffo of Messina.

Catalogue, p. 76; see also: Hayward Gallery, *Salvator Rosa*, London, 1973,
cat. no. 36. Collections: Ruffo; Hamilton; Slade; Tracy; Roche. AP 70.22

GIOVANNI BATTISTA TIEPOLO, Venetian, 1696–1770

The Adoration of the Magi

Printed about 1745–55. Signed. Etching on paper,
first of three states. 43.1 × 28.8 cm. (17 × 11⅜ in.)

The largest and most elaborate etching made by Tiepolo, this work
ranks as one of his finest graphic achievements. It illustrates the
crucial moment of Christ's manifestation to the world and achieves
a pictorial power which equals that of his painted compositions. In
this print, the artist used his etching needle like a pen to create fluid,
delicate lines, either simple flicks or dense webs. The silvery, light-
filled atmosphere is well in keeping with the Venetian artistic tradi-
tion, as is the rich and fanciful mixture of Eastern and classical trap-
pings which enhance the imagery of the Biblical event.

See: Rizzi, *The Etchings of the Tiepolos*, 1971, cat. no. 27. Collections: Graf.

AP 76.5

Italian – 18th Century | 143

GIOVANNI BATTISTA TIEPOLO, Venetian, 1696–1770

Chronos

Drawn about 1745–50. Black chalk on blue paper
(verso: red chalk, heightened with white).
31.8 × 26.2 cm. (12½ × 10⅜ in.)

The preeminent master of 18th-century Venetian painting, Tiepolo
was also an inveterate draftsman. This drawing is a preparatory study
of the Greek god Chronos for the large allegorical painting, *Time
Unveiling Truth* (Museum of Fine Arts, Boston). Tiepolo varied the
pressure of the chalk, producing flickering passages of light and
shadow which carve out the resolute features and firm musculature
of Chronos. This study exemplifies the artist's extraordinary com-
mand of fluent line and form-revealing light. On its reverse is a
drapery study in red chalk.

Collections: de St. Saphorin; Chaikin. AP 79.4

GIOVANNI DOMENICO TIEPOLO, Venetian, 1727–1804

Christ at Gethsemane with Saints Peter, James and John

Probably drawn after 1770. Grey and bistre wash
over pen and ink, traces of chalk, on paper.
46.2 × 36.5 cm. (18¼ × 14⅜ in.)

Giovanni Domenico Tiepolo, son of Giovanni Battista, created his
own distinctive style, which is marked by a mastery of dramatic nar-
ration and intense feeling. This monumental sheet, which illustrates
Christ's descent from his agony on the Mount of Olives, is probably
from a group entitled "The Life of St. Peter" in the extensive "Large
Biblical Series." Tiepolo evinces the poignancy and highly charged
emotion of the moment after Christ's question to St. Peter: "What,
could ye not watch with me one hour?" The carefully orchestrated
washes reach their deepest saturation around the two men, where the
luminous white paper is left untouched. This produces a visionary
quality in the Christ figure, whose mystical light is reflected on the
awestruck St. Peter.

Catalogue, p. 99. Collections: Cormier; Duc de Trevise. AP 71.9

CANALETTO, Venetian, 1697–1768

Venice: The Grand Canal at Santa Maria della Carità

Painted about 1726–30. Oil on canvas. 46.4 × 63.5 cm. (18¼ × 25 in.)

Canaletto's remarkable technical mastery of perspective, color and light is seen in this sparkling view of the Grand Canal, the principal water route through the island of Venice. This exotic city was an essential stop on the 18th-century traveler's "grand tour" of Europe, and the artist's lively and meticulous views were bought as pictorial souvenirs. This particular painting is from a dozen such scenes acquired by Prince Joseph Wenzel of Liechtenstein. Today, the topographical accuracy of Canaletto's paintings provides valuable documentary evidence of the changing appearance of the city.

Catalogue, p. 92. Collections: Princes of Liechtenstein; Kimbell Bequest.

ACK 52.3

CANALETTO, Venetian, 1697–1768

The Molo, Venice

Painted about 1735. Oil on canvas. 62.3 × 101.3 cm. (24½ × 39⅞ in.)

This view records the busy commercial life of the Molo, the wharf of
Venice. The artist creates a pageantry of costumed figures and sway-
ing boats on a sun-drenched day, against a pristine architectural back-
ground. The atmospheric richness of color and light emerges from a
peculiarly Venetian tradition that extends back to the earliest works
of Bellini and his school. He primed the canvas with a ground of pale
Venetian red, imbuing the wharf, buildings and thinly painted sky
with an underlying, almost palpable warmth. A painter particularly
esteemed by English travelers, Canaletto later spent ten years in
England, painting similar views of London and Thames River scenes.

Catalogue, p. 94. Collections: Earl of Rosebery; Jenks. AP 69.22

FRANCESCO GUARDI, Venetian, 1712–1793

Study of Four Figures *The Assumption of the Virgin*

Drawn about 1775. Brown ink and
brown wash on paper.
13.0 × 13.1 cm. (5⅛ × 5¼ in.)

Drawn about 1775–78. Brown ink and
brown wash, over black chalk, on paper.
34.9 × 24.2 cm. (13½ × 9½ in.)

Both of these drawings show Guardi's remarkable ability to create
luminous pictorial space through a few rapid penstrokes, thin veils of
translucent wash and bold use of the white paper itself. *Study of
Four Figures* is a succinct, broadly washed notational sketch, its fig-
ures resembling those in several of Guardi's paintings. The other
work condenses the grand style of large-scale 18th-century painting
in its drama, soaring weightlessness, and breathtaking fusion of earth
and cloud-banked sky. In both drawings, the dominant role of light
—extraordinarily atmospheric and evocative—reveals Guardi's Vene-
tian heritage, passed down from the early days of the Renaissance.

Figures— Collections: Cernazai (?); Dal Zotto. AP 76.3
Assumption—See: Morassi, *Guardi, Tutti I Disegni*, 1975, cat. no. 142.
Collections: Gritti; Hanfstaengl. APX 76.14

FRANCESCO GUARDI, Venetian, 1712–1793

Venice Viewed from the Bacino

Painted about 1780. Oil on canvas. 63.0 × 95.7 cm. (24⅞ × 37¾ in.)

Views of Venice painted as tourist souvenirs brought Guardi numer-
ous commissions but little artistic recognition. Almost a century
passed before his originality was appreciated. Though topographically
accurate, Guardi's landscapes are more highly personal than those of
his older contemporary, Canaletto. Melting colors and dazzling virtu-
oso brushwork characterize Guardi's attempts to catch the ephemeral
qualities of Venice's unique light, air and mood. In the moisture-
laden atmosphere, details picked out by the sun wink like semaphores
across the lagoon, giving depth and distance to the spectacle of the
Ducal Palace and shoreline.

Catalogue, p. 96; see also: Morassi, *Guardi*, 1973, cat. no. 396.
Collections: Ingram; Godfrey; Rimington-Wilson; Wolfson. AP 70.19

Spanish

El Greco, *Giacomo Bosio* (detail), page 153

JUSEPE DE RIBERA, 1591–1652

Saint Matthew

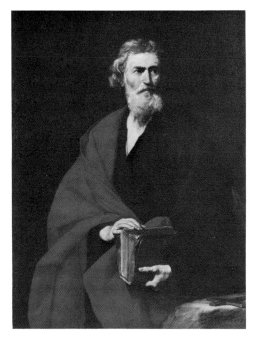

Dated 1632. Signed. Oil on canvas.
128.2 × 97.8 cm. (50½ × 38½ in.)

Ribera's emphatic detailing of essentials—the vigorously modeled head, the strong, gnarled hands, the book and simple cross—makes this imaginary portrait quite believable. Its dramatic impact is heightened by the sharply contrasting lights and darks that focus attention on the compassionate yet virile face. This sense of vitality and drama was fundamental to much Counter-Reformation art. Although Ribera spent most of his career in the Spanish viceroyalty of Naples, his realistic images like this painting significantly influenced later Spanish religious painting.

Catalogue, p. 59. Collections: Wimborne; Deschamps. AP 66.10

EL GRECO, 1541–1614

Giacomo Bosio

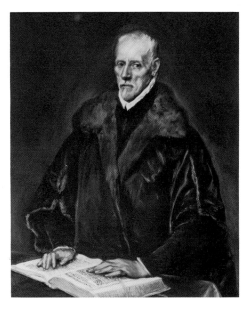

Painted about 1600–10. Oil on canvas.
107.0 × 90.0 cm. (42⅛ × 35½ in.).
Also illustrated p. 150.

This imposing portrait dates from late in El Greco's career when he was the preeminent artist of Spain. It depicts the Italian cleric and historian who was agent to Pope Gregory XIII for the Order of the Knights of Malta. El Greco's austere color harmonies, expressionist handling of paint and taut composition all emphasize Bosio's gaunt face with its ascetic, penetrating gaze. The artist imbued his sitter with immense dignity and presence, complemented by the marvelously painted hands, relaxed yet powerful, and the rich, fur-trimmed coat. This incisive characterization is one of the most impressive of fewer than thirty portraits by El Greco, whose religious paintings are more numerous and better known.

See: Gudiol, *El Greco*, 1973, cat. no. 247. Collections: Condesa de Quinto; Oudry; Bamberg; Kings Carol I and Carol II of Rumania. AP 77.5

BARTOLOMÉ ESTÉBAN MURILLO, 1617–1682

The Immaculate Conception

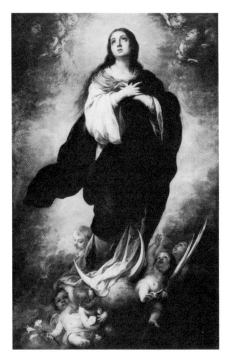

Painted about 1670–80. Oil on canvas.
168.5 × 109.0 cm. (66⅜ × 42⅞ in.)

The Sevillian painter Murillo was a leading interpreter of the doctrine of the Immaculate Conception, as seen in this majestic Baroque painting. The subject was a popular one, especially after rules on its iconography and representation were officially formulated by the Roman Catholic Church in the early 17th century. As laid down by Counter-Reformation officials, the rules called for the crescent moon at the Virgin's feet and the lilies, roses and palms, symbols of purity and victory. Murillo provided emotional immediacy through fluid, swirling brushwork, delicate colors, golden lights and rich shadows.

Catalogue, p. 83. Collections: Blackwood; Cartwright. AP 69.14

JUAN DE ARELLANO, 1614–1676

A Basket of Flowers

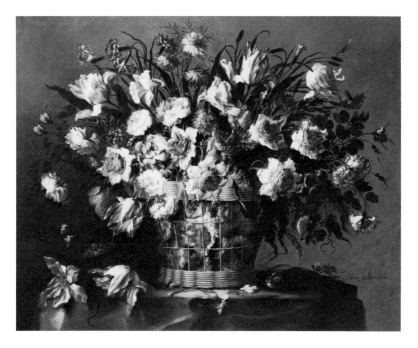

Painted about 1670–76. Signed. Oil on canvas. 83.8 × 104.8 cm. (33 × 41¼ in.)

The decorative opulence of this still life epitomizes the *florero*, a distinctive Spanish mode of flower painting that originated in the 17th century. Arellano, who lived most of his life in Madrid, was one of the most prolific and accomplished painters of flower still lifes. This late work shows his mastery of *florero* conventions in the precisely drawn forms, near-symmetry of design, and the luxuriant abundance of carefully arranged red, yellow and blue blooms. The palpable presence of the flowers is intensified by the raking light from the left and the warmth of the muted brown background.

Catalogue, p. 74. Collections: Waldhausen; Kimbell Bequest. ACF 65.5

FRANCISCO DE GOYA, 1746–1828

Rita Luna

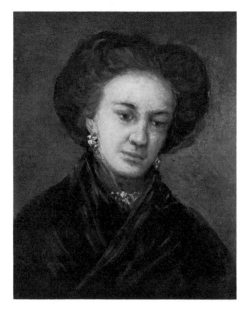

Painted about 1814–15. Oil on canvas.
42.5 × 34.2 cm. (16¾ × 13½ in.)

One of the most admired tragediennes of her day, Rita Luna (1770–
1832) was active in the Spanish theater for more than fifteen years
before retiring in 1804. Goya painted this profoundly introspective
portrait about ten years later. Her downcast eyes and strongly shad-
owed face, along with the somber hues, evoke an almost melancholy
mood. This subjective focus is typical of Goya's late paintings which
include some of the most intensely psychological studies in all of art.

Catalogue, p. 163; see also: Crombie, "Goya and the Stage,"
Apollo, vol. XCVIII, July, 1973. Collections: Mariano Goya (?);
de Carderera; Duke of Béjar; Condesa de Oliva; Conde de Oliva;
Kimbell Bequest. ACF 54.1

Francisco de Goya, 1746–1828

The Matador Pedro Romero

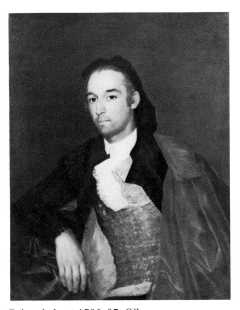

Painted about 1795–97. Oil on canvas.
84.1 × 65.0 cm. (33⅛ × 25⅝ in.)

Goya's sympathetic portraits of his friends, such as this superb painting, are among his most penetrating character studies. Romero, who fought from 1771 until his retirement in 1799, was one of the most illustrious figures in the early history of bullfighting. A clear-eyed gaze, erect torso and relaxed right hand convey the handsome matador's vitality and self-possession. The gently modeled hand, said to have killed more than a thousand bulls, anchors a complex composition of rich colors and patterns. The varied flesh tones concentrate attention on the face, and luminous blacks, greys and whites set off the plum color of the cape and the intense crimson of the jacket lining. Goya's brushstrokes, revealed clearly because of the work's excellent condition, range from blunt impasto in the clothing to the smoothly blended strokes of face and hand.

Painting—*Catalogue*, p. 159. Collections: Xavier Goya (?); de Vera; Rochefort; Lafitte; R. Kann; Abdy; Sachs. AP 66.12

20th Century

Picasso, *Man with a Pipe* (detail), page 164

EDVARD MUNCH, 1863–1944

Madonna

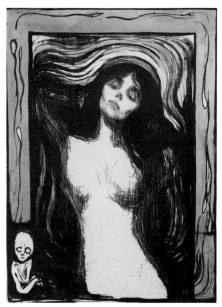

Printed in 1895; colors added in 1902.
Signed. Hand-colored lithograph.
61.0 × 44.3 cm. (24 × 17½ in.)

This powerful image is an arresting summary of Munch's view of woman: at once spirit and flesh, allure and threat, mother and lover, life-giver and harbinger of death. Its intense psychological impact derives from Munch's deep interest in the subconscious and his profound awareness of the intellectual turmoil of his time. Dramatic intensity is provided by strong contrasts of lights and darks and by the startling juxtaposition of motifs: the fetus-like figure and spermatazoa in the border and the sensual, flame-haired woman, shown in the momentary ecstasy of conception. This impression was hand-colored by Munch as a printer's model for later lithographic colored impressions. It is also distinguished by the artist's inscribed dedication to Norwegian critic Jappe Nilssen, one of Munch's earliest admirers.

See: Timm, *The Graphic Art of Edvard Munch*, 1969. Collections: Nilssen; Steinmetz. AP x 75.2

EDVARD MUNCH, 1863–1944

Girls on a Bridge

Painted about 1904–7. Signed. Oil on canvas.
80.5 × 69.3 cm. (31¾ × 27¼ in.)

Bright colors, vigorous brushwork and dynamic structure characterize
the work of Munch, the great Norwegian Expressionist who explored
human psychology with subjective intensity. Here, three anonymous
figures stand self-absorbed in a setting lit by the midnight sun. Their
lack of interaction and the faceless girl in the foreground evoke one
of Munch's primary themes, isolation. The figures function as the
anchor for a space-defining compositional device: the emphatic
diagonal of the bridge balanced by the strong horizontal of the land-
scape. The scene, which recurs in Munch's work, depicts Aagaard-
strand, the town south of Oslo where the artist lived most of his life.

Catalogue, p. 210. Collections: Bratt; Grether. AP 66.6

EDOUARD VUILLARD, 1868–1940

The Model in the Studio

Painted about 1905–6. Signed. Oil on cardboard. 62.5 × 86.0 cm. (24⅝ × 33⅞ in.)

The intimate, casual appearance of this interior view and its exquisite, tapestry-like paint surface epitomize Vuillard's mature style. The model, disrobing in the artist's Parisian studio, poses informally as if caught off guard. Although clearly defined, her figure is subtly interwoven with the delicate colors, decorative patterns and abstract shapes of the tautly structured composition. The ambiguous space, at once three-dimensional and emphatically flat, creates the calculated tension typical of Vuillard's work.

Catalogue, p. 205. Collections: Sainsère family; Farjon. AP 67.2

ANDRÉ DERAIN, 1880–1954

The River Seine at Chatou

Painted in 1905. Signed. Oil on canvas. 70.7 × 110.7 cm. (27⅞ × 43⅝ in.)

The bright, often arbitrary colors of this landscape view represent a radical departure from the concern for fidelity to natural appearances that had dominated Western painting since the Renaissance. Harmonies and dissonances of spontaneously applied color build an entirely cohesive composition in this superb painting. Stimulated by Van Gogh and Matisse, Derain and his colleagues explored the expressive possibilities of free, exuberant colors seen in full light. Their controversial works earned them the name "Fauves" (wild beasts) which gave the short-lived but influential Fauvist movement its name.

Catalogue, p. 208. AP 66.13

PABLO PICASSO, 1881–1973

Man with a Pipe

Painted in Summer, 1911. Signed. Oil on canvas.
90.7 × 71.0 cm. (35¾ × 27⅞ in.). *Also illustrated p.* 158.

The abstract forms of this monumental painting well exemplify
Cubism, a radical and influential stylistic movement of the early 20th
century. The figure is fragmented into flat, geometrically shaped
planes within an oval format, which allowed Picasso to concentrate
the most solidly structured forms in the center. The heavy outlines,
monochromatic color and overlapping forms assert the primacy of the
flat picture surface. To offset the visual complexity, clues are given
to the subject: a pipe projecting beneath a curving moustache, a
brown suit with a white collar, and a journal held in the sitter's lap.
Picasso painted this while vacationing in the French Pyrenees with
Georges Braque who, with him, forged the new style of painting of
which this is a daring and advanced example.

Catalogue, p. 215. AP 66.8

PABLO PICASSO, 1881–1973

Lysistrata by Aristophanes

Celebration of Peace and Reconciliation
Published in 1934. Signed. Bound
volume: 6 etchings, 29 lithographs,
118 pp. 30.0 × 24.0 cm. (11¾ × 9½ in.).
Copy no. 392 of 1,500.

In Aristophanes' 5th-century B.C. play, the heroine Lysistrata incites
the women of Greece to revolt and withhold their marital favors in
order to end the Peloponnesian War. This important volume is the
only American publication with original etchings by Picasso. It re-
flects the distinctive classicism he developed in the 1920s and 1930s
in its traditional literary subject, monumental forms, restrained
linearity and, above all, in its concentration on the human figure as
the primary vehicle of expression. Picasso's robust humor is revealed
in the vigorous, often bawdy illustrations of this spirited narrative.

See: Hofer and Garvey, *The Artist and the Book, 1860–1960*, 1961, cat. no. 226.
Collections: Cantey. Gift of Mrs. Sam B. Cantey, III, AG 79.1

ODILON REDON, 1840–1916

The Birth of Venus

Painted in 1912. Signed. Oil on canvas.
143.4 × 62.2 cm. (56½ × 24½ in.)

Momentarily suspended between two worlds, the Roman goddess of love and beauty rises from the sea, her delicate form poised against a shell of pearly iridescence. The ethereal atmosphere of shell, clouds and sky is created by soft brushwork, heightened by touches of opaque white. The serene lyricism of this scene seems to signal Redon's joyful release from the nightmarish imagery and somber coloring of his earlier prints. Between 1890 and 1912, the visionary artist created many works on mythological themes. Although he worked outside the mainstream of French art, his imaginative independence inspired a new generation which included Maillol and Vuillard.

Catalogue, p. 217. Collections: Sabouraud; Hauert; Higgons. AP 66.14

EMILE ANTOINE BOURDELLE, 1861–1929

Penelope

Dated 1909. Monogrammed. Cast bronze,
dark green patina. 119.7 cm. high (47⅛ in.)

Bourdelle's interest in the classical
sculptural effects of strain and balance
found a felicitous outlet in this sub-
ject. Penelope, steadfast and devoted
through a long, trying separation,
yearned for the return of her husband,
Odysseus, from the Trojan War. Work-
ing through several versions of Pene-
lope, Bourdelle sought to refine the
image through ever-greater monu-
mentality and abstraction. Massive
contours are relieved by surfaces
broken to catch the transient play of
light, a technique Bourdelle learned
from his teacher Rodin. The solidity of
the figure contrasts with the delicacy
of her head and gesture.

Catalogue, p. 212. AP 69.3

HENRI MATISSE, 1869–1954

Odalisque with Green Shawl

Painted about 1921–22. Signed. Oil on canvas. 88.6 × 116.3 cm. (34⅞ × 45¾ in.)

Brilliant color, elegant line and decorative charm characterize the work of Matisse throughout his long career. In this painting he studied a favorite subject, the female form, here posed as an odalisque, or harem woman, lounging in a light-filled interior. The patterned, highly colorful design suggests Matisse's pleasure in the luxurious and the exotic, while the languorous pose echoes the traditional European theme of the idealized nude. The model's bobbed hairstyle and shaped eyebrows, however, are purely of the time and typify the naturalism of Matisse's works produced in Nice in the 1920s. The bold composition, structured in large masses of color and vibrant in the opposition of red and green, extends the lessons of Fauvism.

Catalogue, p. 218. Collections: Matisse; Duthuit. AP 68.6

HENRI MATISSE, 1869–1954

Jazz

The Circus
Designed 1943–47. Published in 1947. Signed. Portfolio volume: 20 color stencil plates, 146 pp. 41.9 × 32.4 cm. (16½ × 12¾ in.). Copy no. 203 of 270.

Jazz stands both as a culmination of Matisse's previous creative activity and as a prospectus for his subsequent work in the cut-out medium. The work includes twenty dazzling colored images, abstracted from natural forms and printed from stencils with an elegant manuscript text composed by the artist. The vibrant images derive from Matisse's memories of music halls, the circus, a trip to Tahiti and the experiences of his heart, while the poetic text is an informal manifesto of his aesthetic and philosophical principles. Produced during the occupation of France, the spirited imagery of *Jazz*—often joyous, often tragic—is perhaps the artist's reaffirmation of humanity in a war-torn society.

Collections: Zwemmer; Rosenberg. APX 77.3

GEORGES ROUAULT, 1871–1958

Miserere

"*Have mercy upon me, O God . . .*"
Designed about 1914–18. Printed 1922–27. Published in 1948. Signed.
Portfolio album: 58 etchings with aquatint. 53.3 × 45.7 cm. (21 × 18 in.).
Copy no. 339 of 450.

Rouault's best-known graphic work, *Miserere*, powerfully illustrates human agonies and man's redemption through Christ. These trenchant images, their subjects taken from both the Bible and everyday life, have the power of icons. The album was commissioned by the famous art dealer, Ambroise Vollard, who helped to revive the art of fine bookmaking in France. Published without a text, this series of profoundly moving prints reveals the years of labor Rouault devoted to the project.

See: Wheeler, *Georges Rouault, Miserere*, 1952.
Collections: Johnson. Gift of Ruth Carter Johnson, AG 74.2

ARISTIDE MAILLOL, 1861–1944

Daphnis and Chloe by Longus *Les Géorgiques* by Virgil

Daphnis and Chloe Embracing
Published in 1937. Signed. Bound
volume: 52 woodcuts, 212 pp. with
54 proofs. 19.7 × 13.0 cm. (7⅞ × 5⅛ in.).
Copy no. 48 of 250.

Weeding the Vineyard
Designed about 1908–44. Published
1937–50. Two portfolio volumes:
I, 61 woodcuts, 174 pp.; II, 61 wood-
cuts, 154 pp. 32.1 × 23.8 cm.
(12⅝ × 9⅜ in.). Copy no. 128 of 750.

These books are superb examples of the art of the illustrated book in
their masterful orchestration of text and image on the pages. The
elegance of Maillol's simple, linear designs is enhanced by their
juxtaposition with the open character of the type. These classic
themes from ancient literature are complemented by the archaic
grace of the monumental human forms. A series of idyllic scenes in
Daphnis and Chloe depicts the awakening of passionate love in a
bucolic setting. *Les Géorgiques* is a famous didactic work which deals
with both the practical affairs and the poetry found in a life of rustic
labor.

See: Rewald, *The Woodcuts of Aristide Maillol*, 1943. Collections: Johnson.

Gifts of Ruth Carter Johnson, AG 73.2 a,b; AG 73.1 a,b

ARISTIDE MAILLOL, 1861–1944

L'Air

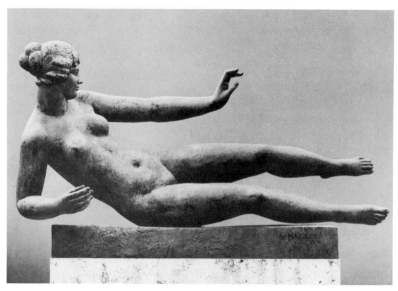

Designed in 1938; cast in 1962. Signed. Bronze with blue-green patina. Fifth cast in an edition of six. 153.6 × 239.9 × 96.5 cm., including plinth (60½ × 94 × 38 in.)

This heroically scaled, classically styled nude typifies the feminine ideal conceived and reaffirmed by Maillol throughout his career. A major work from late in the artist's career, the sculpture was commissioned in 1938 by the city of Toulouse in southern France to commemorate the World War I pilots who had trained in that city. Symbolizing flight, the serene and gracefully balanced figure appears to float majestically in the air, pushing away masses of clouds. The Kimbell sculpture was cast from the model for the French monument.

Catalogue, p. 220.

AP 67.6

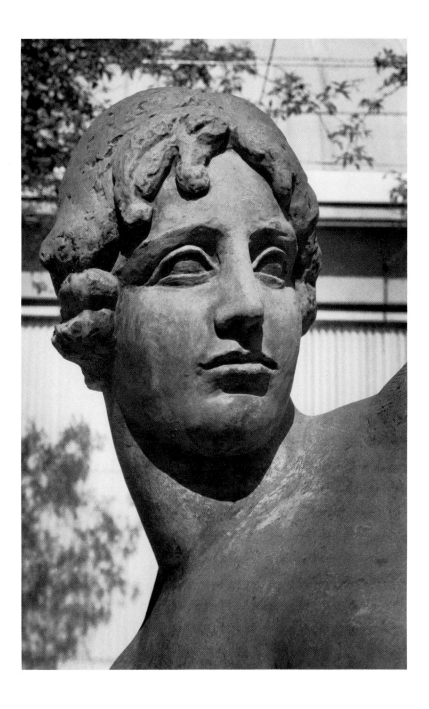

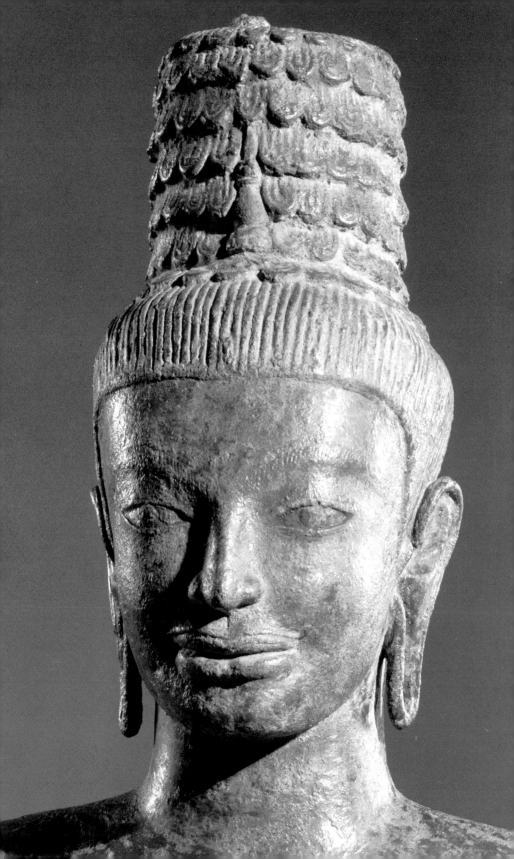

South Asian

Cambodian, *Maitreya Buddha* (detail), page 185

Indian, Kushan Period, about 50 B.C.–A.D. 320

Standing Buddha

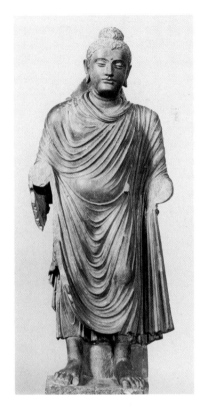

2nd Century. From Gandhāra.
Grey schist. 130.8 cm. high
(51½ in.)

The Buddha, a man who lived and died in northeast India in the 6th century B.C., established a religion that spread throughout Asia and profoundly affected its culture. This serene statue is among the earliest anthropomorphic images of this great religious leader. The Buddha was not depicted in an iconic, human form until about the 1st century when two types of statues appeared, one reflecting a purely indigenous sculptural tradition. The second, from the area of Gandhāra in northwest India, shows the influence of contact with the Roman world, seen in this statue. Originally destined for a temple niche, the work bears a strong resemblance to Græco-Roman statues of Apollo in the togalike robe, the sensuous, well-proportioned face, and easy stance.

Catalogue, p. 227. AP 67.1

Nepalese, Licchavi Dynasty, about A.D. 400–850

Standing Buddha Śākyamuni

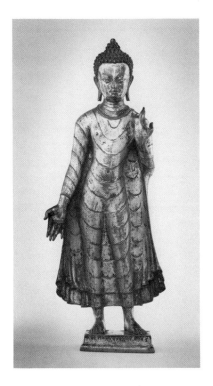

7th Century. Gilded copper.
50.2 cm. high (19¾ in.)

This richly gilded figure represents the mortal Buddha, Śākyamuni, Sage of the Śākya clan. He displays a number of physical signs, such as snail-shell curls, a cranial protuberance (uṣṇīṣa), extended earlobes and webbed fingers, that have come to represent the Buddha's divinity. The Buddha's right hand is raised in the gesture of bestowing gifts, as his left hand gathers up the hem of his robe. The clinging diaphanous material, revealing the undulating contours of the body beneath, and its regular, stylized folds suggest that the Indian Gupta style was the inspiration for this figure. Its origin is identified by the Nepalese inscription on its base.

See: Pal, *Nepal: Where the Gods are Young*, 1975, cat. no. 1.
Collections: Heller. AP 79.1

Indian, Medieval Period, about 600–1200

Standing Female Deity

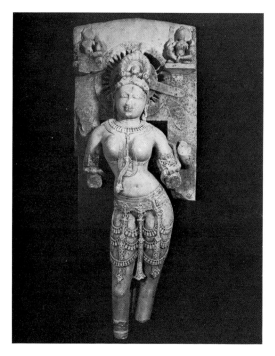

10th or 11th Century. From Rājasthān.
Pinkish-tan sandstone. 143.8 cm. high (56¼ in.)

Voluptuous goddesses are significant in Indian art from earliest times, personifying fertility, maternity, and Indian ideals of feminine beauty. These goddesses became very important in later Hinduism where they began to express different aspects of the female character, triumphant and fierce as well as passive and dependent. This figure's large size and attendants attest to her importance, her halo with its projecting sword to her power. Since two of the original four arms and all the attributes they held are missing, her identity remains a mystery until the sculpture's original temple site is determined. Her delicate and precisely carved jewelry and girdle subtly contrast with the supple contours of her torso and swaying hips.

Catalogue, p. 229. AP 68.1

Indian, Medieval Period, about 600–1200

Head of a Jina

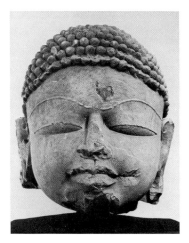

11th Century. From Rājasthān
or Madhya Pradesh. Grey-pink
sandstone. 77.1 cm. high (30⅜ in.)

This massive head represents one of the twenty-four saviors of the
Jain religion who, having broken the unending cycle of rebirth, help
others to do the same. Originally part of a colossal statue, this head
was produced when the Jain community was flourishing in Rājasthān.
Its elongated eyes, curving brows and full lips are typical of the me-
dieval sculptural tradition of northern India, which required precise
adherence to the proportions prescribed in iconographic texts. The
snail-shell curls and elongated, pierced earlobes are conventions
shared by Buddhist sculpture, but the absence of a cranial protuber-
ance (uṣṇīṣa) confirms the Jain iconography. Lacking earrings or
turban, the Jina is an ascetic who has renounced material goods.

Catalogue, p. 230. Collections: Heller. Gift of Ben Heller, AG 68.1

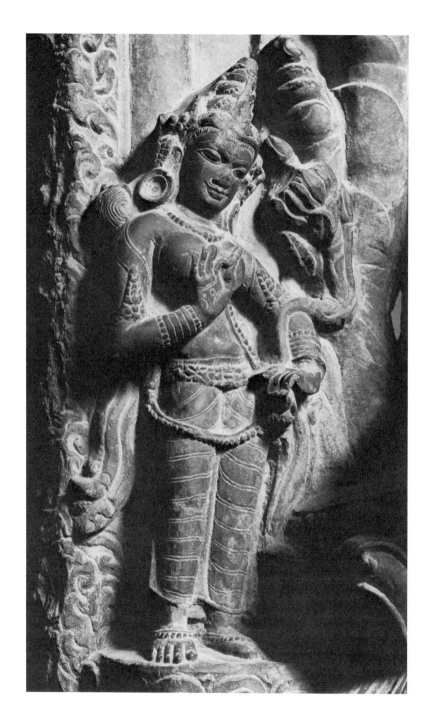

Indian, Pala Dynasty, 760–1142

Khasarpaṇa Lokésvara

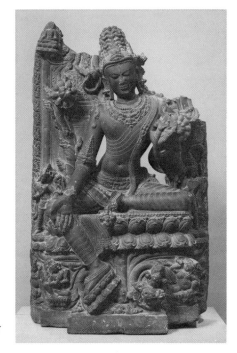

12th Century. From Bengal. Grey
schist. 124.9 cm. high (49¼ in.)

After the 7th century Buddhism declined in India, surviving through
the 12th century only in the northeastern state of Bengal before it
disappeared completely from the country of its origin. Khasarpaṇa
Lokésvara is an esoteric form of the bodhisattva of compassion,
Avalokitésvara, created by the absorption of Hindu elements into
Buddhism. This bejeweled figure is seated on a double-lotus throne,
surrounded by attendants, demons and a profusion of detail. It is an
example of the complex iconography, ornamentation, and stylization
that characterizes the last phase of Buddhist art in India. Nevertheless,
the fluently rounded body of this princely figure, which combines
youthful male form with feminine grace, conveys to the worshipper
the serenity of the devotional image.

Catalogue, p. 232. AP 70.13

South Indian, Chola Period, about 850–1310

Vishṇu

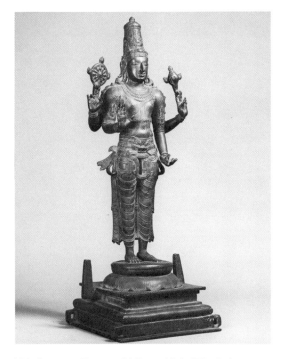

13th Century. Bronze. 85.7 cm. high (33¾ in.)

In the triad of Hindu deities representing the Creator, Preserver and Destroyer, Vishṇu is the Preserver, the mediator between opposing forces active in the universe. This beautifully cast statue presents Vishṇu in his highest aspect as the final resting place of all phenomena. His rigid frontal pose, standing immovably on a lotus pedestal, indicates his divinity, as he beckons the worshipper to approach unafraid. Vishṇu's manifold powers and activities are symbolized by his many arms, their gestures and emblems. The wheel recalls Vishṇu's origins as a Vedic solar deity, and the conch, blown as a horn in battle, suggests his ability to terrorize his enemies.

Catalogue, p. 234. Collections: Heller. Gift of Ben Heller, AG 70.1

South Indian, Vijayanagar Period, 1336–1565

Pārvatī

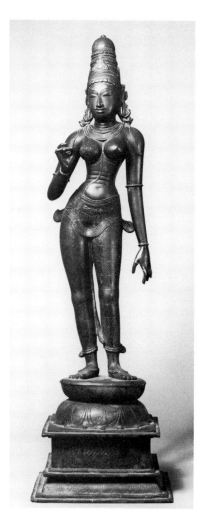

15th Century. Bronze. 90.7 cm. high (35¾ in.)

In the Hindu religion, Pārvatī, the consort of Shiva, is the archetypal mother goddess and fertility image. She benevolently mediates between the worshipper and the Divine. This sensuous, graceful image is intended to suggest the divinity as an ideal beauty. Her heavy breasts, narrow waist and rounded hips conform to established systems of proportions set down in Hindu artistic-theological manuals. This delicate bronze was placed in a temple, and its relatively small size permitted devotees to carry it in religious processions.

Catalogue, p. 236. AP 69.13

Indian, Rajput Period, about 1500–1900

Ragamala Painting of Dhanasri Ragini

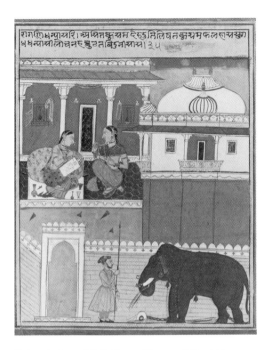

Painted about 1690. From Mewar, Rājasthān.
Gouache on paper. 25.7 × 21.6 cm. (10⅛ × 8½ in.)

Here, Ragini, lonely for her absent lover, paints his portrait, the floating moon and fiery red background suggesting the intensity of her passion. Many such miniatures were contained in Ragamala albums which followed the organization of Indian music into several modes. Each mode had a special mood and time of day associated with it, and related music and paintings would have been experienced simultaneously. The bright, saturated color of this nocturnal scene is typical of the indigenous folk art of Mewar.

Collections: Wiener. Gift of Mr. and Mrs. Edward Wiener, AG 75.3

Cambodian, Pre-Angkor Period, A.D. 550–802

Standing Maitreya Buddha

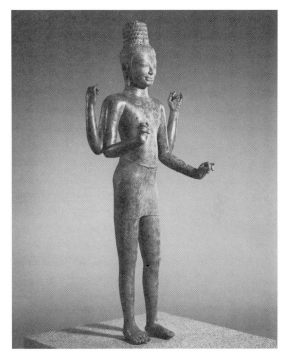

Probably 8th or 9th Century. From Pra Kon Chai.
Bronze. 122.5 cm. high (48¼ in.). *Also illustrated p.* 174.

This exquisite figure with a serene, compassionate expression is the Maitreya, the Buddhist messiah, also known as the Buddha of the Future. Freestanding and perfectly balanced, his body is activated by a gentle S-curve. The four arms indicate his divinity and represent a multiplicity of powers. His stylized garment fits like a second skin, reinforcing his essential nudity. His hair is piled high in a chignon composed of six rows of curls, with a tiny stupa in the center front which symbolizes his attainment of nirvana. The Maitreya's wide-open eyes are alert, his smile benign, revealing a divinity both approachable and life-giving.

Catalogue, p. 237. AP 65.1

Cambodian, Khmer Empire, 802–1431

Standing Shiva

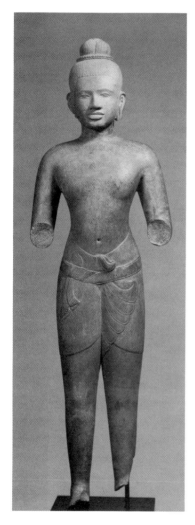

About 1000–1050. From northeast Thailand.
Grey sandstone. 138.2 cm. high (54½ in.)

The restrained grace and assured confidence of this erect figure emphasize the auspicious nature of Shiva, the Hindu deity of the destruction necessary for renewal and creation. Shiva is here identifiable by his third eye, etched lightly in the forehead. The dignity and strength are salient qualities of the Baphuon style, named for the mountain-temple built in the 11th century at the then-new capital of Angkor. The sensuous elegance of this refined style is particularly evident in the subtly modeled torso, the straight hair carved in low relief, and the delicately articulated *sampot,* with its carefully arranged, pocket-like folds on the left thigh and a stylized bow rising high in the back.

See: Lee, *Ancient Cambodian Sculpture,* 1969, cat. no. 22. Collections: Heller. AP 80.5

Cambodian, Khmer Empire, 802–1431

Buddha Enthroned

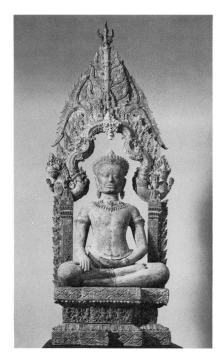

10th or 11th Century. Probably from
Chaiyaphûm Province.
Bronze. 175.5 cm. high (69⅛ in.)

In Cambodia, the primary forms of Indian religion and art were
adapted to indigenous concepts of ceremonial function, technique and
style. The elaborate temple complexes and monumental sculptures
produced by the Khmer kings are frequently interpreted as their ef-
forts to effect an identity with the Divine. This magnificent statue has
the firm, simplified body, open eyes, and wide mouth distinctive to
the Khmer style, but the crown and necklace indicate a departure
from the Indian concept of the Buddha as a monk. The figure is
seated beneath a sinuous, polylobed arch embellished with twenty-
five small Buddha figures and topped with a trident. An emphatic
statement of religious devotion, this unusual piece is one of the most
remarkable Cambodian sculptures in the West.

Catalogue, p. 240; see also: Woodward, "The Bàyon Period Buddha Image in
the Kimbell Art Museum," *Archives of Asian Art*, vol. XXXII, 1979. AP 66.9

Chinese

Zhu DeRun, *Returning from a Visit* (enlarged detail), page 198

Chinese, Tang Dynasty, A.D. 618–907

Amphora-shaped Vase *Ewer with a short spout*

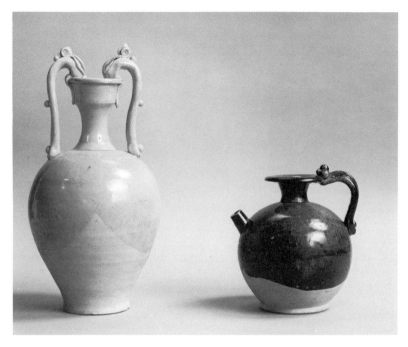

7th or 8th Century. Stoneware, with transparent glaze. 37.8 cm. high (14⅞ in.)

8th or 9th Century. Stoneware, mottled golden-brown glaze. 19.0 cm. high (7½ in.)

The amphora shape of the vase, modeled after Hellenistic prototypes, has been translated into Chinese idiom by the use of a single color and substitution of dragon handles for the ordinary loop variety. The finely crackled, almost colorless glaze falls in a graceful swag which separates the glossy upper body from the unglazed portion below. The ewer is distinguished by its spherical shape and lustrous brown glaze which falls short of the base in a sweeping curve, revealing its light buff body. The handle terminates at the rim in a stylized, natural form.

Vase—*Catalogue*, p. 244. AP 69.16
Ewer Anonymous gift in memory of Dr. Jane Byars, AG 73.3

Chinese, Tang Dynasty, A.D. 618–907

Jar with cover

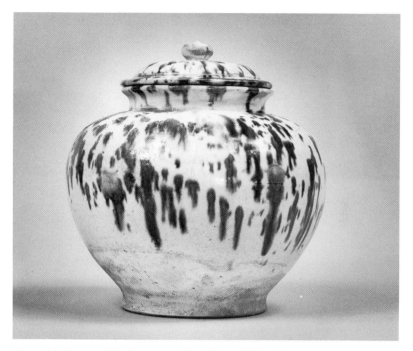

About 9th Century. Earthenware with white and blue glazes.
22.5 cm. high (8⅞ in.)

The full, vigorous form of this jar reflects the vitality and optimism of the Tang Dynasty. Its buff clay body, roundly swelling shape, and splashed decoration all combine to form an organic whole, each element complementing the other. While color-splashed wares are common during the Tang period, the use of blue pigment is relatively rare and ordinarily reserved for choice pieces. The splashes dripping down the sides exemplify the "controlled accident" by which carefully planned effects appear spontaneous and effortless. This jar was probably preserved through burial, but the existence of its original cover is unusual.

Catalogue, p. 245.

AP 71.18 a,b

Chinese, Song (Sung) Dynasty, 960–1279

Zhejiang (Chekiang) Ware

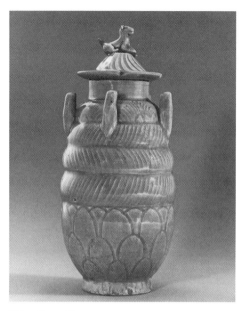

Wine Jar with cover
11th or 12th Century. Inscribed.
Stoneware, olive-green glaze.
31.7 cm. high (12½ in.)

This covered jar probably contained a funerary offering of wine, which is suggested by the inscription around the neck. Its remarkable state of preservation, with cover and all appendages intact, undoubtedly results from its burial for many centuries. It is notable for its graceful proportions; crackled, transparent glaze; and the subtle variations of its carved and incised decoration. The five vertical tubes on its shoulder do not penetrate the body; their purpose is unknown, although this motif originated as early as the 9th century during the Tang Dynasty. The floral-shaped cover is surmounted by a little dog.

Catalogue, p. 247. Collections: Cox; Dickes. AP 70.8 a,b

Chinese, Song (Sung) Dynasty, 960–1279

Northern Celadon Ware

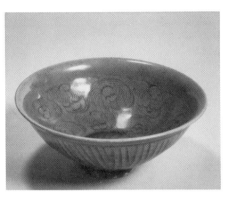

Bowl with wave design
12th or 13th Century. Stoneware,
olive-green glaze. 15.9 cm. diam.
(6¼ in.)

Bowl with lotus design
12th or 13th Century. Stoneware,
olive-green glaze. 18.4 cm. diam.
(7¼ in.)

The elegantly shaped bowl with a wave design has thin walls and a flared lip. Its pale glaze has a jadelike quality much admired by connoisseurs. An allover "comb" pattern of abstract foliate scrolls is incised and carved on the interior. In the bottom of the bowl, the glaze has the transparency of glass, reaffirming the high quality of the object. The lotus bowl is a sturdier example from the same period. Its thick walls, boldly carved lotus design, and deep celadon glaze are complementary and form an organic whole. The thin glaze pools in the deeply cut furrows reinforce the strong patterning.

Wave design—*Catalogue*, p. 248. Collections: Dickes. AP 70.9
Lotus design—*Catalogue*, p. 249. AP 71.16

Chinese, Song (Sung) Dynasty, 960–1279

Jun (Chün) Ware Southern Guan (Kuan) Ware

Plate with foliate rim
10th to 11th Century. Grey
stoneware, lavender blue glaze.
19.5 cm. diam. (7¾ in.)

Pear-shaped Vase
Southern Song Period, 1127–1279.
Stoneware, grey-green glaze.
12.2 cm. high (4⅞ in.)

This small, flat plate is a refined example of the early Jun wares pro-
duced in Henan province, often for imperial use. The elegant shape
of this plate and subtle color of the opalescent glaze epitomize the cre-
ativity of the Song period potter. The rhythmically foliate rim of this
rare piece is a delicate antecedent to later Jun wares produced from
the 12th century which were more massive and frequently spotted
with brilliant flushings of color. The Song vase is notable for its grace-
ful shape and the remarkable depth of its finely crackled glaze. Guan
("official") ware was made at the Jiao Tan (Chiao-t'an) or "Altar of
Heaven" kilns, southwest of Hangzhou (Hangchow). This factory
produced ceramic wares for the Southern Song imperial court which
were highly prized.

Plate—Collections: Peters; Johnson. Gift of Ruth Carter Johnson, AG 77.1
Vase Anonymous gift, AG 74.1

Chinese, Song (Sung) Dynasty, 960–1279
Attributed to XIA GUI (Hsia Kuei), about 1180–1230

Mountain Landscape by Moonlight

Painted about 1200–1225.
Colophon and two seals.
Hanging scroll, ink on silk.
53.0 × 35.6 cm. (20⅞ × 14 in.)

This scroll expresses the vastness and harmony of nature through compositional devices characteristic of Southern Song painting. The time is nightfall; the mood is one of serenity as the moon shines through the mists, revealing the steeply falling, jagged edge of the mountain. This diagonal line creates the asymmetrical composition, in which the weight is confined to the lower right third of the painting. The upper two-thirds, faintly tinted silk, creates the atmosphere which permeates the painting, eliminating unessential detail. Man is dwarfed and absorbed into nature, integrated with the moon, mountain and trees.

Catalogue, p. 250. AP 71.17

Chinese, Song (Sung) Dynasty, 960–1279

Qingbai (Ch'ing-pai) Ware

Melon-shaped Ewer
11th or 12th Century. Porcelain,
pale greenish-blue glaze.
15.2 cm. high (6 in.)

Covered Box with molded peony design
13th Century. Porcelain, transparent
glaze with pale blue-grey tint.
14.3 cm. diam. (5⅝ in.)

Qingbai ware, prized for its elegant restraint, was produced near the great ceramic center of Jing De Zhen (Ching-te-chen) in Jiangxi (Kiangsi) Province, South China. These delicate porcelains are distinguished by a clear, bluish glaze over incised, combed, or molded decoration. On the ewer, a broad band of lightly incised floral scrolls with "dotted combing" adorns the body and shoulder. In contrast, the box is embellished by molded decoration, a technique developed in the 13th century, including a single peony blossom with leaves on the cover and vertical ribbing on the sides.

Ewer—Collections: Johnson.
Box

Gift of Ruth Carter Johnson, AG 76.1
Anonymous gift, AG 71.1

Chinese, Yuan Dynasty, 1270–1368

Qingbai (Ch'ing-pai) Ware

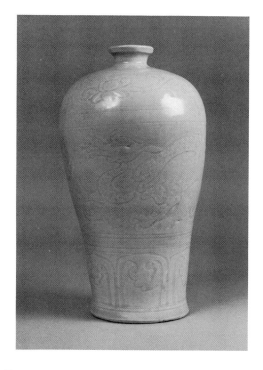

Meiping (Mei-p'ing) Vase
First half, 14th Century. Porcelain,
pale greenish-blue glaze.
31.8 cm. high (12½ in.)

This vase, with a shape resembling an inverted pear, is an excellent example of the subtlety of design found in *Qingbai* ware. It is called *meiping*, meaning "plum," because it was designed to hold a single branch of blossoming plum. Its decoration consists of carved and incised motifs in three registers. Floral scrolls circle the shoulder, a dragon twists through puffy clouds in a broad band around the center, and stylized lotus petals with medallions compose the bottom band.

Catalogue, p. 253. AP 68.8

Chinese, Yuan Dynasty, 1270–1368
ZHU DERUN (Chu Te-jun), 1294–1365

Returning from a Visit

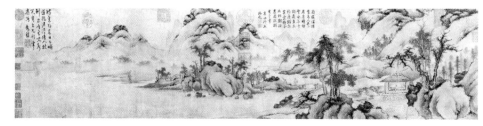

About mid-14th Century. 2 colophons and 32 seals. Handscroll, ink on paper
28.2 × 119.3 cm. (11¼ × 47 in.). *Also illustrated p. 188.*

This scroll was in the Manchu household collection and bears an in-
scription and seals of the Emperor Qian Long (Ch'ien-lung). Though
bathed in mist, the space is continuous and easily traversable, receding
from right to left by means of overlapping, linear and atmospheric
perspective. There is an intimate, inviting quality as the viewer is led
into the composition in the right foreground. Clumps of cedars with
gnarled roots dominate the near distance. The man and his servant
approaching the bridge suggest a familiar theme in Yuan art—the
artist-scholar retreating from the corrupt world of affairs to the un-
touched countryside. The forms of trees and rocks are drawn from the
styles of Northern Song artists who produced monumental landscapes.

Catalogue, p. 255. Collections: Manchu; Takeuchi. AP 72.6

Chinese, Yuan Dynasty, 1270–1368

Cizhou (Tz'u-chou) Ware

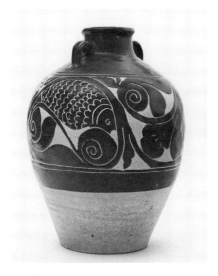

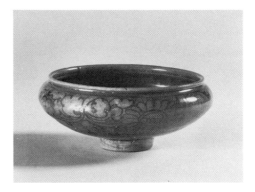

Vase
14th Century. Stoneware,
greenish-brown glaze.
40.0 cm. high (15¾ in.)

Bowl
Late 13th to Early 14th Century.
Stoneware, turquoise-blue glaze.
14.8 cm. diam. (5⅞ in.)

Cizhou is the designation for a group of North China stonewares decorated by painting under glaze or by incising through a colored slip, techniques developed in the Song period. The vase with large patterns of foliate scrolls and fish is a handsome example of the incised method. Initially, the upper two-thirds of the vessel was dipped in brown glaze with the outlines of the design, including the eyes and scales of the fish, cut through it. Background areas were then scraped away to reveal the cream-colored body of the stoneware. The low bowl is an attractive example of Cizhou painted wares. It is unusual because of its rich turquoise-blue glaze which was imported into China from Persia about this time. The band of floral and foliage motifs deliberately coincides with the expanding swell of the bowl.

Vase—*Catalogue*, p. 253. AP 70.6
Bowl AP 73.2

Chinese, Ming Dynasty, 1368–1644

White Ware

Bowl with secret decoration
Early 15th Century, possibly Yong Lo period, 1403–24. Porcelain,
transparent glaze, tinting to pale blue. 21.0 cm. diam. (8¼ in.)

This gracefully fragile bowl is distinguished by purity of form em-
bellished with barely discernible decoration, known as *an hua* or
"secret" decoration. The design is lightly incised on remarkably thin
walls and covered with a lustrous, transparent glaze. Produced in the
Jing De Zhen (Ching-te-chen) area of Jiangxi (Kiangsi) Province,
these white wares demonstrate the excellence of ceramic production
supported by the imperial court.

Catalogue, p. 259. APX 71.20

Chinese, Ming Dynasty, 1368–1644

Blue-and-White Ware

Dish with melon design
Early 15th Century.
Porcelain, blue under-
glaze decoration.
43.4 cm. diam.
(17⅛ in.)

Lotus Bowl
Xuan De (Hsüan-te)
Period, 1426–35. Reign
mark. Porcelain, blue
underglaze decoration.
20.8 cm. diam. (8¼ in.)

Flask
Late 15th Century.
Porcelain, blue under-
glaze decoration.
33.3 cm. high (13⅛ in.)

These elegant porcelains are fine examples of the technical and dec-
orative excellence of Ming Dynasty blue-and-white wares. Designs
of scrolling vines, blossoms, fruit, and waves are executed in cobalt
blue pigment under clear glazes that create brilliant color contrasts
with glossy highlights. The irregularly shaped melon motif centered
in the deep, flat dish is unusual, as are the stylized petals that radiate
around the foot of the bowl. In contrast to the predominately natural
motifs on these two vessels, the round, tall-necked flask features an
abstract woven pattern with scalloped lobes on its flat sides. Modeled
after the shape of Islamic metal vessels, this flask was molded in sep-
arate pieces which were joined before firing.

Dish—*Catalogue*, p. 260. AP 70.3
Bowl—*Catalogue*, p. 262. AP 70.14
Flask—*Catalogue*, p. 264. Collections: von Pflugk; David. AP 68.11

Chinese, Ming Dynasty, 1368–1644
WEN JIA (Wen Chia), 1501–1583

Landscape in the Style of Dong Yuan (Tung Yüan)

Painted in 1577. Colophon and two seals.
Hanging scroll, ink and light colors on paper.
167.0 × 52.0 cm. (65¾ × 20½ in.)

Wen Jia was a major artist of the Wu
school, that group of literati centered in
the city of Suzhou (Soochow) during the
late Ming period, who were not profes-
sional artists but scholar-bureaucrats who
painted solely for pleasure. Wen Jia was a
teacher of Confucian classics, a recognized
poet, and connoisseur of paintings. His
life, like his art, was characterized by
knowledge and refinement. This painting
demonstrates not only his technical virtu-
osity but his knowledge of the past by fol-
lowing the style of the great 10th-century
master, Dong Yuan, especially in the
rounded mountains defined by long, thin
strokes that follow their contours and
give texture to their surface. This tall,
crowded composition of fissured moun-
tains, winding paths, torrents, and leafy
trees still has the gentle, lyrical quality
that is typical of Wen Jia's style.

AP 80.1

Chinese, Ming Dynasty, 1368–1644
DONG QICHANG (Tung Ch'i-ch'ang), 1555–1636

Steep Mountains and Silent Waters

Painted in 1632. Colophon and seven seals.
Hanging scroll, ink on paper.
102.5 × 30.3 cm. (40⅜ × 12 in.)

Dong Qichang, one of the most celebrated
figures in the history of Chinese art, is
famous for his painting, calligraphy, and
his theoretical works on painting. Dong
was an innovative artist who made the
elements of traditional landscapes, such
as the contours of rocks, shading, and spa-
tial relationships, into an abstract, formal
vocabulary with which he created a vari-
ety of new landscape visions. For that rea-
son, he is credited with single-handedly
infusing life back into Chinese painting
at a time when the Ming Dynasty and the
established painting schools were in de-
cline. This composition of dry mountain
peaks has the sharp precipices, bare angu-
lar patches, and unexpected spatial juxta-
positions that are characteristic of his
mature, highly intellectual style.

See: Pan Zhengwei, *Ting fan lou shu hua ji*,
1843–49; Gu Wenbin, *Guo yun lou shu hua ji*,
1882. AP 80.2

Chinese, Ming Dynasty, 1368–1644
LAN YING, 1585–about 1664

Steep Peaks and Tall Pines of Mt. Tian Tai (*T'ien-t'ai*)

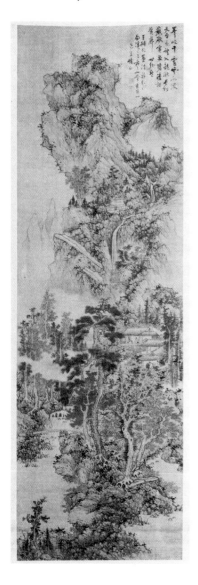

Painted about 1635–40. Two seals.
Hanging scroll, ink and light color on silk.
182.3 × 57.0 cm. (71¾ × 22½ in.)

The high peak in the background is the famous sacred mountain Tian Tai which is covered with Buddhist temples and monasteries. It rises steeply from a sparsely vegetated foreground to an exceedingly complex middle ground of trees, streams, waterfalls, boulders and mist-filled ravines. There is a strong vertical thrust curving up the trunk of the central pine, through the waterfall into the tree-dotted mass of the mountain above. While there is some recession into space, the composition remains relatively flat and close to the picture plane. It functions as a decorative pattern, open at the sides, the landscape motif tending toward abstraction rather then reality.

Catalogue, p. 265. Collections: Hiraki; Cahill. AP 69.17

Chinese, Ching Dynasty, 1644–1912
ZHENG XIE (Cheng Hsieh), 1693–1765

Bamboo

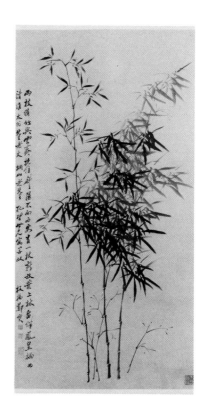

Painted in the 1750s. Colophon and four seals.
Hanging scroll, ink on paper.
179.8 × 95.0 cm. (70⅝ × 37⅜ in.)

Zheng Xie (Cheng Hsieh) is famed for his excellent poetry, painting and calligraphy. The latter interest led him to painting subjects, particularly bamboo, which offered technical challenges in the control of brush and ink. No matter how many leaves overlap in his work, the ink never fails to define form; no matter how few the leaves, they do not seem scattered. Such control is evident in this painting where dense ink and delicate washes produce an image of bamboo receding into mist. Uniting painting and calligraphy, the artist brushed a poem in long lines to complement the vertical composition.

AP 76.13

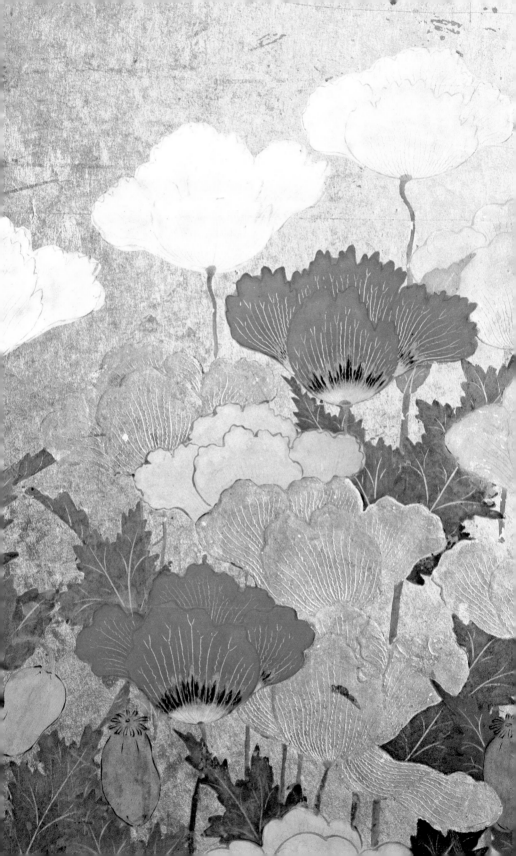

Japanese

Kano Shigenobu, *Wheat, Poppies and Bamboo* (detail), page 223

Japanese, Jōmon Period, about 5000–200 B.C.

Urn with rope pattern and loop handles

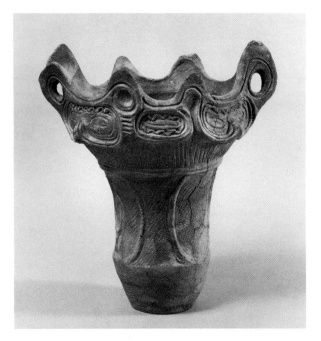

Middle Jōmon Period, 2500–1000 B.C. Low-fired clay.
42.0 cm. high (16½ in.)

The term *jōmon*, meaning "cord-marked," refers to the impressions
left from rolling braided or twisted ropes across the surface of moist
clay. Since this decorative technique is the distinctive feature of pot-
tery vessels made during the neolithic period in Japan, the term is
used to designate the entire cultural epoch. Produced in simple shapes
for domestic use, Jōmon vessels were hand-built with thick walls and
fired at low temperatures in open pits. The mysterious masks, surging
peaks, and undulating coils on the rim of this vessel are characteristic
of the dramatic forms produced during the Middle Jōmon period,
particularly in the fertile plains near modern Tokyo.

APX 74.3

Japanese, Jōmon Period, about 5000–200 B.C.

Female Figurine

Latest Jōmon Period, about 1000–200 B.C.
From Yamagata Prefecture.
Low-fired clay. 20.1 cm. high (7⅞ in.)

The purpose of the Jōmon figurines is not known, but they may have been used as protective charms or fertility symbols. Most were excavated from pit dwellings, but some were recovered from burial sites or simple shrines. The figurines exhibit a variety of abstract, humanoid shapes that appear highly imaginative and even bizarre. Typical of figurines from the latest Jōmon period, this work has a hollow, thin-walled body, supported by short tubular legs and wide hips. The contrast between the smooth body and the restricted areas of incised or cord-marked patterning, which appear here as bands on the face, chest, and hips, is also characteristic of late Japanese neolithic pottery.

Catalogue, p. 268. Collections: Okura.　　　　　　　　　　AP 71.15

Japanese, Kofun Period, A.D. 200–552

Haniwa Seated Man

Late 5th or early 6th Century. From
Hokota site, Kashima, Ibaraki Prefecture.
Tan pottery with cinnabar paint.
76.0 cm. high (30 in.)

Haniwa, or "clay cylinders," were placed around large earthen
mounds covering the royal tombs constructed during the protohistoric
Kofun period in Japan. Their function is unknown, but it is thought
that they were used to protect the sides of the mound from erosion.
The majority of *haniwa* are unadorned, but a number of them are
decorated with a variety of sculpted human figures, animals, and do-
mestic or ceremonial objects. Despite its simplicity and abstraction of
form, this seated man is an excellent example of the expressiveness
achieved in representational *haniwa*.

Catalogue, p. 269. Collections: Okura; Daridan. AP 72.2

Japanese, Kamakura Period, 1185–1333

Tsuina Mask

About 13th Century. From Hōryū-ji, near Nara.
Lacquered and polychromed wood.
26.3 cm. high (10⅜ in.)

The Tsuina mask is used specifically for a goblin-expelling ceremony
that still occurs at Japanese temples each February on the evening of
Setsubun, the last day of the lunar calendar. In the ceremony, people
throw beans at a man wearing a goblin mask to simulate the expulsion
of demons from the temple grounds. Since they are subject to violent
movement and intense wear, old Tsuina masks are quite rare. This
mask's expression of demonic rage is produced by the squared open
mouth, furrowed brow and bulging facial muscles. It is an arresting
example of the innovative carving techniques and interest in realism
that characterize wood sculpture of the 13th century.

Catalogue, p. 271; see also: Japan Art Center, *Japanese Art: Selections from
Western Collections*, vol. 8, 1980, p. 158. Collections: Hara. AP 71.13

Japanese, Kamakura Period, 1185–1333

Style of KAIKEI, died 1220

Jizō

About 1250–60. Wood, mineral pigments and gold foil. 82.0 cm. high (32⅜ in.)

Jizō, one of the most popular Buddhist deities in Japan, is a bodhisattva who protects the vulnerable in this world, such as pregnant women, children and travelers. His mercy extends to the tormented souls in hell whom he comforts and leads to salvation. This statue is a fine example of the realistic hollow wood sculpture produced by the Kei school in the 13th century. The gentle expressiveness of the face and the delicacy of the rich gold leaf ornamentation on the robes suggest that the artist was a follower of the early Kamakura master, Kaikei. The small size of the statue indicates that it was commissioned by an individual for private devotional purposes, rather than for a temple.

See: Japan Art Center, *Japanese Art: Selections from Western Collections*, vol. 8, 1980, p. 131.

AP 73.3

Japanese, Kamakura Period, 1185–1333

Ingen, 1278–1346

Shingon Iconographic Scroll of Kannon

Dated 1309–10. Signed. Handscroll, ink and color on paper.
29.5 × 960.0 cm. (11⅝ × 378 in.). Detail illustrated.

The many forms of Buddhist deities that are systematically presented
in iconographic texts demonstrate the multiple powers of each god.
Monks copied these texts as acts of devotion and as a means of con-
centrating on their content. This scroll was originally part of a ten-
scroll set of the *Iconographic Compendium (Zuzō-shō)*, painted by the
Shingon monk, Ingen, and later deposited at the temple, Entsu-ji,
on Mt. Koya. A fragment of the sixth scroll in the set, it shows five
of the seven manifestations of the bodhisattva of compassion, Avaloki-
teśvara (*Kannon* in Japanese) that are important in esoteric Buddhism.
The smooth, clear-line drawing and delicate washes of primary colors
produce a clarity of image suited to the scroll's didactic purpose.

Collections: (?) Ninna-ji, Kyoto; Entsu-ji, Mount Koya. Anonymous gift, AG 72.1

Japanese, Muromachi Period, 1392–1573
Attributed to SOGA DASOKU, active about 1452–85
Calligraphy attributed to IKKYŪ SŌJUN, 1394–1481

Portrait of Daruma

15th Century. Colophon. Hanging scroll, ink on paper. 92.8 × 34.5 cm. (36½ × 13½ in.)

Daruma, known also by the Sanskrit name Bodhidharma, is the legendary first patriarch of Zen Buddhism. He is said to have been a South Indian prince who introduced the meditative sect of Buddhism to China in the 6th century. Among numerous exploits credited to Daruma, his unbroken nine-year meditation in a mountain cave is the most famous. This immobile profile of Daruma, created by a few swift strokes, suggests this feat and conveys the sense of unyielding discipline admired by the disciples of Zen. The colophon has the signature of Ikkyū Sōjun, a prominent monk renowned for his idiosyncratic interpretation of Zen ideals and also famed as a calligrapher. An old inscription on the painting's box attributes the image to Soga Dasoku, who was a disciple of Ikkyū.

Catalogue, p. 273. Collections: Matsudaira; Kuki; Hyogo. AP 70.7

Japanese, Muromachi Period, 1392–1573
Style of SESSON SHŪKEI, about 1504–1589

Evening Landscape

Painted about 1540. Hanging scroll, ink and light color on paper.
29.0 × 46.2 cm. (11½ × 18¼ in.)

The dramatic massif which dominates the painting rises out of mist
and places the close foreground path and distant mountains in per-
spective. Specific motifs, such as the flock of geese at the right, the
temple nestled in mountain peaks, and the moon at the left, are ref-
erences to the poetic theme of the *Eight Views at the Confluence of the
Hsiao and Hsiang Rivers,* the most common subject of medieval
Japanese ink painting. This scroll has many characteristics of the early
style of Sesson Shūkei, suggesting that it was done by one of his fol-
lowers about 1540. These include the peculiar arc of the waterfall; the
hunched figures with featureless, pointed faces; and the long, jagged
outlines of the mountains, their surfaces textured by short, nailhead
strokes and diagonally applied washes.

Catalogue, p. 277. Collections: Iwasaki; Kumita; Kotei. AP 69.15

Japanese, Muromachi Period, 1392–1573
Attributed to TOSA MITSUSHIGE, 1496–about 1559

An Exiled Emperor on Okinoshima

Painted about 1550. Six-fold screen, ink, gold and color on paper.
148.0 × 348.0 cm. (58¼ × 237 in.)

Exile to a remote area of Japan or a small island off her coast was a
common form of punishment for political crimes throughout Japanese
history. In this screen, the large sea of rough, billowing waves, the
small visitor, and the somber tones of ink and silver suggest the lone-
liness of a distant island. The seated figure in the hut, with only his
books and *koto* as companions, has been traditionally identified as the
emperor Godaigo, who ruled 1318–39. However, recent scholarship
suggests he may be the late Heian emperor, Go-Toba, who ruled
1184–98 and whose record of exile is a celebrated literary passage.
Although the screen is unsigned, the execution of the waves, the hut,
and the cherry trees points to the classical *yamato-e* style of the Tosa
school. The large-screen composition and decorative quality of the
waves suggest a date in the mid-16th century.

Catalogue, p. 274; see also: Japan Art Center, *Japanese Art: Selections from
Western Collections*, vol. 4, 1980, p. 142. Collections: Kawakatsu. AP 71.11

Japanese, Momoyama Period, 1573–1615

Mukōzuke (side dish), Karatsu ware

Late 16th or early 17th Century.
Stoneware, grey glaze and iron oxide
underglaze. 10.5 cm. diam. (4 in.)

The *mukōzuke* is a food container, a side dish used in the *kaiseki* meal
that precedes the drinking of ceremonial tea. This deep, straight-sided
bowl is a beautiful example of painted wares from the Karatsu kilns
established by Korean immigrants on the northwestern coast of the
island of Kyushu. The simple underglaze designs of leafy grass and a
few curled vines, painted in iron oxide on the sides of the bowl, are
characteristic of works from these kilns. The distinctive lobed shape,
graceful proportions, and warm, muted color of the bowl are qualities
the tea connoisseur most admired in utensils from Karatsu.

Catalogue, p. 282. AP 71.12

Mizusashi (water jar)
Late 16th Century. Stoneware,
wood-ash glaze. 20.9 cm. high
(8¼ in.)

Mizusashi (water jar), with cover
Early 17th Century. Stoneware,
wood-ash glaze. 17.7 cm. high
(7 in.)

The Bizen kilns near the town of Imbe in Okayama Prefecture are known to have been active since the 13th century. Like the Shigaraki kilns, they produced a variety of utilitarian vessels until the 16th century when Bizen wares attracted the attention of tea masters who began to order vessels specifically for use in the tea ceremony. These two *mizusashi* are intended to hold the fresh water required at different points in the tea ceremony. Their sturdy shapes and warm, natural finishes are typical of Bizen ware, which is made of a dense, fine-grained clay that fires to a deep reddish brown. The wares are usually unglazed, and the random spots of yellow glaze on these vessels were produced by kiln ashes that fell on the pots and fused during firing.

AP 73.1, AP 72.13 a,b

Japanese, Momoyama Period, 1573–1615

Shino Ware

Shallow Bowl
Late 16th Century. Stoneware, red and grey glaze. 16.0 cm. diam. (6⅜ in.)

Shino, a collective term for pottery wares covered with a thick white feldspar glaze, was one of the most radiant developments in Japanese ceramics. First produced in the 16th century in the Mino area of Gifu Prefecture, these simple but vibrant wares were quickly adapted for use in the tea ceremony. A variety of soft colors from grey to red results from coating the white clay body of Shino vessels with iron oxide before glazing. Although the side of this bowl is deeply cracked, tea connoisseurs admired the unusual pink color of the bowl which was produced from a light coating of iron oxide.

APX 76.9

Japanese, Momoyama Period, 1573–1615, and Edo Period, 1615–1868

Shigaraki Ware

Jar
About 1600. Stoneware, wood-ash glaze. 35.6 cm. high (14 in.)

Large Jar
17th or 18th Century. Stoneware, wood-ash glaze. 61.5 cm. high (24¼ in.)

The Shigaraki kilns in Shiga Prefecture have been an active pottery center since the 8th century. The local clay used for making domestic bowls and jars is distinguished by a light sandy texture and a high proportion of feldspar granules that appear as glassy white spots on the surface of the fired vessel. Connoisseurs of Japanese pottery have long admired the robust shapes and warm colors exhibited in utilitarian vessels like these. The earlier jar has an orange body with an eye-catching splash of green glaze, and the later jar is of rich reddish brown highlighted with yellow ash glaze. These two surface finishes are the most common among Shigaraki wares.

Jar—*Catalogue*, p. 283. AP 69.8
Large Jar—See: Munsterberg, *The Ceramic Art of Japan*, 1964, p. 108.
 Gift of N. V. Hammer, Inc., in memory of Richard F. Brown, AG 80.3

Japanese, Edo Period, 1615–1868

Karatsu Ware

Mizusashi (*water jar*)
About 1700. Stoneware, brownish-black and
creamy-white glazes. 18.5 cm. high (7⅜ in.)

A tea utensil to hold fresh water, this cylindrical jar is an example of
Chosen (Korean) Karatsu ware. This ware is characterized by the bold
combination of two different glazes—an opaque white, straw-ash
glaze and a glossy black, iron-oxide glaze—that streak and blur where
the two glazes meet. Most of these vessels are tea utensils, such as
water jars, vases, and *sake* bottles, made by coiling and paddling the
clay into shape, rather than on a wheel. The gently irregular shape of
this example demonstrates the direct touch of the potter's hand.

Anonymous gift, AG 71.2

Japanese, Edo Period, 1615–1868

Europeans Arriving in Japan (Namban Byōbu)

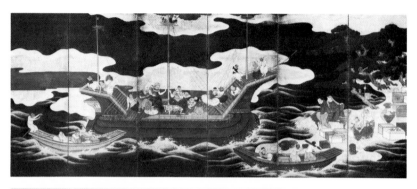

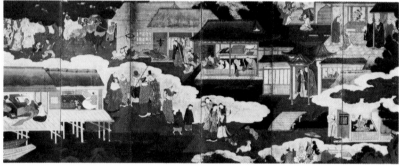

Painted about 1630. Pair of six-fold screens, ink, gold and color on paper.
Each 105.0 × 260.6 cm. (41⅜ × 102⅝ in.)

These richly colored screens *(byōbu)* provide a lively narrative ac-
count of the arrival of a Portuguese galleon at a Japanese port and the
procession of the travelers through the town. The Portuguese traders
and Catholic missionaries, who were the first Europeans to reach
Japan in the mid-16th century, were called *namban,* "southern bar-
barians," because their ships came from a southerly direction. The
strange appearance and clothing of these visitors aroused great curi-
osity among the Japanese, and the painting caricatures their features.
The animated scenes are wonderfully depicted against an abstracted,
cloud-strewn setting. Although these screens have been attributed to
Kanō Dōmi, who was active prior to 1603, it has also been suggested
that they are the work of an anonymous artist active about 1630.

Catalogue, p. 279. Collections: Tachibana. AP 71.14 a,b

Japanese, Edo Period, 1615–1868
KANŌ SHIGENOBU, active about 1635

Wheat, Poppies and Bamboo

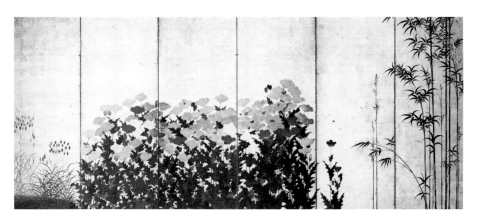

Painted in the early 17th Century. Six-fold screen, ink, colors and *gofun* on gold leaf paper. 152.0 × 357.0 cm. (59⅞ × 139¾ in.). *Also illustrated p. 206.*

This brilliant screen, boldly patterned with bright mineral colors on a gold ground, exemplifies the exuberant decorative style of the Kanō school of artists. This was the most prominent group of painters in Japan from the 16th to the 18th centuries. Colorful paintings on screens and sliding doors were developed during the Momoyama period to embellish the vast, dimly-lit interiors of the new castle architecture. They reflect a change in taste away from the austerity of monochromatic ink painting toward a desire for grandeur and rich display. The Kimbell screen, originally one of a pair, depicts young wheat, blossoming poppies, and bamboo, all of the summer season.

Catalogue, p. 285. AP 69.10

Japanese, Edo Period, 1615–1868
OGATA KŌRIN, 1658–1716

Seiōbo

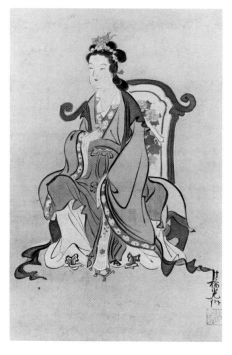

Painted about 1705. Signed.
Hanging scroll, ink and color on
silk over paper. 95.2 × 37.1 cm.
(37½ × 14⅝ in.)

Seiōbo is the Japanese name for the Chinese Taoist immortal, Xi
Wang-mu, the Queen Mother of the West. According to legend, the
garden of her residence in the Kun Lun mountains had trees that,
once every 3,000 years, bore the peaches of immortality, fruits that
conferred longevity on all those fortunate enough to taste them.
Kōrin has depicted Seiōbo as a noble matron in the style of a Chinese
beauty. This interpretation may have been inspired by the appear-
ance of Chinese court ladies in 17th-century genre screen paintings.
The Chinese subject matter, the flowing calligraphic line and bright
colors suggest the influence of the Kanō school on Kōrin, who was the
great master of the Rimpa school.

Catalogue, p. 291; see also: Japan Art Center, *Japanese Art: Selections from
Western Collections*, vol. 5, 1980, p. 143. Collections: Hosomi. AP 67.8

Japanese, Edo Period, 1615–1868
OGATA KENZAN, 1663–1743

Bowl with bamboo leaf design *Bowl with reed design*

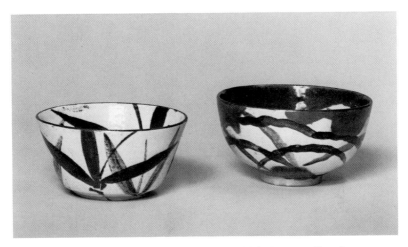

Early 18th Century. Signed.
Stoneware, with iron oxide under-
glaze. 12.0 cm. diam. (4¾ in.)

Early 18th Century. Signed.
Stoneware, glazes, colored
enamels. 10.2 cm. diam. (4 in.)

Ogata Kenzan, one of the great masters of painted ceramics in the Edo period, began potting at the age of 37. He often collaborated on the decoration of his vessels with his older brother, the flamboyant Ogata Kōrin. This accounts for the free, casual manner distinctive to the Rimpa style and its motifs of grasses, blossoms and birds in rich colors which are found in his wares. Kenzan, a student of Zen Buddhism and tea, made vessels primarily for the tea ceremony. These two bowls, used as serving dishes in the *kaiseki* meal, are deftly painted on both interior and exterior with designs that complement their shapes.

Bowl (leaf)—*Catalogue*, p. 294. AP 69.9
Bowl (reed)—*Catalogue*, p. 296. AP 71.10

Japanese, Edo Period, 1615–1868
Arita Ware, Kakiemon Enamels

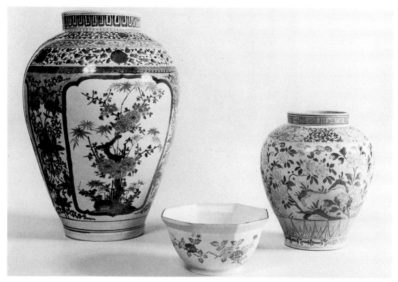

Jar	*Octagonal Bowl*	*Baluster Jar*
About 1652–72.	Late 17th Century.	About 1670. Porcelain,
Porcelain, blue under-	Porcelain, colored	colored enamels.
glaze, colored enamels.	enamels. 10.4 cm. high	28.0 cm. high (11 in.)
48.9 cm. high (19¼ in.)	(4⅛ in.)	

Japanese porcelains were first developed in the early 17th century near the town of Arita in northern Kyushu by Korean immigrant potters who discovered porcelain clay in that area. The earliest wares were decorated in Chinese-style designs painted in underglaze blue. The invention of polychrome overglaze decoration by Sakaida Kakiemon about 1650 was a singular achievement in Japanese ceramics, and these three vessels are excellent examples of this technique. The large jar is distinguished both by its remarkable size and sumptuous but controlled floral ornamentation that subtly complements its regal shape. The smaller jar is unusual in its use of red, green and yellow enamels. In contrast to the two jars, the delicate restraint in the decoration of the bowl is more truly Japanese in feeling.

Jar—*Catalogue*, p. 287. AP 68.10
Bowl—*Catalogue*, p. 290. AP 68.9
Baluster Jar AP 72.12

Japanese, Edo Period, 1615–1868

Arita Ware, Nabeshima Enamels

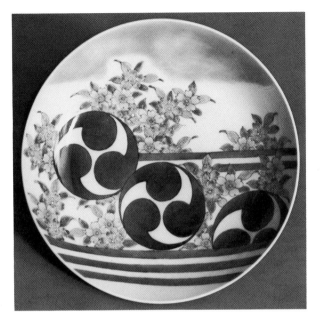

Footed Dish
Early 18th Century. Porcelain, blue underglaze and
colored enamels. 22.1 cm. diam. (8⅝ in.)

The Nabeshima kilns, located near Arita in northern Kyushu, origi-
nally produced ceramic wares for the exclusive use of the Nabeshima
clan lords who dominated that region. These porcelains are distin-
guished by their superior quality and perfection in shape, design, and
enameling techniques. The shallow bowl on a raised foot is a typical
shape among Nabeshima wares, and the balanced combination of
underglaze blue with soft grey-green and light red enamels is charac-
teristic of the kiln's special colors. Textile patterns may have been the
inspiration for the asymmetrical design of cherry blossoms, bands, and
circular *mon*, the crest motif that decorates the dish.

Catalogue, p. 299. AP 68.12

Japanese, Edo Period, 1615–1868
KAIGETSUDŌ ANDO, traditional dates 1671–1743

Standing Beauty

Painted before 1714. Signed. Hanging
scroll, ink, color and *gofun* on paper.
101.3 × 46.7 cm. (39⅞ × 18⅜ in.)

This richly costumed courtesan, silhouetted against a plain back-
ground, stands majestically counterpoised, her head inclined back-
ward as she thrusts her full sleeve forward. The pose displays her
carefully patterned kimono to full advantage and seductively reveals
a delicate white foot at its hem. Solitary and detached, she represents
an ideal beauty of her day and a symbol of the "floating world"
(*ukiyo-e*), the ephemeral world of the pleasure quarters. The stylized
pose, bold textile patterns, and strong black outlines of the figure are
hallmarks of the painting style developed by Kaigetsudō Ando and
continued by his followers in both paintings and woodblock prints.

Catalogue, p. 293. Collections: Saga. AP 71.19

Japanese, Edo Period, 1615–1868
BAIŌKEN EISHUN, flourished 1704–1763

Courtesan in a Procession

Painted about 1720–30. Signed.
Hanging scroll, ink, color and *gofun*
on paper. 89.3 × 44.0 cm.
(35¼ × 17⅜ in.)

Ukiyo-e paintings are perceptive reflections of life in the entertainment quarters of Japanese cities during the Edo period. The outings and amusements of citizens, as well as lavishly dressed courtesans and their lovers, are depicted in paintings that are sensuous, emotional and decorative. This scroll depicts a scene enacted daily as a stately courtesan proceeds proudly through the streets with attendants, the umbrella held by the male retainer proclaiming her rank. The backward glance of the courtesan and the strong black contours of the figures are in accord with the formula established by the Kaigetsudō school which Eishun followed.

Catalogue, p. 297. Collections: Kuki. AP 70.10

Japanese, Edo Period, 1615–1868
MARUYAMA ŌKYO, 1733–1795

Crows

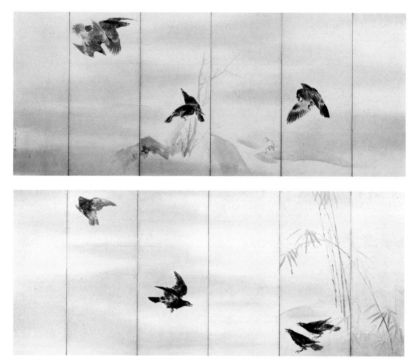

Painted in 1766. Signed and dated. Pair of six-fold screens, ink and gold
on paper. Each 152.2 × 365.0 cm. (60 × 143¾ in.)

In these screens, a clump of young bamboo and a gnarled plum tree
beside a stream provide the setting for a group of crows in flight and
at rest. Soft washes of grey ink and gold convey the feeling of dense
fog and evoke a sense of deep space. The nine birds are boldly ren-
dered in thick, textured brushstrokes in varying tones of grey and
black, achieved by laying down the ink with the side of the brush.
Painted when Ōkyo was 33 years old, these screens demonstrate a
free ink style that is rarely found in works of his youth. However, the
startling realism of these cawing birds and the detailed observation of
natural form are characteristic of Ōkyo's style.

Catalogue, p. 300. Collections: Nakanishi. AP 69.11 a,b

Japanese, Edo Period, 1615–1868

Portable Cabinet with gourd design

Box with courtiers, carts and blossoms

Early 17th Century. Black lacquer with designs in brown lacquer, gold and silver. 30.8 cm. high (12⅛ in.)

Mid-18th Century. Black lacquer with gold and lead designs, mother-of-pearl and shell inlays. 13.0 cm. high (5⅛ in.)

Lacquerware, long admired for its durability and excellent finish, is one of the most painstaking of crafts. Japanese lacquer reached unsurpassed levels of artistic and technical refinement in the Edo period when demand for it increased and production expanded. These two boxes exemplify the vitality of Edo lacquer wares. An informal design of gourds, leaves, and scrolling vines in gold and silver dust embrace the cabinet in a balanced composition with muted color harmonies. The carts and courtiers on the box may be allusions to the famous novel, *The Tale of Genji*. The stylized plum blossoms in mother-of-pearl are in a form distinctive to the Rimpa tradition of Ogata Kōrin.

AP 76.2, AP 76.1

Korean

Koryo Dynasty, *Bottle, celadon ware* (enlarged detail), page 235

Korean, Koryo Dynasty, 918–1392

Celadon Ware

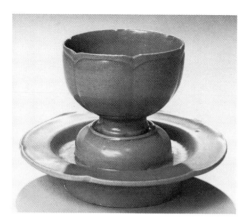

Wine Cup and Stand
12th Century. Stoneware, celadon glaze.
10.0 cm. high (3⅞ in.)

Korean celadon wares, which are among the most highly prized of all Asian ceramics, were originally inspired by Chinese celadons of the Song (Sung) Dynasty. The Korean glazes are more thinly applied than Chinese examples, and unstable kiln conditions produced wide variations in color. The most characteristic color of finer pieces is the grey-green seen in this six-lobed wine cup. Its simple shape and restrained decoration typify the unpretentious intimacy of early Korean celadons.

Catalogue, p. 304. AP 70.12 a,b

Korean, Koryo Dynasty, 918–1392

Inlaid Celadon Ware

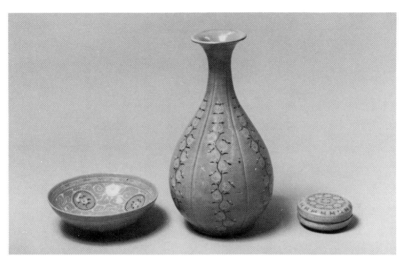

Bowl
12th or 13th Century.
Stoneware, dark green
and white inlay, celadon
glaze. 18.4 cm. diam.
(7¼ in.)

Bottle
Late 12th or early 13th
Century. Stoneware,
black and white inlay,
celadon glaze. 31.0 cm.
high (12¼ in.)
Also illustrated p. 232.

Cosmetic Box
12th or 13th Century.
Stoneware, black and
white inlay, celadon
glaze. 9.0 cm. diam.
(3⅝ in.)

The technique of inlaid decoration on celadon wares is unique to Korean ceramics. Developed about the mid-12th century, it represents the finest achievement of the Korean potter. The inlay was produced by first incising or stamping designs into the clay, then filling the depressions with white or black clay or slip, with the excess carefully scraped away before glazing and firing. These three vessels exhibit a variety of patterns arranged to complement their shapes. Delicate crysanthemum blossoms, vines, and leaves adorn the bottle and small cosmetic box. The bowl is an example of "reverse inlay" in which the ground is incised and inlaid in white, leaving the scroll design to stand out in glazed green.

Bowl—*Catalogue*, p. 306. AP 70.11
Bottle—*Catalogue*, p. 307. AP 69.12
Box AP 72.15 a,b

Korean, Koryo Dynasty, 918–1392

Celadon Ware

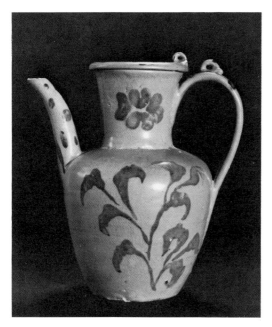

Ewer
12th or 13th Century. Stoneware, celadon glaze over
underglaze iron oxide. 19.8 cm. high (7⅞ in.)

Painted celadons dating to the Koryo Dynasty bear resemblance to
Chinese Cizhou (Tz'u-chou) wares and seem to represent a transition
between the plain glazed and the inlaid Korean celadons. More casual
in appearance than the inlaid wares, this ewer exhibits a freedom in
shape and decoration that is rare among Korean celadons. The blos-
soms and random dots that decorate this beautifully proportioned
vessel create a refreshingly spontaneous image quite different from
the precision of inlaid decoration.

See: Griffing, *The Art of the Korean Potter*, 1968, p. 39. Collections: Dickes.

AP 72.14 a,b

Korean, Koryo Dynasty, 918–1392

Mirror with Dragons

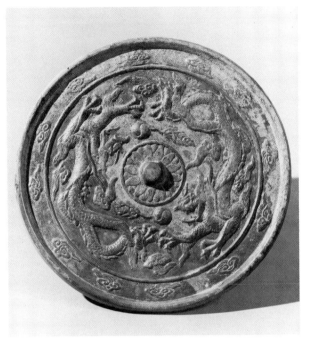

11th to 13th Century. Bronze. 23.5 cm. diam. (9¼ in.)

Mirrors buried with the dead were believed to have served as reflectors of the spirit world. This burial custom originated in China as early as the 4th century B.C., not appearing until the 10th century in Korea where it was in evidence throughout the Koryo period. Although Korean mirrors follow Chinese prototypes in form and design, they have a softer definition of sculptural detail because of the lower tin content of the bronze. This mirror has a round center knob surrounded by petals and a lively pair of dragons which symbolize the spring season and renewal.

Anonymous gift, AG 73.7

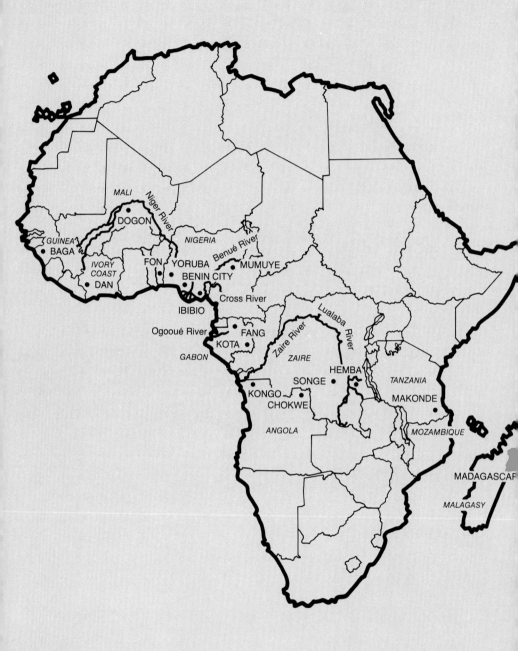

MALI

Niger River

DOGON

GUINEA
BAGA

NIGERIA

Benué River

IVORY
COAST

FON YORUBA MUMUYE

DAN BENIN CITY

Cross River

IBIBIO

Ogooué River FANG

KOTA

GABON ZAIRE

Zaire River

Lualaba River

HEMBA

SONGE TANZANIA

KONGO MAKONDE

CHOKWE

ANGOLA MOZAMBIQUE

MADAGASCAR

MALAGASY

African

Dogon

Standing Figure

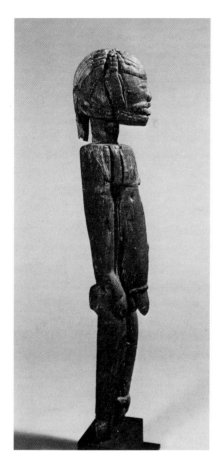

From Niger River area, southern Mali.
18th Century. Wood. 130.2 cm. high
(51¼ in.)

This monolithic sculpture is typical
of the cult figures of the Dogon, an
agrarian people inhabiting the Ban-
diagara cliffs along the Niger River
in southern Mali. These statues
were carved by the tribal blacksmith
and kept hidden in a cliffside sanc-
tuary where they were cared for
only by the priest (*hogon*). They
served as temporary abodes of the
life force and souls of members of a
secret society who had recently died.
This weathered figure is an unusu-
ally large example whose rigid, up-
right pose expresses the indomitable
spirit of the Dogon people.

Collections: Loeb; Kerchache. AP 79.35

Baga

Nimba Headdress

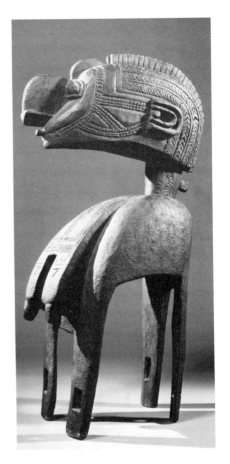

From coastal area, western Guinea.
Late 19th Century. Wood.
133.3 cm. high (52½ in.)

This monumental headdress repre-
sents Nimba, the powerful fertility
goddess of the Baga people who live
in the equatorial area of the Guinea
coast. The goddess is asked to grant
fecundity to a woman or the new
crop. She is carried on a dancer's
shoulders during the agricultural
rites held by the Simo secret society.
The leg supports are covered with a
fiber skirt, and the dancer sees
through the rectangular opening be-
tween the breasts. Bars held in place
in the slots of the legs help him to
steady the bulky structure. The
massive, geometric contours of this
deity are ornamented with elaborate
patterns of scarification. The stone-
like patina of the surface enhances
the solidity of this primal giver.

Collections: Speier; Nash; Kerchache.

AP 79.34

Dan

Spirit Mask

From western Ivory Coast. Late 19th Century.
Wood with fiber.
45.5 cm. high (18 in.)

The Dan tribes, who live in the border area of Liberia, Guinea and
the Ivory Coast, are the preeminent mask-makers in Africa. Their
masks, considered to be incarnations of spirits of the bush, are used in
initiation rituals of the *poro*, the men's society which structures Dan
cultural, political and social life. Conforming to the classic Dan style,
this mask is distinguished by refined carving, highly polished surface
finish and emphatic articulation of facial features. The large circular
eyes and everted lips impart a vivid expression, and the illusion of
reality is heightened by the elaborately braided coiffure, still attached.

Collections: Montague. Funded by gift of Ben Heller, APg 79.20

Ibibio

Spirit Mask

From Niger-Cross River coastal area, southern
Nigeria. 20th Century. Wood with hair.
30.5 cm. high (12 in.)

Masks of the Ibibio people represent the spirits of the dead and have
been used in ritual dances conducted by the powerful male Ekpo
spirit society. Because this group regulated many aspects of tribal
life, from law enforcement and supervision of the planting to the ap-
peasing of life-bestowing ancestors, the specific purpose of the cere-
monial mask remains obscure. The eerie naturalism of this oval face
is intensified by the bold abstraction of the surrounding headdress.
Commanding an awesome respect, the mask seems to hover at the in-
definable frontier between the worldly domain and the spiritual.

AP 79.2

Yoruba

Bent-Legged Man *Guardian with* *Standing Figure*
 Fencing *with Cap*

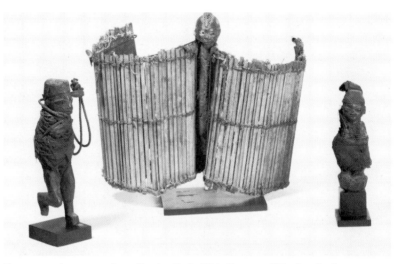

From coastal area, southern Benin. Early 20th Century. Wood and other
materials. Left, 17.3 cm. high (6⅞ in.); center, 22.1 cm. high (8¾ in.);
right, 13.0 cm. high (5⅛ in.)

The Fon and Yoruba peoples, who live in present-day Benin and
Nigeria in West Africa, have intertwined histories and share beliefs
and customs, including the use of magic charms. These objects are far
removed from the familiar court and ceremonial art of these cultures.
Their use as talismans is indicated by their small size and highly in-
dividualized accumulations of accessories. Much of the fascination of
these charms rests in the mystery of the substances applied to the
initial wooden sculpture. In these examples, cords and cloth bind the
figures, restraining the latent energy of their projecting limbs and
heads, emphasizing by concealment their potency. The heads are
strongly articulated and are related to their users by distinctive tribal
scarifications and facial stylizations.

Collections: Kerchache.

AP 79.14
Funded by gift of Ben Heller, APg 79.18
AP 79.13

Fon

Spike-Figure with　　*Paired Kneeling*　　*Paired Spike-*
Two Spears　　　　　 *Figures*　　　　　　*Figures*

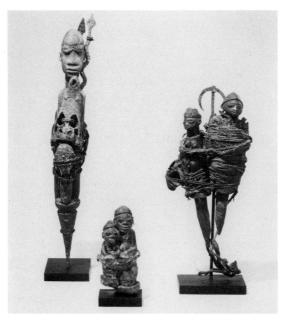

From coastal area, southern Benin. Early 20th Century. Wood and other materials. Left, 48.0 cm. high (19 in.); center, 15.8 cm. high (6¼ in.); right, 29.5 cm. high (11⅝ in.)

The most pervasive aspect of the highly developed Fon religion, with its Great Gods, personal gods and ancestors, is the use of magical charms, or *gbo*. Their power is derived from the gods and invoked to protect the owner and his property and to harm anything which might cause injury. They may guard entrances, be hidden away or carried about. Those with spikes on the bottom, like two of these examples, would be affixed upright in the ground wherever protection is needed. The largest of these with its serpentine metal spears entreats the powers of the snake cult. Each of these examples is a *bochio*, or figural *gbo*. Whereas many *gbo* are composed solely of natural materials bound together, the Kimbell objects are strongly sculptural.

Collections: Kerchache.　　　　　　　　AP 79.17, AP 79.16, AP 79.15

Benin

Standing Oba

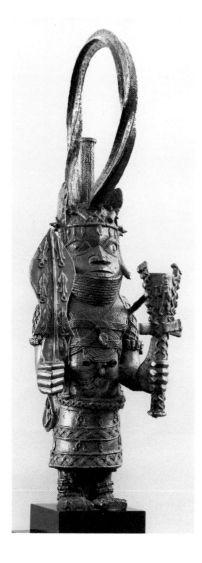

From Benin City, coastal area, Nigeria.
Late 18th Century. Bronze.
57.4 cm. high (22⅝ in.)

The Benin Empire flourished for centuries in the tropical rain forest of southern Nigeria. This bronze figure represents the Oba, divine king of the Bini people. Their artists possess a remarkable expertise in bronze casting, and this sculpture was made in the highly sophisticated "lost wax" technique. It reflects the formal court of the Oba's palace rather than the freer Bini tribal style. Along with bronze memorial heads of past Obas, this figure would have adorned one of the altars of the royal ancestor cult for which elaborate state rituals were held. Emphasis is given to the oversized head, representing the seat of judgment, and the hands, which stand for the power to accomplish things. Holding a ceremonial sword and gong, the Oba is dressed in an ornate, coral-beaded regalia, including a winged headdress, tall collar, bib, sleeves and kilt. His face bears traditional marks of the Bini.

Catalogue, p. 310. Collections:
Pitt-Rivers. AP 70.4

Mumuye

Ancestor Statue

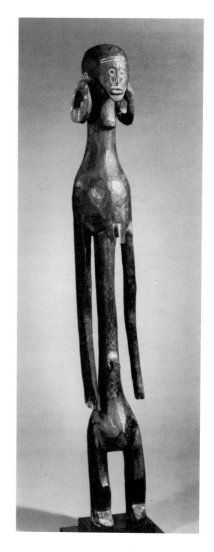

From Benué River area, eastern Nigeria.
20th Century. Wood. 159.1 cm. high
(62⅝ in.)

According to custom, this sculpture
would have been carved upon the death
of a revered tribal figure and placed
next to the skull for several days to ab-
sorb the spirit of the deceased. Usually,
regular offerings were made to such a
statue, which was hidden in a house to
protect it against enemies and disease
and to detect and punish the guilty.
This impressive figure has an appealing
and sympathetic presence. Human pro-
portions are elongated; features such as
the fingers and eyes are simplified; and
other elements are exaggerated, like
the protruding navel and large, looped
earrings. Because the Mumuye people
live in a rugged and remote area of
eastern Nigeria, their works of art were
little-known until the 1960s.

See: Leuzinger, *The Art of Black Africa*,
1972, cat. no. N 22. Collections:
Kerchache. AP 79.40

Fang

Reliquary Head

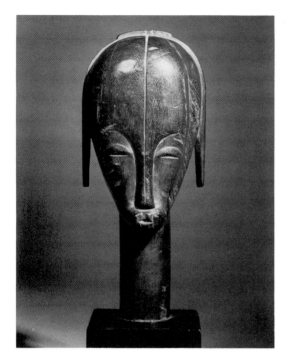

From northern Gabon. Late 19th Century.
Wood. 27.6 cm. high (10⅞ in.)

The delicacy and sensitivity of this reliquary head belies its creation by an artist of the Fang tribe. It was a cannibalistic, warrior tribe who lived in the rain forest of the Ogowe River region of Central Africa. Originally the long neck was inserted in the lid of a cylindrical bark box containing the skull and bones of an important ancestor. This ensemble, called a *bieri*, served as a focus of power and protection. It symbolized ancestor participation when placed on an altar, rubbed with oils and used during initiation rites for male secret societies. The serene elegance and sophisticated simplicity of such Fang carvings have strongly appealed to European collectors.

Collections: Ross. AP 79.41

Kota

Reliquary Figure

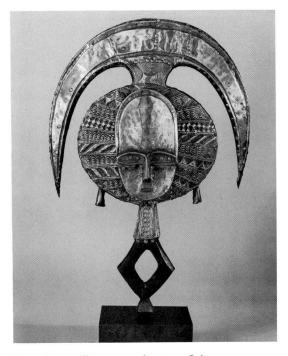

From Franceville area, southeastern Gabon.
Late 19th Century. Brass and copper on wood.
62.8 cm. high (24¾ in.)

Kota reliquary figures were placed on top of containers holding an-
cestral remains in order to ward off evil spirits. Called by the natives
mbulu ngulu (images of the dead), these guardian figures also repre-
sented the souls of the dead. This example is notable for its large size
and for the coloristic effects and intricate detail of its metalwork. The
highly stylized, richly faceted hairdo beneath an assertive, inverted-
crescent headdress becomes a kind of nimbus. The flattened, abstract
qualities of such figures influenced the French artists Picasso and
Braque in their development of Cubism in the early 20th century.

Collections: Le Corneur. APX 77.6

Kongo

Mask

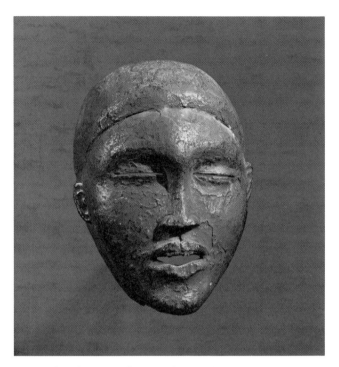

From Zaire River coastal area, Zaire-Angola.
20th Century. Wood.
22.8 cm. high (9 in.)

This hauntingly realistic mask was produced by a sculptor of the
Kongo people inhabiting the coastal region at the mouth of the Zaire
River. The slit eyes and open mouth evoke a trancelike state, appro-
priate to a solemn initiation, a divining ritual or some other religious
ceremony. The emphatic naturalism of this life-size mask is charac-
teristic of Kongo art. The distinctly individual features suggest it
may be the portrait of a deceased tribal member, thus signifying an
ancestral spirit.

Collections: Kerchache; Nash; Pinto; Arman. AP 79.42

Chokwe

Chibinda (The Hunter) Ilunga Katele

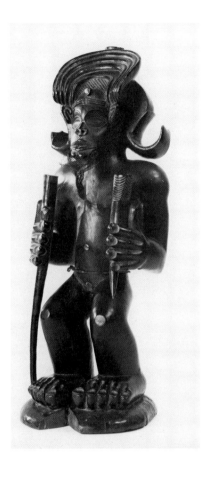

From northeastern Angola. Middle 19th
Century. Wood. 40.6 cm. high (16 in.)

This majestic figure represents the cul-
ture hero Ilunga Katele, royal ancestor
of the Chokwe people (whose name has
received numerous spellings). Ilunga
was a master hunter who lived more
than 400 years ago. The sculpture is
one of eight known examples of this
type of figure, the most sacred and im-
portant done by the Chokwe. They
were attempted only by master artists,
and this example is considered one of
the finest objects of African wood sculp-
ture. Holding a staff and an antelope
horn, the figure wears an elaborate
headdress whose curved flaps balance
his powerfully modeled shoulders. It
conveys both the physical strength of
the hunter's body and the sensitivity
and intelligence of a great leader's face.

See: Bastin, *Statuettes Tshokwe du héros
civilisateur "Tshibinda Ilunga,"* 1978, p. 81.
Collections: Abecassis. AP 78.5

Makonde

Kneeling Mother and Child

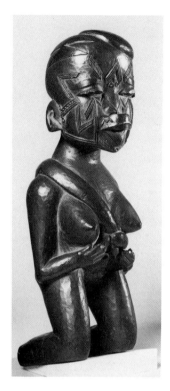

From Tanzania-Mozambique border area.
Late 19th Century. Wood.
36.8 cm. high (14½ in.)

One of the few East African people who make sculptures in any quantity, the Makonde produce unusually naturalistic figures. Most African mother-and-child sculptures are intended to ensure fertility, but this piece indicates the high status of the female in that matriarchal society. It is thought to represent the primeval matriarch who founded the Makonde tribe. Details of the vigorously carved sculpture are wonderfully articulated, including the mother's hooded eyes and her fingers holding the sling in which the baby straddles her back, tiny feet and hands extended. There are also such typical Makonde signs of feminine beauty as the facial scarification, prominent breasts and upper lip distended by a lip plug.

Collections: Pitt-Rivers; Arman. AP 79.37

Songe

Standing Fetish Figure

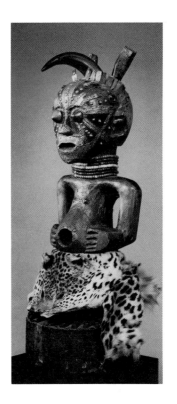

From the Lomami River area, eastern Zaire.
Late 19th or early 20th Century. Wood,
metal, beads and animal pelt.
84.4 cm. high (33¼ in.)

A large tropical area of the Zaire (for-
merly Congo) River basin is dominated
by the Songe people. They are re-
nowned for their aggressive warriors
and the exceptionally prevalent use of
magic by their religious societies. The
power of this guardian figure (known
as *buanga*) derives from the quantity
and richness of his accessories. His
stomach was hollowed to contain magi-
cal ingredients, and the three horns
wedged into the skull cavity probably
also held potent substances. His face is
embellished with hammered copper
strips and studded with iron and copper
nails, all radiating from the eyes. Stiff
hair is suggested by the projecting cop-
per blades. Other attributes of power
include the seven strands of beads and
the animal pelt covering his lower torso.

Collections: Mestach. AP 79.43

Hemba

Ancestor Figure

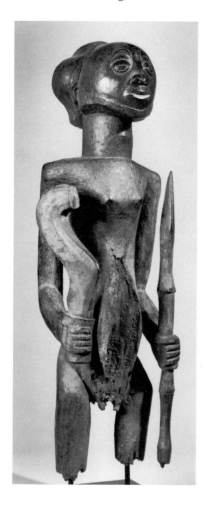

From area of the Lualaba, Luika and Lukuga rivers, eastern Zaire. 19th Century. Wood. 84.1 cm. high (33⅛ in.)

Among the finest achievements of African art are the ancestor statues produced by the Hemba people of eastern Zaire. They migrated into the area as early as the 17th century and formed a highly organized clan society. The cult of ancestor worship influenced every aspect of tribal life, from religious to political affairs. In this refined sculpture, the ancestor figure stands holding a knife and spear, his elegant profile balanced by an elaborate, cruciform headdress. The rhythmic and assertive contours of his body, combined with his remarkably humane expression, convey determination informed by compassion.

See: Neyt, *La Grande Statuaire Hemba du Zaïre*, vol. 2, 1977, cat. no. IV, 12.
Collections: Lambrecht; Kerchache; Scamperli. AP 79.3

Madagascar

Ancestor Figures

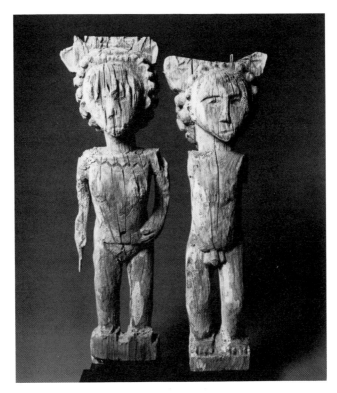

From Malagasy. Early 20th Century. Wood.
Man: 74.9 cm. high (29½ in.) Woman: 78.7 cm. high (31 in.)

This ancestor pair was probably part of a carved wooden grave post
(*aloala*) that stood as a kind of mediator between the living and their
forebears. The restless souls of the dead are thought to reside in such
figures, and prayers and sacrifices were offered to them. Carved in the
round, the figures are animated by a bent-knee stance and the for-
ward thrust of the upper torsos. The facial features are reduced to
bare essentials, in strong contrast to the elaborately detailed head-
dresses and the relative naturalism of the bodies.

See: Leuzinger, *The Art of Black Africa*, 1972, cat. no. Z7.
Collections: Kerchache. AP 79.36 a,b

Pre-Columbian

Xochipala, about 1600–100 B.C.

Standing Man *Seated Woman*

From Xochipala, Guerrero, Mexico.
About 1600–1200 B.C. Clay.
21.6 cm. high (8½ in.)

From Xochipala, Guerrero, Mexico.
About 1600–1200 B.C. Clay.
11.1 cm. high (4⅜ in.)

These figures are among the finest examples of a small number of burial objects found near the remote mountain village of Xochipala. Our fragmentary knowledge of the art of this little-explored area suggests its relationship with the widespread Olmec culture. These small sculptures may represent an early, sophisticated regional style somewhat affected by the art of the Olmec heartland on the Gulf Coast. Alternatively, it is possible they exemplify Olmec art at its earliest or formative period. The animated naturalism of these solid clay figures is distinctive among early pre-Columbian sculpture, as is the assured modeling of forms realized so completely in three dimensions.

Man—*Catalogue*, p. 318. AP 71.3
Woman—*Catalogue*, p. 316. AP 71.4

Olmec, 1200–400 B.C.

Seated Figure

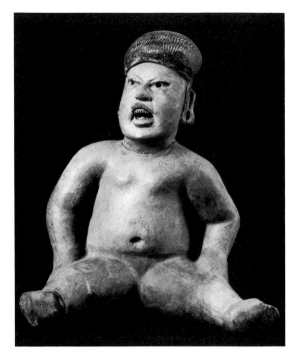

From Tenenexpan, Veracruz, Mexico.
About 1200–900 B.C. Clay, white slip, traces of paint.
27.7 cm. high (10⅞ in.)

The snarling expression, plump babyish proportions and incised head-
dress of this seated figure identify it as a youthful aspect of the power-
ful Rain God whose man-jaguar image is found throughout Olmec
territory. Such representations vary in appearance from near-jaguar
to predominantly human. Here, the flaring lips and sharp teeth indi-
cate the ferocious predator. Highly humanized variants of the jaguar,
like this one, are most frequently found near Veracruz and westward
to the Central Highlands. The rounded, simplified forms of this figure
and its smooth finish are Olmec traits shared with the finest works in
jade and basalt.

Catalogue, p. 314. AP 71.2

Teotihuacán, A.D. 300–700

Singing Priest by Five Maguey Stalks

From the Valley of Mexico. About A.D. 600. Fresco. 60.2 × 110.5 cm.
(23¾ × 43½ in.)

A celebrant in a feathered helmet mask performs a ceremony to en-
sure growth of the maguey (century plant), provider of fibers, food
and potent fermented drink. Orderly sequences of such ritual images,
painted in true fresco, once formed part of the decoration of residen-
tial complexes in the major urban center of Teotihuacán in the arid
highlands north of the Valley of Mexico. They seem to be lucid rep-
resentations of complicated ceremonies asking specific favors of the
gods. Here, fertility-ensuring water is visually evoked in three motifs.
The curving speech scroll contains seashells and other aquatic objects;
blossoms descend to earth from the celebrant's right hand; and spiny
leaves of maguey flourish in the stylized field at left.

AP 72.16

260 | *Pre-Columbian – Classic Period*

Huastec, A.D. 550–950

Smiling Girl Holding a Basket

From Panuco basin, northern Veracruz.
Made about A.D. 600–800. Clay, white slip,
traces of paint. 19.2 cm. high (7⅝ in.)

This seated girl has the animated open mouth, softly modeled cheeks
and broadly flattened head characteristic of the finest small ceramics
of the Huastec culture. It flourished in northern Veracruz during the
time of the Maya, their southern neighbors and distant relations. The
style resembles that of a number of figures from Nopiloa, which also
contrast smooth, mold-made areas with enlivening hand-modeled
details. Especially noteworthy in this example are the tapering fingers,
the jewelry, the seed-festooned headdress, and carefully shaped ob-
jects in the basket which appear to be rolled tortillas.

AP 78.1

Maya, Late Classic Period, A.D. 600–950

Stela with a Ruler-Priest

From the Usumacinta River Valley.
Dated A.D. 692. Limestone.
272.7 × 173.7 cm. (107⅜ × 68⅜ in.)

This stela is a monumental portrait of a Maya ruler who stands displaying his scepter and tasseled shield. He wears elaborate, richly symbolic clothing: his beaded collar and belt are adorned with face plaques, his apron with a large frontal mask. His complex feathered headdress has two superimposed masks which appear in profile. It is dominated by imagery of the creator god Itzam Na, giver of rains and fertile soils, including the motif of a fish nibbling at a water lily which is repeated at apron hem. Maya official portraits like this one were set up in the ceremonial courtyards of pyramid-temples to glorify the ruler and supplicate the gods. The finest Classic Period stelas share with this one a clear linear style and the careful arrangement of figure, glyphs and regalia.

Catalogue, p. 322; see also: Miller, "Notes on a Stelae Pair. . . .," *Primera Mesa Redonda de Palenque*, part 1, vol. 2, 1974, p. 149; Mayer, *Maya Monuments: Sculptures of Unknown Provenance in the United States*, 1980, cat. no. 13. AP 70.2

Maya, Late Classic Period, A.D. 600–950

Presentation of Captives to a Maya Ruler

From the Usumacinta River
Valley. Dated A.D. 782.
Limestone, traces of paint.
115.3 × 88.9 cm. (45⅜ × 35 in.)

This extraordinary relief panel commemorates the presentation of
three recently captured individuals to the ruler of Yaxchilan in
A.D. 782, the date recorded at the top of the double glyph panel. The
other glyphs, though not entirely transcribed, identify the enthroned
figure, his subordinate and the submissive captives and record the
events of their capture and final disposition. Few other Maya relief
sculptures depict so lively a narrative with such convincing gestures.
Equally unusual is the suggestion of an interior space, indicated by
the steps and the furled drapery. The panel once adorned a wall or
lintel of a major building at a ceremonial city with close ties to Yax-
chilan. It is in exceptionally fine condition: the carving is crisp, and
there are extensive traces of once-vivid paint in blue-black and red-
orange.

Catalogue, p. 320; see also: Mayer, *Maya Monuments: Sculptures of
Unknown Provenance in the United States*, 1980, cat. no. 14. AP 71.7

Maya, Late Classic Period, A.D. 600–950

Male Face

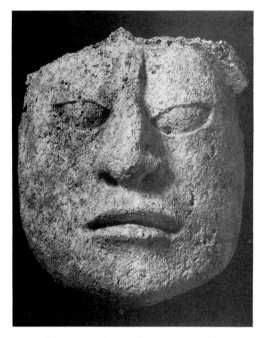

From Chiapas, Mexico. About A.D. 700–900.
Stucco, traces of paint.
26.0 cm. high (10¼ in.)

This larger-than-lifesize stucco head, modeled in high relief, was
originally an architectural ornament for a state ceremonial building.
Probably the portrait of an important official, the face has the high-
bridged nose of the quintessential Maya profile, while the broad face—
with its shallow eye sockets and irregular features—is highly indi-
vidualized. Originally its rough surface was covered with a smooth
plaster finish, then painted; traces of brown and red pigment remain.
Palenque, the great ceremonial city of the western Maya, was the
center for the development of such stucco sculpture. Its finest struc-
tures were richly enhanced by large portrait reliefs and ritual scenes.

Catalogue, p. 325. AP 71.5

Maya, Late Classic Period, A.D. 600–950

Carved Vase with Ceremonial Scene and Large Glyphs

From Jaina Island, Campeche. About A.D. 690–750. Clay, traces of paint.
20.7 cm. high (8⅛ in.)

This carved Maya vase is one of the most elegant known. It is distinguished by the unusually fine carving—done in the leathery clay before firing—of the low-relief figure scene and the eight large incised glyphs on the back. The glyphs, now partly transcribed, probably commemorate the event depicted on the front, perhaps a private ritual. There, a seated ruler—commanding in pose and imperious in expression—holds a fringed object, which is possibly a mirror, rare among the Maya and associated with royalty. Few other carved Maya vases indicate so successfully an interior palace setting, complete with fringed drapery and mat-covered bench-throne. The style is that of northern Yucatan, a coastal location further supported by the ruler's frigate-bird headdress.

See: Coe, *The Maya Scribe and His World*, 1973, cat. no. 53. APX 74.4

Maya, Late Classic Period, A.D. 600–950

Painted Vase with Five Figures

About A.D. 750–800. Painted clay.
25.8 cm. high (10¼ in.)

The exceptional quality of this painted ceramic is indicated by two features which distinguish the finest Maya vases: its subtly incurved profile and its white painting-ground, which sets off with luminous clarity the warm hues of the figures and glyphs. These sophisticated formal elements complement the fluid, flexible ease of the outline drawing and calligraphy. The vase is further enhanced by the rich elaboration of costumes, poses and features in the painted figures. The paired groupings may reflect a double ceremony or successive stages of a Maya ritual.

Anonymous gift in memory of John William and Mary Seeger O'Boyle, AG 79.2

Maya, Late Classic Period, A.D. 600–950

Painted Vase with Processional Scene

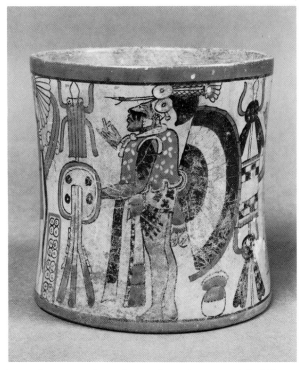

From the Usumacinta River Valley. About A.D. 750–850.
Painted clay. 16.0 cm. high (6⅜ in.)

Five figures march in stately procession around the circumference of
this impressive, polychromed Maya vase from the Usumacinta River
Valley. Four of the men are dressed in ceremonial and martial splen-
dor; the other is a nude prisoner, his arms bound behind him. The
drawing style is bold and emphatic, reinforcing the strength and so-
lidity of the figures. The captor-captive theme is an important one in
Maya art, for it appears in all major media—wall paintings and relief
sculptures as well as vase paintings.

APX 76.16

Coclé, A.D. 500–1200

Twin Warriors *Two Deer Heads*

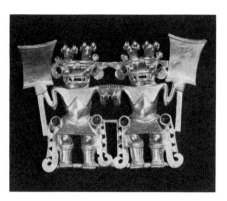 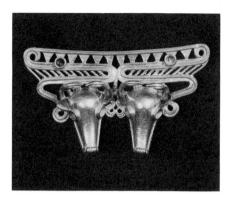

From Azuero Region, Panama. From Azuero Region, Panama.
A.D. 800–1200. Gold. A.D. 800–1200. Gold.
12.2 cm. wide (4⅞ in.) 11.9 cm. wide (4¾ in.)

These solid cast-gold pendants are among the finest examples of Coclé art known today. The twin warriors, adorned with flamboyant waist pendants and fantastic headdresses, have human bodies with bat-nosed faces. The antlered deer heads are smoothly cast below bold, stylized alligator profiles, presenting an emphatic contrast of fluid lines and clean geometric forms. The powerful imagery of these chest ornaments—usually found in burial sites—may have reinforced the status of their wearers, while their intrinsic value conferred prestige. The craft of fine goldwork probably reached Panama from South America. The exceptional quality of these rare examples derives from their strong, clear modeling, large size and flawless casting.

Twin Warriors—Collections: Weinstock. AP 79.23
Deer Heads—Collections: Weinstock. AP 79.24

Mixtec, 950–1500

Rain God Vessel

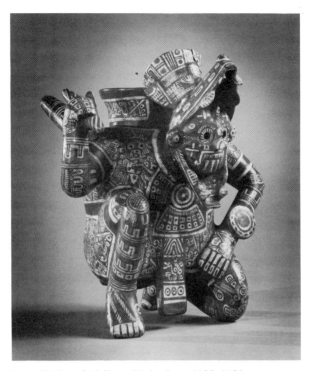

From El Chanal, Colima. Made about 1100–1400.
Painted clay. 24.7 cm. high (9¾ in.)

This remarkable spouted vessel in the form of a crouching masked
figure was undoubtedly created for ritual use. In a double impersona-
tion of important gods, the figure wears two masks. One is that of an
open-jawed, round-nosed beast; the other bears the goggles, jaguar lip
and fangs of the rain god. Intricate ornaments, including death sym-
bols, cover spout, neck and figure. The complexity of forms in this
vase and its elaborately painted and incised surface suggest a brilliant
conjunction of West Coast and Mixtec stylistic traits.

Collections: T. Ford. APX 74.2

Nahuat (?), 900–1500

Xipe Totec

Probably from Central Mexico.
Made about 900–1200. Clay.
40.0 cm. high (15¾ in.)

Xipe Totec, "our lord the flayed one," grimly epitomized for Pre-Columbian Mexicans the ceaseless death-and-renewal cycle of the universe. This god of spring and regeneration was worshipped by a priest who, dressed in the skin of a flayed victim, ritually enacted the advent of the earth's new coat of vegetation. Xipe was a major deity of the linguistically-related Toltec, Nahuat and Aztec people. In successive waves over several centuries, they penetrated the Valley of Mexico, Puebla plateau and Gulf Coast, creating rich, eclectic regional cultures. This work closely resembles Aztec stone figures in the smooth modeling, sturdy body, and rounded lips and eyes. Clay sculptures of Xipe are common, however, in the pre-Aztec art found in Nahuat areas. These include the Valley of Mexico and southern Veracruz, where figures in a similar red-orange clay have been discovered.

AP 79.39

Aztec, 1325–1521

Seated Man, possibly Huehueteotl

About 1500. Basalt.
64.1 cm. high (25¼ in.)

This austere sculpture probably served as a guardian figure for the stairway of an Aztec temple platform. On ceremonial occasions he may have held a banner staff in his right hand and worn a ceremonial costume. His sturdy body and coarse features indicate that he is an old *macehual,* or man of the people. The stylizations of his body—in the face scarification and in the abstract patterns of the kneecaps, shoulder blades and vertebrae—suggest that he also represents the "Old God," Huehueteotl, the Aztec patron of fire, the sacred element from which all life emanated.

Catalogue, p. 326; see also: Nicholson, "The Late Pre-Hispanic Central Mexican (Aztec) Iconographic System," *The Iconography of Middle American Sculpture,* 1973. Collections: Ullmann. AP 69.19

Index

Artists: Attributed Works

Cultures: Unattributed Works

Museum Information

Hours

Tuesday through Saturday, 10:00 a.m. to 5:00 p.m.
Sunday, 1:00 p.m. to 5:00 p.m.
Closed Mondays, New Year's Day, Independence Day, Thanksgiving,
Christmas Day.

Location

The museum is located at 1101 Will Rogers Road West, between West
Lancaster Street and Camp Bowie Boulevard. Mailing address is P.O. Box
9440, Fort Worth, Texas 76107. Telephone number is (817)332-8451.

Public Services

Admission is free.

Guided tours, conducted by museum docents, may be scheduled through
the Fort Worth art museums Tour Coordinator, telephone (817)738-6811.

The Bookstore offers many original slides, postcards, notecards, posters,
selected art books and periodicals.

The Library is open to visitors only by appointment through the Librarian.

Hand-held cameras are permitted in the galleries, unless otherwise posted.
Tripod and flash photography is not permitted in the galleries without
prior permission from the Communications Office or, on weekends, from
the Security Supervisor.

The galleries, refreshment area, and auditorium are accessible by elevator
to those using wheelchairs or strollers. Wheelchairs are available.

Publications

Kimbell Art Museum: Catalogue of the Collection, 1972
Light is the Theme: Louis I. Kahn and the Kimbell Art Museum, 1975
Louis I. Kahn, Sketches for the Kimbell Art Museum, 1978
Handbook of the Collection, 1981